In the Kitchen of

Marco Grassi

In the Kitchen of Art

Selected Essays and Criticism, 2003–20

Criterion
Books

First American edition published in 2021 by Criterion Books, an activity of Encounter for Culture and Education, Inc., a nonprofit, tax exempt corporation. Encounter Books website address: www.encounterbooks.com

Manufactured in the United States and printed on acid-free paper. The paper used in this publication meets the minimum requirements of ANSI/NISO z39.48–1992 (R 1997) (*Permanence of Paper*).

FIRST AMERICAN EDITION

LIBRARY OF CONGRESS CATALOGING-IN-PUBLICATION DATA

Names: Grassi, Marco, author.
Title: In the kitchen of art : selected essays and criticism, 2003–20 / Marco Grassi.
Other titles: New criterion (New York, N.Y.)
Description: First American edition. | New York : Criterion Books, [2020] | Includes bibliographical references and index. |
Identifiers: LCCN 2020049185 (print) | LCCN 2020049186 (ebook) | ISBN 9781641771955 (paperback) | ISBN 9781641771962 (ebook)
Subjects: LCSH: Art.
Classification: LCC N7445.2 .G73 2020 (print) | LCC N7445.2 (ebook) | DDC 700–dc23
LC record available at https://lccn.loc.gov/2020049185
LC ebook record available at https://lccn.loc.gov/2020049186

Contents

To my wife Cristina, whose patience with me far exceeds my patience with paintings

A Florentine childhood

Some introductory remarks.

SEEING, IN PRINT, what one writes is, even for a professional penman, a uniquely satisfying experience. For an amateur like me, it is sublimely ego-enhancing. I am all too aware of possessing zero credentials and less-than-zero name recognition as a writer. What I do have, thankfully, are good friends: Roger Kimball and James Panero, respectively Editor and Executive Editor of *The New Criterion*, and Brandon Fradd, eminent cultural entrepreneur-about-town and generous patron of this book. Pure vanity prompted my immediate, and enthusiastic, response to their generous suggestion that some of the articles I had submitted over the years might be collected in book form. Because I am neither a published "art historian" nor an academic scholar, I felt it necessary to clarify my personal profile as an "outsider." Such an account makes sense only if it starts at the beginning – in other words, in childhood. After all, if Wordsworth's well-worn dictum contains a grain of truth, I – the man – am the child of my younger self.

Were 1934, the year I was born in Florence, to be mentioned, it would, if at all, be remembered quite differently by Italians than by Americans. Here, one might recall the cinematic end to the gangster John Dillinger's career or, with more lasting consequences, the birth of another, far longer-lived, career: that of Donald Duck. Italians, instead, would almost certainly recall events of seemingly greater gravitas: that year, il Duce,

with non-stop speeches, was celebrating before oceanic crowds the twelfth, and perhaps most successful, year of his Fascist regime. Impressive new public buildings – stations, schools, *Case del Popolo* ("Houses of the People"), apartment blocks, even private villas – were sprouting up seemingly everywhere. In an effort to revitalize regional backwaters, many of these ambitious projects were in areas near the southern and eastern coasts of the peninsula and not a few were designed by Marcello Piacentini, the regime's architect-*en-titre* in a deco-on-steroids style that proclaimed Fascism's obsession with revolutionary renewal; a legacy of the movement's roots in Italian Futurism. And, yes, the trains *were* running on time. They were dubbed *Littorine* in a nod to the ancient Roman lictors who carried the central icon of the regime: the *fasci*. The trains were marvels of streamlined design and mechanical efficiency. On the high seas, the success of the Italian Line's SS *Rex* in capturing the coveted "Blue Riband" for the fastest transatlantic crossing only added volume to the nationalistic drumbeat. The renowned airman Italo Balbo gathered his share of celebratory headlines when, in 1933, he reached Chicago's "Century of Progress" exhibition at the head of a squadron of twenty-eight seaplanes.

I have sometimes wondered what my parents made of all this the year I was born. They were living in Florence, already gladdened by the presence of my brother, Luigi, born three years earlier. My father, Arturo – a second-generation art dealer – was thoroughly apolitical and hardly a joiner, so I never saw the square, tri-color Party emblem (derisively called *la cimice* – the bedbug) pinned to his lapel. Cornelia, my mother, an Indianapolis native with German and Yankee roots, was as uninterested in politics as she was in popular culture. In truth, they were really only interested in each other. Their story had begun on their first meeting in the South of France in 1928 and would last their entire lives.

I have often described that romance as a Fred Astaire movie. In the society pages of the *Indianapolis Star*, the announcement of their wedding in Nice reported breathlessly that "the couple will live in Florence, where a palace is being prepared for them."

One would search in vain for that "palace" in any guidebook, for it was, in reality, just a large and architecturally undistinguished building of the Biedermeier period. Its only claim to historical significance was that King Victor Emanuel II settled one of his mistresses there when Florence served as united Italy's first capital in the 1860s. Even that small fact had receded from memory by the time my grandfather Luigi purchased the house in 1903. It became his residence and art gallery and, eventually, the home of his two sons: Arturo and my uncle, Gian Giulio. The timing worked brilliantly, for the elder Grassi's premises were thenceforth known as "Luigi Grassi & Sons" and became an obligatory destination for all manner of serious collectors, museum functionaries, and scholars. As a result, the Grassi name lies firmly tucked away in countless provenance listings the world over. By all accounts, "Professor" Luigi Grassi knew what he was doing. Not only did he exercise a keen perception in his purchases, he also unmasked several clever forgeries and their creators. Untouched by scandal – not easy in those days – he was named head of Italy's art-dealers' association and was invested in the Order of Saints Maurice and Lazarus by the Crown. Luigi Grassi enjoyed, in sum, a long and remarkably successful career presiding over a well-respected undertaking with a distinguished international clientele and a huge, diversified stock of paintings, furniture, and works of art.

The timing was rather less auspicious for Arturo and my uncle after Luigi's death in 1937. Alas, the post-war hyperinflation in Germany and, on its heels, the American securities crash severely curtailed demand for art in those two

markets, the ones that had principally sustained my grand-father's business. By the breakout of the Second World War in 1939, the lights at the firm of Luigi Grassi & Sons had irrevocably gone dark.

Such melancholy circumstances hardly affected my child-hood. The spacious home, the grand upstairs gallery halls, and, above all, the large rear and side gardens provided an unparalleled fantasy land where my brother and I, together with our friends, could endlessly "wage war," gallantly "res-cue" our allies, and "rule" over our ever-changing dominions. An early interest of mine, bordering on passion, was naval warfare. Between the two world wars, Italy had undertaken an ambitious ship-building program resulting in an impres-sive fleet of swift light cruisers and destroyers. I learned by heart every specification of these sleek, beautiful ships by poring over the copy of the minutely detailed *Almanacco Navale Internazionale* ("International Naval Almanac") that my father had given me.

Both my parents' evident unconcern with politics allowed my brother Luigi and me to partake enthusiastically in the youth programs of the regime, patterned vaguely on the American Boy Scouts. There were, naturally, several levels of seniority with different uniforms and insignia. Oh, how I envied Luigi's *Balilla* knickers and pea cap while I had to make do with the silly fez and white suspenders of a *Figlio della Lupa* – "Son of the She-Wolf" (!). I guess I was left free to identify either with Romulus or Remus. At all events, my childhood inclinations were surely anything but pacifist.

Soon enough, it would not be necessary to make believe or to imagine: the real war was on. My father, an Italian Army reserve captain, was called up and posted as an intelligence officer in Rome (translating and vetting Allied prisoner-of-war letters). This resulted in the curious *ménage* of two citi-zens of warring nations living happily under one roof. This

was, actually, not that unusual in Florence, a city cosmopolitan enough not to have made too much of a fuss about the legendary art dealer Bernard Berenson, who was not only American but also famous *and* Jewish. He managed to live through the war and the German occupation (1943–45) relatively unmolested. The city certainly suffered its share of human tragedies as well as significant losses to its artistic patrimony. The demolition of entire areas bordering the venerable Ponte Vecchio in a mindless (and useless) German attempt to slow the northward Allied advance was a terrible injury to the city's ancient urban fabric, as was the destruction of Ammannati's Ponte Santa Trinita as part of the same "tactical operation." But these casualties pale in comparison to the destruction of Monte Cassino, the fire-bombing of the Campo Santo in Pisa, or the total loss of Mantegna's Ovetari Chapel in Padua. In sum, Florence managed to dodge reasonably well the conflagration's worst bullets. I can truthfully say that while there may have been fear and apprehension in the Grassi household, there was never palpable terror.

For us children, the comings and goings of armed men, regardless of their allegiance, was as exciting as the rumble of passing armored vehicles or the recurring air-raid sirens. Unaware as we were of their murderous mandates, the German military were of particular interest; at least to us, it seemed that their gear, weapons, and uniforms were particularly dashing and intriguing. Thanks to a dreaded Swiss-German governess, Luigi and I also possessed the rare advantage over our local chums of being fluent in German. We could sidle up to a strolling Feldwebel and ask as to the caliber of his sidearm or the number of cartridges of its clip. A memorable moment came when a friend of the family – a German lady who had lived for decades in a Florentine

villa – asked whether her son, a Lieutenant in the Wehrmacht, could take refuge in our basement. Being perfectly fluent in Italian, he had been assigned to the Headquarters Staff of General Gerd von Runstedt, the commander of all German forces in Italy. As the front approached Florence, the young man felt he had done his duty and wished to throw in the towel. Nevertheless, as a loyal soldier, he did not want that the precious tactical information he possessed to be too "fresh." Several days needed to pass before he surrendered, since the Gestapo would surely and immediately be knocking at the door of his mother's villa. Hiding until the Allied liberation was his only chance to survive summary execution.

The handsome young man – in full uniform, with decorations and sidearm – instantly became the somewhat perilous focus of our household. For us children, if not necessarily for our parents, it was too good to be true. Here was an impeccable source who could answer every one of our military questions. It was not so bad either for our cook's daughter, an attractive lass charged with bringing meals to the basement guest ... the story's modest but touching love interest. And yet, like many good things, this, too, was soon over. General Mark Clark's Fifth Army, after its momentary arrest at Monte Cassino, moved northward at ever increasing speed. By July 1944, it entered Florence preceded by British Indian units. The German lieutenant departed, and my mother, in a transport of patriotic furor, burst upon the Allied command proffering her collaboration in Red Cross relief. The officers in charge wisely understood that she might not make an ideal Florence Nightingale but would rather be far more effective as a hostess. After all, our home was still in functioning mode despite the meager food supply garnered mostly via the black market and the silver tableware buried in the garden. Wine and spirits, let alone

tobacco, were, needless to say, almost forgotten pre-war luxuries.

No sooner had my mother happily agreed to welcome General Clark and the Americans for dinner than a gigantic U.S. Army truck pulled into the garden and began disgorging a cornucopia of provisions including – eureka! – my first Hershey bar. It was evidently understood that a select number of Florentine society ladies would be in attendance at the dinner, and so too for the several further dinners that followed the evident success of the first. Before bedtime, my brother and I would be led, in pj's, to properly greet the assembled guests. Our delight in these close encounters with the new military in town was somewhat dampened by the realization of how modestly and unadorned even their general officers were turned out. No shiny boots, crisp, tailored jackets, or tassled epaulettes. It was often impossible to distinguish seniority or rank. Was this democracy? If so, we were not impressed.

These congenial evenings must have generated a reciprocal amity between Clark and his hosts. He and my mother were, after all, both Indiana natives. At any rate, someone must have mentioned to my parents that a ship was soon to depart from Naples for New York, and that, should they wish, a place might be available for the family. I can only imagine how this must have set their hearts racing. Italy was in ruins; prospects for a return to normalcy were dim at best; much of Europe was teetering on the brink of Communist domination; but, most compellingly, my mother had not seen or communicated with her Indianapolis family in nearly five years. By September 1945 we were on our way to Naples as part of a small convoy of U.S. Army command cars. The two-day trip afforded a succession of harrowing visions of a war-devastated land and its devastated people. Could such a nation ever recover? Yet, by 1950, Italy had,

indeed, recovered – a re-birth that has been, rightly, described as a "miracle."

In Naples we boarded SS *Gripsholm*, a Swedish Line passenger ship that had been requisitioned by the Allies to repatriate American civilians who had found themselves stranded in the Mediterranean area when war broke out. There were other stops, including Athens, Alexandria, and Marseilles. The final passenger roster reflected an exotic gathering of dubious business types, down-and-out journalists, spies, and political refugees.

In retrospect, I now realize that, as we saluted the Statue of Liberty on entering New York harbor, my life was about to be transformed. I was only eleven years old but would soon experience the acute anxieties of adopting a new, American identity. This became immediately evident the moment I looked about me on arrival in New York: every single American boy my age and even younger wore *long* pants! There we were – myself and Luigi, my older brother – in horrific little suits with *short* pants. They had been sewn together by a seamstress in Florence from a bolt of brilliant green billiard-table flannel purchased on the black market by our mother. Loud and vigorous protests were met with assurances that there was no better-quality fabric and that it would last ever so long. This had only served to heighten our discomfiture. We imagined years of being dressed as make-believe frogs. It was Luigi who finally proclaimed a general strike: we would simply *not*, thenceforth, emerge from our hotel room unless properly attired. Faced with such a coordinated ultimatum, there was nothing for it but to cross Fifth Avenue and seek relief at De Pinna, one of the many department stores that dotted Midtown in those years. My brother and I actually insisted on choosing our purchases. In doing so, we determined our appearance and, in a sense, our identity.

Now in my eighty-sixth year, I look back and realize that this may well have been the moment when my childhood came to an end and when, for better or worse, I became the man I am today.

March 2021

In the kitchen of art

A conservationist & dealer discusses his business.

ERNST VAN DE WETERING, the Dutch art historian, recently remarked, perhaps only partly in jest, that in today's world a few thousand people earn their living touching works of art while earnestly preventing untold thousands of others from doing just that. I have lived my professional life as one of the former. This tiny minority of which van de Wetering speaks is busy, in museums and ateliers all over the world, in what Bernard Berenson with a tinge of contempt called "the kitchen of art." He meant by this to describe that murky backstage frequented by scholars, technicians, and craftsmen where the pulleys, gears, curtains, and props of the art world are manipulated. "BB," for one, was profoundly suspicious. Regarded more benevolently, this "off limits" terrain is generally known as the "restoration studio" or, alternatively, as the "conservation laboratory." These two terms, though usually describing settings that are quite similar, refer, in fact, to very different traditions. A brief backward glance will illustrate this.

There is ample evidence since remotest antiquity that the specificity and singularity of certain man-made objects bearing artistic meaning have been recognized as being worthy of conservation. The need to preserve and maintain the special characteristics as they are represented in a "work of art" is already clearly evident in an account of the elder Pliny. He recounts how a painting by Aristeides of Thebes, a contemporary of Apelles, representing "A Tragic Actor and

a Boy," "was ruined through the ignorance of the painter to whom Marcus Junius as praetor [*ca.* 25 B.C.] entrusted it to be cleaned before the games of Apollo."

The desire to intervene, when necessary, to preserve artistic patrimony runs uninterrupted through medieval times, becomes ever more compelling during the Renaissance and Baroque periods, and finally, and not surprisingly, emerges full-blown in the Age of Enlightenment. Until the mid-eighteenth century, one finds that it was practicing creative artists who, almost invariably, were charged with intervening upon the handiwork of their predecessors and fellow artists: Duccio revising Guido da Siena (in the Palazzo Pubblico *Madonna*), Cellini completing a fragment from the antique (the *Ganymede*), Vasari reinventing the Palazzo Vecchio (the "Sala dei Cinquecento"); the list is endless . . . and the results occasionally disastrous. What is surprising, however, when compared to the often disturbing visual testimony, is that when a *written* record survives, whether in correspondence, contracts, memoirs, or the like, the level of artistic (as opposed to art-historical) awareness and perception is of a very high order indeed. It is a discourse occurring between artist and artist or between artist and patron, each perfectly cognizant of the responsibilities and implications of their undertaking. These concerns were shared not only within the confines of the princely or ecclesiastical courts of Europe, but also in the "most serene" Venetian Republic. Here, the resourceful and energetic Pietro Edwards, an Italian of English descent, was, by 1778, in charge of the Republic's "public paintings," drawing up inventories, ordering surveys, and supervising restoration campaigns. He is, in every way, a new figure in the scheme of things: neither artist nor patron but a knowledgeable connoisseur in public service – the prototype of the modern curator. France in this same

period saw the emergence of yet another novelty, the "professional" restorer. It was, in fact, during the waning decades of the *ancien régime* that several enterprising and hugely ego-centric craftsmen developed transfer and lining techniques that were to put some of the Crown's greatest masterpieces at unconscionable risk. Not painters by training, the Hacquins, *père et fils*, the Picaults, *père et fils*, the widow Godefroid, to mention the most prominent, plied their trade well into the museum age, each promoting his or her own special and very secret techniques. This coincided roughly with the fall of the monarchy and the establishment of the Musée National (later Musée Napoléon, and later still, Musée du Louvre). It was the first public gallery to open its doors, and although artists of the stature of Jacques-Louis David were still very much involved in the new enterprise, the museum consecrated the roles of restorer, curator, and administrator. The "kitchen of art" is born.

Unlike other institutions – hospitals, universities, libraries – whose origins can boast roots dating back centuries, the museum is a "new" invention. Its growth and development, through the course of the nineteenth century, was conditioned by a mixture of local traditions, expediency, and idealism. Restoration remained a craft practiced by independent and secretive private entrepreneurs who were able to maintain a delicate balance between their private and public clientele. It was only in 1888 that a museum (Berlin) established the first in-house studio. Art history, meanwhile, was no less a newcomer to the academic landscape. Indeed, until the early years of the last century, all the activities connected to the care, study, and administration of art objects were dispatched in a somewhat ad hoc manner by cultured, well-intentioned, and generally quite talented amateurs posing as professionals – updated versions of Pietro Edwards. Though

not necessarily trained in the art academies, they continued to maintain close ties with artists and the creative environment. The world of collecting and dealing was also very much part of this milieu, for it was during the nineteenth century that the private demand for art and its consumption assumed gigantic proportions as the princely collections began to be dispersed.

At this juncture we again meet Mr. Berenson, one of the first, and surely one of the most gifted, practitioners of the new art historical discipline. Pursuing his inquiries as much on research as on perception, his method can be described in one word: connoisseurship. As he himself admirably put it: "connoisseurship ... proceeds, as scientific research always does, by the isolation of characteristics of the known and their confrontation with the unknown."

Not long after this was written in 1902, Alois Riegl theorized about the nature of artistic "monuments" (including for the first time all manner of art works in this category). Riegl deals with artistic value, defining it in its various manifestations. Yet he adds to his analysis a very important, perhaps the most important, ingredient: historical value. This concept, having almost nothing to do with connoisseurship, is a clear signal that the intellectual paths to be traveled by Messrs. Berenson and Riegl and their followers would progressively diverge. It can reasonably be argued that the advances of art history through the last century – and they have been prodigious – were conditioned by the dynamic juxtaposition of these contrasting poles, the one weighted by its concern over stylistic, formal, and aesthetic issues, the other centered on questions of contextual, historical interpretation. Not, of course, in the sense of being contradictory or mutually exclusive, but rather as two sides of the same coin. Inexorably, however, the currency of "history" soon overshadowed the values of "art." This was, after all, the

dawn of the new century, and the practitioners of the new art historical discipline were still in search of legitimacy. What Mr. Berenson stood for was an interpretative pursuit based primarily on intuition, talent, perception, and honed on relentless visual inquiry ... what has become known as "eye." Such an approach could not but be profoundly suspect, particularly to that growing number of "historicists" who were at last earning a respectable place in the academic sun.

A parallel evolution was occurring in the practice of restoration: the "studio" was being transformed into the "laboratory." Those generations of resourceful craftsmen who, a century earlier, had carefully wrested their practice from the hands of creative artists found themselves, by the end of the nineteenth century, on the threshold of becoming "conservators," a distinctly desirable and upwardly mobile progression. But the qualifications were now becoming far more complex and demanding: no longer was proficiency at the easel and at the work-table sufficient. The microscope, the X-ray radiograph, the spectrometer, and a host of other tools and techniques were eagerly embraced by the descendants of the Picaults and Hacquins. No longer were the esoteric secrets of the craft to be passed down from master to pupil; specialized, public institutes would freely provide the training and openly develop the parameters. The distance separating the "art" of restoration and the "science" of conservation was growing ever greater. In a century enchanted by the siren song of science and technology, restorers rushed headlong in this direction.

By the mid-1950s paintings and all manner of other works of art were being "treated" by earnest, highly trained conservation technicians clad in white smocks within the confines of carefully scrubbed, white-tiled labs where nary a sliver of daylight, nor for that matter a bit of common sense or aesthetic judgment, was allowed to penetrate. No artifact,

public or private, seemed immune, and the dismal results all too often became front-page news: the brutal "cleanings" at London's National Gallery, the savage "deconstruction" of the Jarves early Italian paintings at Yale, the transformation of some celebrated fresco cycles (Piero at Arezzo and Giotto at Santa Croce) into archaeological digs ... a long litany of undertakings often performed with the application of "modern" but wholly unsuitable materials such as plastics, fiberglass, aluminum, synthetic resins, and waxes of all stripes.

While no one today would question the fact that technology and the physical sciences must be applied to the understanding of works of art as material objects, and that this understanding will contribute to their future preservation, it is no less evident that the process is doomed to failure if the artistic identity of these objects is ignored. And indeed it was, almost programmatically.

The problem was compounded by the fact that, by mid-century, art-historical criticism was ill equipped to come to the rescue. That field had, itself, veered dramatically towards a diligent, occasionally Marxist, historicism with ever-narrowing specialist pursuits. The coin of art history was being significantly debased by the pursuit of aberrant intellectual dead-ends. Fortunately, there were brilliant exceptions: figures such as John Pope-Hennessy, Federico Zeri, and Pierre Rosenberg, to mention only three of the most influential. They and their successors were able to persevere in their staunch pursuit of the "old-fashioned" approach – the intuitive, insightful, yet rigorously philological process of reading the artistic texts placed before them. Not surprisingly, Pope-Hennessy titled the account of his life in art *Learning to Look*.

Unlike the realm of scholarship where a tradition can survive in written form, for a craft it must be handed down, master-to-pupil, within the context of a shop practice. The

situation in the restoration studio, therefore, was particularly serious. In this most tactile and visual of tasks, manual skills and perceptive talents were not only discounted but even discouraged. There was every reason to fear that, within perhaps a generation, the evolution from craft to technology would become irreversible.

If there was a turning point in this progress it may well have occurred in 1963, when the Italian scholar and critic Cesare Brandi published *Teoria del Restauro*. It is a compendium of lectures, papers, and studies that Brandi had developed over many years, particularly as head of Rome's Istituto Centrale del Restauro. These texts, imbued with the historical idealism of Benedetto Croce, became immensely influential and can be said to have given the practice of restoration the ideological compass and programmatic equilibrium it had always lacked. The primacy of the artistic component within the object's material manifestation was definitively affirmed, and, although variously implemented in different working environments, Brandi's conceptual ground rules are now universally recognized and respected. In America, where the pendulum had swung furthest in the direction of reductive applied technology, the terrain was particularly arduous. Operators, much respected in their time, such as Murray Pease (at the Metropolitan Museum in the 1940s) and Sheldon Keck (at the Brooklyn Museum and later at Cooperstown in the 1950s) had rendered the field impervious to the thoughtful and measured approach advocated by Brandi and other Europeans. To this day, the pendulum has not entirely reversed its motion. It was surely hastened in its swing, however, by the arrival to these shores of Andrea Rothe, who, about twenty-five years ago, took the helm of the paintings conservation department at the nascent J. Paul Getty Museum, then in Malibu. Rothe had trained in Florence and fully partook of that city's humanistic and artisan

traditions. He was followed at the Metropolitan Museum, in a similar position, by the late John Brialey, who had previously presided over a thriving private practice in London. Exploiting their very visible pulpits, Rothe and Brialey were not just eloquent advocates, they also presided over the intellectual formation and training of scores of younger talents. The changes – surely for the better – that they have set in motion have been profound.

The restoration profession marked a further important milestone in 1980, and by a remarkable historical coincidence it was again in Rome. That year the Vatican authorities began what was surely to be the most significant conservation project of the century: the Sistine Chapel. In a novel arrangement, the immense costs were to be borne by a Japanese media company in exchange for the visual rights for a number of years. Cesare Brandi's significant legacy was acknowledged by the fact that Gianluigi Colalucci, a pupil of Brandi's and a graduate of the Istituto Centrale del Restauro, was named the chief restorer. Fabrizio Mancinelli, a brilliant young scholar attached to the Vatican Museums, was charged with overseeing the project and coordinating its art-historical research. This collaboration between the skilled "hand" of the restorer and the curatorial "eye" guiding its progress had long been advocated by Brandi and others, but in the Sistine project it was implemented as never before. The Chapel was to become, on a huge scale, the model of how the best resources of traditional manual crafts, up-to-date scientific and technological tools, and scrupulous scholarly investigation can be combined – a clear lesson that such a combination can and should be equally effective in much smaller and less significant projects. In reconciling the often conflicting priorities of different disciplines, the Vatican undertaking will remain a paragon of achievement in the field of restoration. Paradoxically, despite the spectacu-

lar results obtained in the Sistine project, it became the object of fierce worldwide criticism. The fame of the monument itself may have partly contributed to this attention, but certainly the premature publication of the dramatic cleaning "tests" was particularly ill conceived.

Naturally, it was in the interest of the Japanese sponsors to begin recouping their investment as quickly as possible. The problem, of which all the responsible authorities should have been well aware, is that photographic emulsions, no matter how sophisticated, can never render faithfully the correct tonal rapport between two adjacent areas of differing brightness: the "clean" will inevitably appear faded and thin, the "dirty" as saturated and dark. Film simply does not possess the exposure latitude to compensate for such differences. The hugely contrasted images that appeared in every magazine shocked even the more informed observers . . . yet another cleaning controversy was upon us! In reality, and justifiably, never had greater care and sensitivity been lavished on painted images. No one who was accorded the privilege of visiting the workplace atop the scaffolding and of examining Michelangelo's miraculous surfaces with the far more sensitive lens of the human eye could doubt that what had survived the centuries had been preserved intact. Fortunately, the Vatican's own counter-offensive on behalf of the project and the more measured and responsible assessment by the specialist community has, in time, blunted much of the ill-advised earlier criticism.

Can we, then, feel confident that order and sanity have at last returned to the kitchen of art? Are the artistic priorities that served as guideposts to generations of scholars and restorers still considered valid for the understanding and conservation of our cultural heritage? The answer is . . . yes and no. *Yes* to the extent that we are still from time to time treated to events such as the recent Gentileschi or the present

El Greco exhibitions at the Metropolitan. These remarkable undertakings, combining the talents of curators and restorers, exemplify the levels of quality that can be achieved – in scholarship, research connoisseurship, and presentation, when the noblest traditions of their individual pursuits are respected with intelligence, perhaps even reverence. And *no* when one realizes that the dark clouds of academic historicism and hyperspecialization continue to blur the horizon. The socioeconomic concerns of "post-modern" criticism have contributed to further debase the currency of art history. In this intellectual climate, the subject of the discourse – the artistic artifact itself – has been progressively and almost totally marginalized. Having been subverted and deprived of its intrinsic values, the work of art has, in effect, been rendered superfluous. Considered in this light, it is not surprising that a distinguished scholarly periodical was recently the host to articles such as: "Blemished Physiologies: Delacroix, Paganini, and the Cholera Epidemic of 1832" and "Two Waldorf-Astorias: Spatial Economics as Totem and Fetish." In the field of conservation, a respected journal offered: "Contribution of dust at floor level to particle deposit within the Sainsbury Centre for Visual Arts," wherein the authors dramatically concluded that the "study suggests visitors' shoes are an important contributor to dust loading on the floors in museums."

Served with such unappetizing dishes of *nouvelle* art inquiry, the only solution for the civilized patron will be firmly but politely to . . . send them back to the kitchen.

December 2003

Part I: Art & Artists

On Renaissance portraiture.

IN THE NAVE of a small conventual church in the Tuscan hill town of Casole d'Elsa, there is a monument that, as they say in French guidebooks, "*vaut le voyage.*" The detour-worthy work of art was commissioned by a relatively obscure knight and magistrate of the Republic of Siena called Bernardino del Porrina not long before his death in 1309. The standing, life-size, and in-the-round marble likeness of Porrina looks down from his perch in an elaborate Gothic niche, clearly implying that this is not a tomb but a cenotaph to the man's living presence (the actual burial is in a nearby crypt). Funerary monuments of the period had endlessly repeated the French format of representing the deceased lying in state (*gisant*). No less obscure than the sculpture's patron is the artist: an elusive, itinerant stone carver named Marco Romano, who is presumed to have died sometime after 1318 (the date of his only signed work, a more conventional wall-tomb in the Church of San Simeone Grande in Venice.)

What Marco wrought in Casole d'Elsa was instead an unprecedented and revealing portrait of a man, as he looked and as he wished to be perceived: imposing of girth and four-square in stance. The symbols of Porrina's elevated status – the law book held firmly in his left hand and the broadsword hanging at his right side – are carefully described, as are the details of his cassock, ample cloak, and soft beret. The sitter's pudgy, slightly jowly facial features are rendered with uncanny verisimilitude, and his stern yet benevolent gaze is

uncompromisingly directed downward toward the viewer. One might well feel reassured if submitted to this man's judgment in a court of law. Incredibly, the cenotaph to Porrina was not recognized as a capital work of Romano's until 1983. Finally, last year, a small but significant local exhibition drew together the sparse strands of this gifted and innovative artist's stylistic genesis, development, and legacy. This much overdue attention to Marco Romano served as a reminder to the art-historical community that, on the subject of portraiture, fresh insights are not only possible but often readily at hand.

There is now little doubt that the desire to render human likenesses in specific, rather than generalized or idealized, terms began in Italy in the thirteenth century, well within the late-medieval artistic tradition and almost a century before the Porrina monument. If there were one cause to be cited as the wellspring for this innovation, it would be the birth and whirlwind expansion of the Franciscan movement. The story of the young, spoiled rich boy of Assisi who, in a moment of spiritual awakening, transformed his life is all too well known. Less familiar is the profound effect that Francis's life, ministry, and writings had on the culture of pre-modern Europe: for the first time since Saint Paul and the Early Church, a man's intimately personal relationship to God and the world He created became, once again, the central theme of the Christian faith. Salvation was, once again, believed to be won through a man's individual commitment to a life in imitation of Christ's – good works and prayer, rather than churchly intercession, were the keys to salvation.

It was a radical message that, while emphasizing humility and sacrifice, empowered and ennobled the human condition. It was Francis – as a man – reliving Christ's human life, which gave his lesson such power. It is no coincidence that the earliest depictions of the Crucifixion in Italian art, those

dating to the early thirteenth century, inevitably depict the subject in kingly attire and very much alive on the cross – quite immune, and above, earthly constraints. As the century progressed and the Franciscan movement gathered momentum, Christ's divinity was eventually replaced by His human dimension. In Cimabue's memorable depiction of 1270 (Arezzo), He is shown poignantly and unmistakably expired on that same cross. Similar images, and the pietistic tracts that proliferated in these years, were clearly meant to elicit direct participation in the human drama recounted by the Gospels.

In contrast, the very worldly ambitions of a French monarch, Charles of Anjou (1226–85), and, later, of an Italian pope, Boniface VIII (1230–1303), loomed large against this backdrop of religious zeal and reform. Both tried, albeit unsuccessfully, to redraw the political map of southern Europe and both are remembered in monumental, celebratory portrait marbles by the Tuscan sculptor Tino da Camaino (*ca.* 1240–1300). Although of a more hieratic and schematic cast than the Porrina portrait, the likenesses of the two subjects are rendered with striking individuality. The pope and the king share a further distinction: Dante gave them both bit parts in the *Divine Comedy* (Boniface in Hell and Charles in Purgatory), which attests to how intimately the human comedy of his contemporaries absorbed the immortal poet's attention. Dante's surviving death-mask is proof that the attention was amply repaid, spawning, as it did, endless posthumous portraits through succeeding generations. By the mid-fourteenth century, any Tuscan merchant willing to underwrite the cost of an altarpiece or a church fresco could get himself, and occasionally his wife, included as participants. They would be shown in stylized profile and diminutive scale, kneeling stiffly in prayer, timid precursors to the Renaissance portrait.

It was in Naples, rather than in Tuscany, that the "donor" figure assumed full and equal stature as protagonist in a monumental painting. In 1317, the great Sienese painter Simone Martini was commissioned by Robert of Anjou to portray his investiture as king of Naples symbolically crowned by his brother Louis, Bishop of Toulouse. Louis was Robert's elder sibling but had renounced his inheritance to profess religious vows as a Franciscan tertiary friar. He died at the age of twenty-three and was canonized shortly thereafter. Simone Martini's brief from Robert was, therefore, to produce a powerfully convincing political statement legitimizing his ascension to the throne of Naples that many regarded as usurped. Saint Louis is shown enthroned in gorgeously elaborate bishop's regalia, quite in contrast to what is known of the young man's almost ascetic piety. Robert, in knightly robe, appears in profile kneeling at his brother's feet. There is no discourse between the two figures, but their respective weight in the composition is so carefully balanced, their features and costumes so faithfully recorded, that the illusion of witnessing the solemn ritual in real time is completely convincing.

What might, with good reason, be called the *Double Portrait of Louis and Robert of Anjou* is noteworthy for its size, startling iconography, exquisite execution, and – very significantly – its early date. The painting is now one of the treasures of the Capodimonte Museum in Naples and serves as apt confirmation of John Pope-Hennessy's insightful comment: "the portrait in the Renaissance is no more than a watershed between the medieval portrait and the portrait as we know it." As further proof, Pope-Hennessy cites a commemorative gold coin struck in 890 by King Arnulf of Carinthia and Frederick II Hohenstaufen's similar medal of 1230, both of clean, classical design and bearing credible likenesses of the two rulers. A curious paradox is that these

6

medieval medals are often more faithful to their antique prototypes than fifteenth-century examples based on similar sources. The endlessly repeated explanation that the Renaissance portrait originated with a reawakening of interest in Roman coins and funerary effigies is, if not generally incorrect, certainly woefully incomplete.

7

It is to Pope-Hennessy, in fact, that we owe a clearer and deeper understanding of the typological and geographical complexities of Renaissance portraiture. In six memorable lectures given at the National Gallery in 1963 (and published in 1966), the eminent scholar, critic, and curator blocked out the subject's broad canvas as no one had done before or has attempted since. Each of the discourses constitutes a separate chapter dedicated to the portrait, alternatively as an artistic, cultural, and political artifact. The topics are varied and range from technique and patronage to social and religious mores and literary and historical reference; all are individually examined in chronological perspective; in short, it is art history at its most rewarding.

Identifying the *Trinity* fresco in Santo Spirito by Masaccio as the headwater of Florentine innovation, Pope-Hennessy gives the story of the Renaissance portrait a very precise beginning. The date was 1425. That initial headwater was to swell rapidly into a broad, rushing river. Money, again as in all things Florentine, played a part. The donors of the fresco, Lorenzo Lenzi and his wife, kneel at the entrance to a grand, barrel-vaulted niche framed by an imposing columned archway. The entire architectural complex is rendered as seen from below in faultless perspective foreshortening. All the figures within the fictive space (the crucified Son, the Father behind and above Him, the mourning figures of Mary and John) as well as the Lenzi spouses are equally proportioned. Nothing new here; Simone Martini had already taken that important step more than a century earlier. What Pope-Hennessy saw

as innovative was the donors' position *outside* the sacred space of the niche, occupying the actual world of the viewer. In this sense, portraiture was subtly but decidedly severed from the religious realm, becoming an irrevocably secularized genre on its own.

As the fifteenth century advanced, not only were the merchants and bankers of republican Florence eager to be portrayed, but, to the greater glory of their rule, every prince, *condottiero*, high prelate, and minor potentate in all corners of the peninsula sought immortality by promoting their likenesses. It has been Western culture's good fortune that scores of supremely gifted artists in every medium were there to fill the demand by creating masterpieces as diverse as the monumental equestrian bronze likeness of *Gattamelata* by Donatello (Padua), the group portrait in fresco of the Gonzaga Family by Mantegna (the Bridal Chamber, Ducal Palace, Mantua), and the exquisite marble bust of *Leonor of Aragon* by Francesco Laurana (Louvre). These were all real people whom the artists surely knew and were able to observe in life. We are fortunate to know their names and some of their personal stories, but scores of others have remained anonymous. Oddly, this lack of identity seems not to have diminished their hold on our imagination. Their status as works of art depends on other factors beyond simple historical recognition.

One form of portraiture that does not pre-date the early Renaissance is *self*-portraiture. It is only with Masaccio (as an Apostle in the *Tribute Money*) that the artist reveals himself, albeit modestly. Then just a few years later, the celebrated head peering from a roundel in the *Doors of Paradise* of the Florence Baptistery is unmistakably Ghiberti's, one of the Renaissance's insuperable self-portraits. The ability to look squarely into the artist's eyes, and to have our gaze returned, is a revolutionary achievement of humanism and

the intellectual and spiritual ground from which the Renaissance sprang.

Nearly fifty years after the Pope-Hennessy Mellon lectures, Renaissance portraiture is once again front and center on the art-world stage. A massive joint undertaking between the Berlin Museum and New York's Metropolitan has brought together a cornucopia of masterpieces, in virtually every medium except fresco, that affords a breathtaking panorama of Renaissance portraiture, from its earliest examples to the early sixteenth century. As usual in these collaborations, the two venues will differ somewhat in the selection. The catalogues, on the other hand, share identical scholarly essays and, cumulatively, this undertaking promises to offer the most comprehensive survey of the genre ever attempted.

The Berlin version of the exhibit, titled "Gesichter der Renaissance: Meisterwerke Italienischer Portrait-Kunst," included, during its first weeks, the supernova of Renaissance portraits, Leonardo's *Lady with an Ermine*, causing the predictable traffic jams and the expected six-figure income for the Czartorisky Foundation of Kraców that owns it. The portrait deserves every bit of this attention: apart from its impeccable conservation, intriguing iconography (the ermine is rich in heraldic and erotic symbolism), and winsome subject (the still teenage Cecilia Gallerani was briefly the mistress of Milan's *signore* Lodovico "Il Moro" Sforza), Leonardo does with the *Lady* something entirely unprecedented: he has her turning her head to look back over her shoulder. It was a stunning invention for the early 1480s, yet its influence did not become readily discernible until Titian. The latter remains beyond the scope of the exhibition, whose curators chose 1500 as its outer limit, suggesting perhaps that the Metropolitan was more precise in its choice of title: "The Renaissance Portrait from Donatello to Bellini."

Besides Cecilia Gallerani, another famous lady of the

Quattrocento will also miss the trip to New York. She normally resides in Milan's Poldi Pezzoli Museum and despite the fact that she has remained nameless, her profile likeness is one of the most familiar and beloved of the early Renaissance. The unforgettable cameo-like rendering dates from the early 1460s and may be a collaborative effort by the Florentine goldsmiths, sculptors, and painters Piero and Antonio del Pollaiuolo – the controversy over attribution has caused much ink to flow in the past. With the sparest of detailing and subtlest of modeling, the artists have faultlessly captured the young woman's slightly wan complexion, handsome, erect posture, and forthright gaze. Visitors to the Metropolitan will see that museum's somewhat weaker rendering of a very similar woman, in identical pose and possibly by the same artists – proof that the pictorial formula for portraiture initiated in Florence earlier in the century by Masaccio and Fra Filippo Lippi was now well established.

An aspect of the early Renaissance that continues to cause wonder is how rapidly diverse regions mastered the same visual language, albeit with different accents. The exhibition very effectively illustrates the ebb and flow of stylistic currents in the matter of portraiture among Italy's city-states, each contributing new technical and formal solutions that would then be developed and translated elsewhere. Much of this was due to the seemingly incessant travel by many of the artists themselves, one example being the several important commissions Donatello received far afield from Florence.

The very nature of Renaissance creativity was a powerful stimulus for versatile artists, such as the Pollaiuolo brothers and Andrea del Verrocchio, to create masterworks in various media, thereby initiating a fluid discourse that crossed disciplinary and cultural boundaries. An early and emblematic

figure was Pisanello (Antonio di Puccio Pisano, *ca.* 1395–1455), who cast what may be the first bronze portrait medal of the Renaissance in 1438. It portrayed, in profile, John VIII Palaeologus of Byzantium, who visited Italy that year in a failed attempt to heal the ancient rift with Rome and garner support for his tottering thousand-year-old empire. If nothing else, the Emperor's exotic court retinue of Greek savants generated a sensation among Italian humanists.

Cosimo de' Medici hosted the ecumenical council in Florence, and he considered the epochal event so important to his family's prestige that he later commissioned Benozzo Gozzoli to commemorate it. The imperial progress was portrayed in the guise of the Magi's journey to Bethlehem. In reality, Gozzoli pictured it as a very secular chronicle of the actual event, replete with vivid portraits of all the principal protagonists, most prominently the two Emperors, John VIII and his Western counterpart, Sigismund of Luxembourg. Cosimo de' Medici is shown with his son Piero and two grandsons, Lorenzo and Giuliano, together with a smattering of contemporary grandees. The artist, unlike Masaccio-in-disguise, clearly identifies himself via a golden inscription on his beret as he peers out at us from the crowd, while Pope Pius II stands just steps behind him. Not surprisingly, this distinguished humanist pontiff, being Sienese, rated not more than second-tier status in Florence.

The success of Pisanello's Palaeologus medal must have been considerable because within a few years he had struck portrait likenesses of most of northern Italy's political and intellectual elite – republican Florentines were, for a time, reluctant to indulge in such overt self-promotion. Pisanello was equally in demand as a painter: the artist also executed a striking painted portrait of Emperor John VIII and, on his own self-portrait medal, described himself as *pictor*. Most notably, he exercised his varied talents in the service of

Leonello d'Este, Marquis of Ferrara, whose court became one of Italy's most brilliantly cosmopolitan. The Berlin/New York exhibition overflows with Leonello images, the superbly painted profile by Pisanello (in the Accademia Carrara, Bergamo) being the most renowned.

A selection of precious drawings by the artist is also on view; in one, his careful metal point delicately traced the profile of Borso d'Este, Leonello's half-brother and successor, and in another rendered a matchless study, in three-quarters, of a sad and seemingly embittered old man. Not one of these portraits can be remotely described as idealized. The sitters are invariably shown as they were seen by their contemporaries, perhaps haughtily strutting their emblems and their armor, but not necessarily ennobled by them; they are before us warts and all. Significantly, the inscription *non aliter* (not otherwise) appears prominently on a number of paintings and sculptures – a sure indication that the intent was truthful reporting. Stunning in this respect is a beautifully chased medal by Matteo di Andrea de' Pasti with the profile of Guarino Guarini, a humanist and teacher of Verona. The poor man must have been positively toad-like, yet we are transfixed by his forceful presence and almost anticipate hearing some biting, clever aphorism uttered in a rasping growl; it is portraiture at its most convincing ... barely nine centimeters across!

Despite New York's loss of Leonardo, the ultimate marquee name, a sufficient quantity of spectacular paintings, sculptures, and works of art have traveled here to propel this exhibit to the very top of the Metropolitan's attendance charts. Possibly the most fetching and alluring visitor is Simonetta Vespucci (1453–76). She was the mythical beauty who died in Florence in her early twenties and may have inspired, if not actually sat for, two remarkable portraits by

Botticelli that now reside in Germany (Berlin and Frankfurt). The same woman is shown in profile, though facing in opposite directions, her flowing blond hair coiffed and tressed in phenomenally complex arrangements. If contemporary accounts and the verses of Poliziano are to be believed, her brief reign as the city's most beautiful woman was fully justified.

Accompanying Simonetta are two very similar Botticelli portraits of Giuliano de' Medici, her presumed lover. He, too, met an untimely death, but at the hands of the Pazzi conspirators in 1478, two years after Simonetta. Such is the romance and glamour of the two sitters, and the distinction of the painter who portrayed them, that an entire exhibit might well be imagined around just these four paintings. Seeing them together, however, unfortunately reconfirms the long-held conviction that portraiture was not, in fact, Botticelli's strongest suit. His was an artistic vision that sprang from a sumptuously lyrical and linear conception of form, not ideal for the discipline of observing and recording, so essential to portraying likenesses.

In this respect, Botticelli's near contemporary Domenico Ghirlandaio possessed a far superior analytical eye. It served him particularly well in the famous frescoes in the Sassetti Chapel of Santa Trinita where the episodes of St. Francis's life are recounted as occurring in contemporary Florence and are punctuated by group portraits of all manner of Sassetti and Medici bystanders. Fortunately, a supreme example of Ghirlandaio's art is present in the exhibition. It is the Louvre's *Old Man and a Boy*. The painting is memorable for being one of the very first portraits of the Renaissance to show the sitter in three-quarter view. The inclusion of a second subsidiary figure within the same pictorial space is equally groundbreaking. Beyond this, the incredibly touching portrayal of

the benevolent, aged man, cruelly afflicted with rhinophyma ("Morgan's nose"), and the cherubic youngster looking lovingly up to him, lifts this unforgettable image from the realm of portraiture to that of poetry.

14

The book on the Renaissance portrait was written in many media and by many authors. A crucial sequel to the story was how Italian, particularly Florentine, innovation resonated in Northern Europe. One need only cite the Metropolitan's magnificent *Francesco d'Este* (Leonello's illegitimate son) by Rogier van der Weyden as an example of how the influences and ideas flowed both ways: here is a Ferrarese prince, visiting Brussels (in 1460), impeccably decked out in Burgundian fashion, portrayed by a Flemish master. Yet, it is fair to say that the most important chapter in the book belongs to sculpture in the round, a medium with which Italians, as we saw, had felt at ease since medieval times. It was not, therefore, a technical or quantum leap in the early 1450s for the Florentine workshop of Desiderio da Settignano to render in lifesize terracotta the likeness of Niccolò da Uzzano, an important early supporter of the Medici.

Alas, the astonishing polychrome bust is missing in New York, but we can nonetheless become acquainted with two Florentines of even bigger caliber: Piero de' Medici, and Niccolò Strozzi. Both are marbles by Mino da Fiesole, completed at a slightly later date than the Uzzano bust, but no less impressive or significant. The facial features, expressions, and bearing of these individuals leave no doubt that the subjects' corporeal presence was precisely as we see it, not yet affected by the celebratory or ideological subtexts that color so much of later Renaissance and Baroque portraiture. The opportunity of seeing these masterworks under the same roof will be truly unprecedented because Piero de' Medici still resides in Florence (at the Bargello Museum)

while Niccolò Strozzi emigrated from his ancestral palace to the Berlin museum in 1877.

While one should certainly be grateful for the opportunity of re-encountering many of these familiar faces, especially gathered together in such a conspicuous number, there are, of necessity, few true surprises: the rare thrill of discovery accompanies the more customary delight of recognition. From a small museum in Genoa comes an arresting, lifesize bronze bust of the Neapolitan humanist Giovanni Pontano. Both the subject and the artist, Adriano Fiorentino, played, at best, secondary roles in early Renaissance Italy, yet by any reckoning this sculpture is a capital work. Impeccably cast and chased, the bust forcefully commands our attention by its uncompromising presence and weight. The man's Roman tunic, rather than being a temporal or symbolic reference, serves to present his handsome features on their own terms: dignified, austere, and intelligent. A measure of this sculpture's mastery can be appreciated by the exhibition's inclusion of two further likenesses of Pontano by the same artist: one bas-relief profile in marble and one in bronze. They are, by comparison, conventional and uninteresting.

Whether confronted with Pontano or with any of his more famous and powerful contemporaries – and there were many women among them – we feel an inescapable sense of inferiority before these noble and self-aware individuals. They seem to exist at a higher level, far removed from the afflictions of mere mortals. Theirs is a human condition of a different, more exalted kind, and it is a privilege to pass even a brief spell in their presence. Moreover, with the recent inauguration of the magnificently reconfigured and reinstalled galleries containing the "Art of the Arab Lands," a visitor to the Metropolitan is afforded a stunning lesson in

comparative cultural history: human presence and human character as it was glorified in Renassaince art and virtually erased in Islamic art.

December 2011

On a new addition to the Metropolitan Museum of Art.

IMAGINE THIS: like most other civilized people, you have more than a superficial interest in the great music of the past. For decades you have been aware of a rumor circulating among music professionals that a manuscript score for an early Mozart quartet – an autograph by the teenage prodigy – was found soon after the last war in one of the Lobkowitz castles near Prague, having inexplicably eluded the scrutiny of the diligent Ritter von Köchel. It had then languished through the long Communist night in a safe of the Ministry of Culture. Only tantalizing bits and pieces of third-hand transcriptions had filtered out – a pale reflection of the delights that the work in its entirety might reveal. Suddenly, today's front page of the *Times* informs you that, after years of musicological research and endless legal squabbling, this 647th Mozart composition will receive its first full performance in over two centuries – by the Guarnieri – at Carnegie. *Quel frisson!*

The art-world equivalent of such a dream-event has just occurred, and the *frisson* it produces is no less memorable. One needs only to bear right at the top of the Metropolitan Museum's grand staircase and step into the first room: correct, the one where those peculiar Italian "primitives" often merit, at most, only fleeting glances. Here, drawn together by a tiny, miraculous newcomer, are the Metropolitan's other magical, early (fourteenth-century) Sienese paintings, surrounding it as if to pay homage to their illustrious predecessor. And well they should, for they are the "Duccesque"

followers and the newcomer is their master, Duccio himself: a re-apparition every bit as momentous as a first performance of the mythical Mozart quartet. Created – "painted" is far too prosaic a word – in the closing years of the thirteenth century, the diminutive panel has firmly maintained its place in the slim catalogue of Duccio di Buoninsegna's works since it first surfaced in a Roman collection at the turn of the last century. But, unlike other celebrated paintings, this *Madonna and Child* had become, for well over fifty years, truly inaccessible – a potent but invisible presence. Not one of the four scholars who have published full-dress monographic studies on Duccio since 1951 had ever even seen the painting. They were obliged to list it as simply "whereabouts unknown," or more tantalizingly: "formerly, Brussels, Adolphe Stoclet Collection."

Adolphe Stoclet ... it is a name that, to this day, resonates powerfully with anyone interested in the history of taste and collecting. The scion of a Belgian banking and industrial family, he had, as young man, the great fortune of meeting and marrying a niece of the painter Alfred Stevens. It was a match of which his family took a very dim view but that would change his life. Stoclet's bride had been reared in an environment uniquely rich in artistic accomplishment and open to the intellectual cross-currents of Europe at the end of the nineteenth century. The couple's early sojourns in Milan and Vienna served as preparation for a lifelong endeavor of artistic experimentation, discovery, and collecting. Returning to Brussels in 1901, they eventually commissioned the Viennese architect Josef Hoffmann to design a grand residence that epitomized, within and without, the purest of *Wiener Werkstätte* style. Completed in 1913, the villa's austerely elegant spaces slowly filled with a remarkable variety of exquisite artifacts, principally representing the "early" phases of many diverse cultures – China of the Shang

and Chou Dynasties, Middle Kingdom Egypt, Sassanian Iran, Sumerian and Assyro-Babylonian Mesopotamia – and early medieval Europe.

This marvelous trove of antiquity was not open to the casual visitor, but in the memory of those privileged few who experienced it in its original setting, the collection exuded a unity in taste and quality that belied the great diversity of its elements. It was continually enriched until both Stoclets died in old age, barely a week apart – a remarkable and touching partnership in life and art. There is little doubt that the couple, in their time, was considered rather exotic, if not downright eccentric, yet their perceptive eye and scholarly expertise is discernible in every piece that bears a Stoclet provenance, even long after the collection was dispersed.

In fact, there is no evidence to suggest that there had ever been an intention to maintain the life's work of these exceptional collectors as a self-perpetuating entity . . . not necessarily, in itself, a lamentable destiny. The Goncourts' beautifully reasoned (and reasonable) advocacy for not keeping collections intact after the demise of their creators is particularly apt for holdings as typologically diverse as those assembled by the Stoclets. Indeed, since their deaths and through three generations of their descendants, the collection has trickled through various channels of the art market into new and equally appreciative hands, both public and private.

But the Duccio had remained, all these years, the unseen and ever-elusive Holy Grail of the Stoclet collection. Thought at one time to have been originally the center of a portable triptych, the small gold-ground panel was first recorded in the collection of Count Gregory Stroganoff, a Russian grandee who had set himself up in a princely *palazzo* in Rome at the end of the nineteenth century. Stroganoff was a discerning collector of early and Renaissance Italian art, and his considerable holdings comprised paintings, drawings,

sculpture, and decorative arts. As the First World War approached, income from the Count's estates began to dwindle and, by 1910, a first sale was held in Rome. Several others followed until a final dispersal in 1925. The Stoclets may have purchased the Duccio from a Florentine dealer soon after the war, adding it to an already distinguished body of thirteenth- and fourteenth-century Italian paintings – the school of Siena being a particular favorite.

About two years ago, as preparations were progressing in Siena for a major gathering of the works of Duccio and his school, there was persistent talk that the Stoclet *Madonna and Child* would, at last, make its first public appearance in nearly a century. The magnificent exhibition opened in October of 2003 (in the handsomely restored ancient hospital of Santa Maria della Scala), but, sadly, the precious panel missed its historic rendezvous. Only a few art-world professionals at this point suspected or knew the real reason for this absence: the Duccio was on its way to London to be offered for sale, privately, through Christie's. Despite this disappointment, the Siena exhibition was a glorious occasion to study, to savor, and to celebrate the art of the city's greatest painter.

Traveling to Siena from Florence on the "superstrada" is barely an hour's smooth ride through the luscious Tuscan landscape. And though both cities have been joined politically for over four centuries, the difference in their character and language is palpable to this day. That is because until the dominion of Florence was forcibly imposed in 1555, Siena existed as a fiercely independent city-state with a flourishing commercial, industrial, intellectual, and artistic life. At no time was this urban flowering more intense and vibrant as in the second half of the thirteenth century. During this period, Florence was blossoming as well, and, as if in a miraculous equilibrium, each city produced artists of

genius. None were to be more significant for the later course of Italian art than Giotto in Florence and Duccio in Siena. Each was able to transform and innovate, building on an older tradition. They succeeded in creating figurative languages that were radically different from the past and yet quite different from each other.

The Stoclet Duccio – we can now proudly call it "the Metropolitan Duccio" – is an astonishing accomplishment if considered only in terms of scale. Although tiny, it has none of the annoying "look-at-me-with-a-magnifier" precision of a miniature. From a photograph one could easily imagine a much larger picture. More importantly, the artist places the Virgin at a slight angle to the viewer, behind a fictive parapet. She gazes away from the Child into the distance while He playfully grasps at Her veil. One must realize that every aspect of this composition represents a departure from pre-existing convention. With these subtle changes, Duccio consciously developed an image of sublime tenderness and poignant humanity, almost a visual echo of the spiritual renewal that St. Francis of Assisi had wrought only a few decades earlier.

A careful examination of Duccio's two surviving versions on the theme of the Mother and Child that predate the Metropolitan's painting reveals the remarkable evolution of his art during the years of his early maturity. The Byzantine tradition is much more clearly reflected in those earlier works, as is the somewhat austere style of Duccio's predecessor, Cimabue. In 1308, perhaps a decade after the Metropolitan's *Madonna*, Duccio received the hugely important commission for the *Maestà* (altarpiece) that would adorn the Siena cathedral's high altar. Although this great undertaking produced one of the milestones of Western art, one can confidently state that Duccio had already achieved the high point of his stylistic development in the panel we can now

admire at the Metropolitan; he simply went no further in terms of formal perfection and expressive intensity. Furthermore, we are doubly blessed by the fact that, apart from some quite minor abrasion in the gold background, the image has survived in a remarkably fine state – no small matter when judging a work of this size and significance.

If adding "strength to strength" is a judicious policy in building collections, then, with the addition of the Duccio, its rewards will be particularly bountiful for the Metropolitan. The museum's holdings, combined with those of the Lehman Collection, now afford an account of Sienese art of the Gothic and Early Renaissance periods unrivaled in the world but for the museums of Siena and Florence. To be sure, the art of Duccio can be admired elsewhere in America, even a few blocks down Fifth Avenue at the Frick Collection. Here and elsewhere (Washington, Philadelphia, and Fort Worth) precious bits and pieces of the *Maestà* have come to rest as a result of its tragic dismemberment in the eighteenth century. The Boston Musuem of Fine Arts is fortunate to possess a fine small triptych that may date from the end of the artist's life. But in all these examples, scholars have suspected the possible collaboration of the assistants that Duccio surely employed in his workshop once the great *Maestà* project got underway. Also, these paintings found their permanent homes here many decades ago – the "old days" of the art market. There are simply no others out there.

And so, the Metropolitan's recent arrival now rules supreme in this exalted company, and surely this could not have happened were it not for the outstanding quality of the museum's curatorial resources. Chief Curator Everett Fahy and Associate Curator Keith Christiansen of the Department of European Paintings, in addition to Laurence Kanter, Curator of the Lehman Collection, constitute, together, a particularly prestigious concentration of scholarly expertise

in the field of earlier Italian painting. No other museum can boast of a more distinguished team. One suspects that they, more forcefully and convincingly than anyone, made the case for the Metropolitan's prodigious expenditure, and their advocacy merits our gratitude and applause.

But, of course, the expenditure *was* prodigious and this, inevitably, caught everyone's attention. It prompted the routine exercise of comparing the values of Southampton McMansions, star pitchers, or even Picassos to the object in question. Such considerations are, of course, meaningless, as are the pro forma comments about the venality of our culture (as if venality had not existed in fourteenth-century Siena). More to the point would be a second, careful, visit to the Met, to that first room on the right wherein a temporary dialogue of Sienese voices is in progress. We have listened to and begun to comprehend the celestial strains of *kappelmeister* Duccio. Diagonally across, in a deservedly central position, is a slightly larger *Crucifixion* teeming with visual and emotional excitement. Also immensely rare and impeccably preserved, it is by Pietro Lorenzetti, a Sienese artist who understood his sources (Duccio, of course, and to a lesser extent, Giotto) and knew what to make of them. It tiptoed into the collection about two years ago with little fanfare (the expense was significant but not prodigious), and yet as a work of art it is almost as satisfying as its more famous neighbor. One can earnestly hope that the notoriety of the Duccio will draw more attention to the Lorenzetti; it will reward the viewer handsomely and be yet another dividend deriving from the Metropolitan's courageous investment.

February 2005

An examination of Gentile da Fabriano's artwork.

THE YEAR 2006, as with wines, was also a banner vintage in Italy for the visual arts. Florence alone was host to four small but significant exhibitions. Proceeding southward, the fortunate traveler would have found, in the refurbished stables of Rome's Quirinal Palace, a comprehensive and exciting gathering of Antonello da Messina's paintings, together with those of some of his contemporaries. Still further south in Naples, the portraiture of Titian was displayed in all its grandeur in the magnificent setting of Capodimonte. But then, Florence–Rome–Naples is the granddaddy of all Italian itineraries. Were our fortunate traveler to have had the curiosity and stamina for a detour east, to Fabriano, he would have been even more richly rewarded.

No matter how one approaches this enchanting small town in the hills of the Marches, the landscape flows by, verdant, bucolic, and unspoiled. And were it not for the rapid progress of two *autostrade* bearing down from two directions, the old roads are still all that a sporting driver could wish for.

Fabriano, like so many towns in central Italy, emerged from the Middle Ages independent, industrious, and belligerent, and, like so many of its neighbors large and small, was ruled by a succession of petty tyrants who, with uneven results, attempted to establish dynastic rule. Eventually, the entire region comprising the Marches and Umbria became part of the Papal States, relegating Fabriano to the role of a comfortable provincial backwater. Although today the town

is a bustling hive, producing everything from kitchen fur-
nishings to high-tech alloy castings, its trademark is the
quality hand-laid "Fabriano" paper that has been made
there for centuries. Another local glory is the painter who 25
was born within its walls about 1370. Gentile was his given
name but, even by his contemporaries, he was known as
Gentile da Fabriano.

Gentile's stature as an artist not only earned him his "da
Fabriano" surname, but also more than justified the highly
important and painstakingly prepared exhibition which his
native town devoted to him earlier this year. It was the first
compendium of his work ever assembled, and it drew to the
task an impressive roster of scholars, notable among them
Keith Christiansen, the associate curator of European paint-
ings at the Metropolitan Museum of Art. It was Christiansen
who, in 1982, prepared the definitive catalogue of Gentile's
paintings, accompanying it with a perceptive analysis of the
artist's role in the story of Early Renaissance Italian art.

The story is, inevitably, incomplete. One would wish that
Gentile da Fabriano's early training were better delineated
by reliable documents and identifiable works. Who, for
instance, was his first mentor and where did his training
occur? What part did the Chiavelli, *signori* of Fabriano, play
in the rapid progress of the artist's career and notoriety?
Finally, what were the circumstances of Gentile's incessant
lifelong travels throughout northern and central Italy?
Inevitably, in the absence of a written record, the visual evi-
dence must suffice, but in Gentile's case, this is complicated
by the fact that, although he was steadily and successfully
employed as an *affresco* painter, virtually all his work on
walls has disappeared. Moreover, only about thirty of his
panels survive – of his drawings, a mere handful.

The two panels that contemporary criticism places at the
very beginning of Gentile's career, *circa* 1395, speak clearly

of the artist's presence in Lombardy and of his association with the Visconti court (*Virgin and Child with Saints*, Pinacoteca Malaspina, and *Virgin and Child with Saints and a Donor*, Berlin, Gemäldegalerie), the latter, lamentably, absent in Fabriano. It was at this time that Milan was entering, under Visconti rule, a period of unparalleled economic prosperity and military power. Gian Galeazzo Visconti, after having shared sovereignty for fifteen years with his uncle Bernabò, had finally, by the end of the century, succeeded in eliminating him (literally) and having himself anointed Duke of Milan and Lombardy by the Emperor. Repeated attempts by Milan's archenemy, Florence, to limit Visconti hegemony in northern Italy had ended in costly failures. Gian Galeazzo, in true Renaissance fashion, was not modest in savoring his uncontested preeminence. This was reflected by the splendor of his court which, in spirit and manners, closely adhered to the chivalric models of France, Burgundy, and the Empire.

The exhibition opens with a number of drawings, objects, and paintings appropriately illustrating the "gothic" elegance, refinement, and opulence of Milan under Visconti rule. A drawn likeness of Gian Galeazzo may be by Gentile himself; it is miraculously crystalline and almost Ingres-like, attesting not only to the young's artist's proficiency, but also to his early *entrée* into the highest reaches of courtly patronage. Further drawings and several paintings by artists such as Giovannino de' Grassi, Michelino da Besozzo, and an anonymous hand that goes by the name of "Master of the Barbavara Altarpiece" help to define the figurative language that Gentile made his own. It is one of exquisite color, flowing, sinuous line, and delicately balanced composition – all combining to create a precious, otherworldly lyricism very reminiscent of book illumination.

Then there is the gold. Several objects – shimmering, jewel-encrusted reliquaries, chalices, and crosses – command

attention by their mere presence. Gold, of course, has always denoted wealth and power, and, seen in such profusion and so intricately worked, it still inspires awe in our jaded post-modern eye. In late medieval ecclesiastical and court ritual, however, gold was much more than an indicator of value, beautiful to behold. It was present as a prime ingredient of the religious and artistic experience. Gold, in its unalloyed perfection, served as a metaphor for spiritual purity, for eternity, and, ultimately, for holiness – attributes that in many ways applied to the Church as well as to the Court.

No other European artist used gold so skillfully and intelligently as Gentile da Fabriano. Gold is everywhere: in the elaborately tooled backgrounds and haloes, in the high-lights of draperies and in the very texture of their weave; in the brightness cast by heavenly apparitions and in every accoutrement and caparison worn by man or beast. Many of these golden details are also given sculptural relief so as to augment their visibility and verisimilitude. Gold leaf actu-ally underlies many areas that were then covered with trans-parent glazes; these surfaces were subsequently scored to produce effects that are magically luminous. In a word, Gen-tile's art is all about gold.

Returning, with this in mind, to that early work now in Berlin, the *Virgin and Child with Saints and a Donor*, one can-not fail to be struck by the gilt throne and background, occupying, in a painting of this considerable size, what must be well over a third of the surface. Then, virtually every-where else, the eye picks up the minute and complex gold embroidery, beading, and highlighting. On one level, all this is perfectly consistent with the late Gothic mannerisms and techniques from which Gentile emerged. What announces itself here as radically different and innovative is the *equilibrium* of the composition and the *substance* of the figures. The sinuous and graceful shapes no longer solely

describe an elegant play of line, contour, and color. Each form is modeled with an evident understanding of its weight and mass, and each is arranged in a clear relationship to its setting. The figure of the donor is an admirably executed portrait – no longer merely a pro forma stand-in, but a recognizable, living *person*. Gentile is careful to give even the saintly figures their human individuality and expression.

Gentile's early and widespread recognition is easily understandable when one realizes that several paintings of this caliber are generally dated before the close of the fourteenth century. By 1410, he was in Venice at work on the Serene Republic's most prestigious commission: fresco decoration of the main chamber of the Doge's Palace, unfortunately now lost. It was probably for a Venetian patron that Gentile carried out the first of his three major surviving altarpieces, the so-called Valle Romita polyptich (Milan, Brera). Conceived within a relatively conservative framework comprising a central composition – *The Coronation of the Virgin* – flanked by separate standing figures of saints, with a *Crucifixion* and smaller figures of saints above, this impressive pile is much more than a sum of its parts. The relationship of attitudes and poses is so skillfully orchestrated that the viewer is hardly troubled by the fact that the altarpiece is actually a composite of ten separate and discrete images. Each element blends seamlessly into a single, and sublime, heavenly vision. If considered at close quarters, however, one discovers with wonder how Gentile's brush is tireless in its careful exploration of the substance and texture of *real* things such as fabrics, flowers, and flesh; each item is examined, weighed, and then revealed in its corporeal – utterly truthful – specificity.

Within the space of another ten years or so, Gentile had progressed from Venice, to Brescia, back to Fabriano, and then to Florence where he arrived in 1420. The presence

there of Pope Martin V may well have had something to do with the artist, by now greatly renowned, having been attracted to the same city at this moment. The endless schism of the Church had been finally recomposed, and the pope could now proceed to Rome. The fact that Florentine diplomacy and Medici money had played such an important role in these events allowed the city and its ruling oligarchs to enjoy immense new prestige on the world stage.

Foremost among Florence's commercial and banking elite was Palla Strozzi. He had not only amassed a huge fortune, but, like his slightly younger contemporary, Cosimo de' Medici, was universally respected for his wisdom and prudence. Also like Cosimo, Palla Strozzi did not stint on building projects which would add luster to the family escutcheon and at the same time would promise rewards in the hereafter. Such was the decoration of the Strozzi Chapel in the prestigious and very central conventual church of Santa Trinita.

Florence was hardly experiencing a shortage of artistic talent in 1420, and Palla Strozzi was therefore blessed with an embarrassment of riches. Not surprisingly, he was characteristically munificent and perceptive in his choice of painter for the great altarpiece that would adorn his chapel; Gentile was, by then, one of the most famous artists in Italy, and undoubtedly the most expensive. Strozzi must not have been disappointed with the result. *The Adoration of the Magi*, with its grand dimensions, elaborate framing, and lavish execution is an unsurpassed masterpiece, and not only within the context of Gentile's work; it stands as one of the pinnacles of early Italian Renaissance art. Removed from Santa Trinita in 1810 (when one of its precious *predella* panels was spirited off to Paris) and, since 1919, a treasure of the Uffizi, the *Adoration* altarpiece could not be expected to undertake the journey to Fabriano. Even in its absence,

however, Gentile's microcosm of teeming potentates, court-
iers, camp followers, peasants, stallions, dogs, and sundry
exotic animals casts its magic spell on the exhibition. The

temporary return to Italy of the Paris *predella* (*Presentation
in the Temple*, Paris, Louvre) was, at least, a small but very
welcome consolation.

The theme of the Adoration enjoyed great favor among
Florentine artists of the Quattrocento; later interpretations
by Filippo Lippi, Botticelli, Ghirlandaio, and Benozzo Goz-
zoli are all justly famous. The subject, treated as a royal
progress – a magnificent parade – must have had a special
appeal in a city that still considered itself an austere repub-
lic where sumptuary laws were rigorously enforced, and any
ostentation of personal luxury and wealth much frowned
upon. If Florentines might have derived voyeuristic plea-
sure from admiring an event quite so foreign to them, then
they must have felt abundantly rewarded by Gentile's cine-
matic "cast of thousands." The leading and supporting
actors, the countless extras and *staffage*, not excluding the
occasional monkey and leopard, are all resplendent in jew-
els, brocades, feathers, and turbans. When observed from
afar in its panoramic entirety, *The Adoration of the Magi* can
be enjoyed as a wonderland fairytale, but, as always with
Gentile, *reality* resides in the details: the astutely observed
foreshortenings, the convincingly modeled drapery, the
lovely tiny flower rendered with the precision of a botanist.

The one presence in Fabriano that, to some extent, miti-
gates the absence of the Uffizi altarpieces is the *St. Francis
Receiving the Stigmata*. Almost totally inaccessible in an Ital-
ian private collection until 1978, it is now part of the Mag-
nani Foundation, near Parma – slightly out of the way, but
decidedly worth the detour (a great Goya masterpiece is an
extra dividend). Gentile painted the *St. Francis*, and its *verso*
now in the Getty, on a visit back to Umbria and the Marches

in the mid-1420s. He then continued on to Rome to fulfill a major papal commission at the Basilica of St. John Lateran. Only fragments of this fresco survive, however, and what there was remained incomplete at the artist's death in 1427.

The *St. Francis* is, therefore, the one capital work that still speaks clearly of Gentile in his later years. It does so also because of the painting's absolutely uncanny preservation – possessing a surface that is truly unblemished and miraculously *un-cleaned*. In this context, "un-cleaned" does not mean "dirty"; it means that the surface has been spared attempts at rendering it brighter and more sparkling – generally by the application of strong, caustic solvents. This is rare and, when encountered, it immeasurably increases an understanding of the artist's intent. Here, Gentile was obviously aware of the challenges he faced: placing two figures at varying distances in a mountainous setting, and portraying them at the moment of impact with the divine presence of the Holy Spirit. Giotto's sacred precedent, of course, was inescapable, and Gentile, far from reinventing the iconography, merely heightens the drama with a mystically charged light. Its rays invest, in subtle gradation, every detail ... again, the details becoming protagonists. Each of these visual annotations, rather than fragmenting the form, adds to it. As a result, the elements of the composition – the rocky cliffs and the humble oratory of La Verna, the simply draped figures, their heads and hands – assume a surprising sculptural integrity and mass. Contemporary criticism has finally recognized this aspect of Gentile's art as having a great deal in common with Masaccio, that perennial hero of the "real" Renaissance. Could this have been the thinking behind the curious title of the exhibition: "Gentile da Fabriano and the Other Renaissance"?

September 2006

Fra Angelico comes to the Met.

IN 1896, a Scottish insurance magnate named Evan Mac-Kenzie set himself to erecting a massive "medieval" castle on a glorious site overlooking the Mediterranean, hard by the outskirts of Genoa. For this extravagant client, a gifted young Florentine architect named Gino Coppedè concocted a huge turreted, crenellated, and rusticated fantasy that, to this day, remains a masterpiece of *fin de siècle* historicism run amok. As the final jewel in MacKenzie's baronial crown, Coppedè designed a chapel and commissioned for its walls some suitably religious frescoes. Executed by the brilliant Russian copyist, and later restorer, Lockoff, these decorations paraphrase and mimic the one primitive (Roman Catholic) artist with whom the presumably low-church MacKenzie would have felt comfortable: Fra Angelico (1395–1455). The choice is not surprising: by the end of the nineteenth century, the "beatification" of the celebrated Dominican friar-painter had reached its apogee. And this was not due to having been "rediscovered" – not, certainly, in the way other great European artists of the past, such as Vermeer, Botticelli, and El Greco, were beginning to re-emerge from obscurity just at this time.

Fra Angelico's given name was Guido; the addition of the prefix "Fra" occurred when the painter became a Dominican friar, known as Fra Giovanni, in the early 1420s. The "angelic" appellation was acquired posthumously, by 1469, only a scant two decades after the artist's death. "Fra Angelico," as

he was invariably called thereafter, was never to be absent in later historical accounts of Italian art. Vasari goes to great lengths to describe in highly laudatory terms Angelico's moral rectitude, modesty, and religious devotion, adding that, throughout his life, the angelic friar always disdained wealth and worldly recognition. This compliment has a curious ring, offered as it was by a man whose appetite for worldly rewards was notorious. But by Vasari's time, during the later sixteenth century, the rising tide of Counter-Reformation orthodoxy assured that Fra Angelico's piety, and to a lesser extent, his art, would not be forgotten. Indeed, writing in the 1660s, André Félibien was unable to cite a single example of the art but was suitably fulsome in his praise of the piety.

By a curious paradox, the event that may have contributed most effectively towards the recognition and fame of Fra Angelico's art was the suppression of convents and religious confraternities in Tuscany, a measure enacted by a reformist grand-ducal government in 1777. It was at this time that Angelico's magnificent "Linaiuoli Tabernacle" entered the Uffizi, becoming one of the artist's first works accessible to the public. In 1810, at the behest of Napoleon's minister of culture Vivant-Denon and the painter Jean-Baptiste Wicar, the great *Coronation of the Virgin* from the Convent of San Domenico in Fiesole was requisitioned and transported to Paris for the Musée National, predecessor of the Louvre. At the same time or shortly thereafter, many other significant works were, little by little, finding their way to private and public collections all over Europe: the so-called "Thyssen Madonna" to William IV of England, another altarpiece from San Domenico to Russia, a magnificent early *Annunciation*, again from San Domenico, to the Spanish royal collections via the Farnese inheritance, and finally numerous *predelle* and other fragments from dismembered altarpieces, scattered in every direction.

Of course, central to an understanding of Fra Angelico's art are his frescoes in the Convent of San Marco in Florence and at the Vatican in Rome. These, fortunately, have mostly survived intact and were regarded by artists and writers as important destinations throughout the nineteenth century. The fame of the Vatican frescoes was much enhanced by the 1810 engravings of Francesco Giangiacomo and those of the San Marco convent by Vincenzo Marchese's similarly lavish publication of 1851. It is therefore entirely understandable how, in the 1850s, both Manet and Degas derived inspiration from these frescoes as well as from the Louvre *Coronation*. But the keen sensibilities and connoisseurship of these two artists seem, in retrospect, somehow at odds with the prevailing nineteenth-century perception of Fra Angelico as a charmingly primitive, *retardataire*, late-gothic artist – exemplifying in his life and art those Christian virtues so dear to the Victorian ethos. Most writers, beginning with August Wilhelm von Schlegel, who published the first modern biography of Fra Angelico in 1817, viewed the artist through this lens. It was, after all, an era of medievalist revival and, more specifically as we have seen, an age of relentless collecting of "early" art: William Beckford and William Young Ottley (in England), Édouard Aynard (in France), Johann Anton Ramboux (in Germany), and Giampietro Campana (in Rome).

By the time MacKenzie commissioned Maestro Lockoff to produce his "Angelico" confection, this great Early Renaissance master seemed trapped in a deadly stereotype and destined forever to adorn, in abominable rotogravure, the wastebaskets and lampshades of the world's *petit-bourgeois* households.

It is three early scholars and critics to whom credit is due for initiating a serious reappraisal of the Dominican friar:

Bernard Berenson, R. Langton Douglas, and Frida Schott-müller. Each, drawing from earlier sources and their own keen observations, began to dispel the mythology and to delineate a more historically convincing outline. Thanks to their pioneering efforts, by about 1915, the chronology of Fra Angelico's works was emerging more clearly. Despite these advances, however, the artist was still viewed as an essentially "transitional" figure. Perhaps the single greatest obstacle to the evolution of critical thinking on the subject was what might be called, for lack of a better term, the "Masaccio/Angelico" antithesis.

Based on a mistaken assumption (initiated by Vasari) that Fra Angelico was born in the 1380s, this presumed twenty-year seniority over Masaccio automatically placed the older artist comfortably within an earlier, late-Gothic tradition. The younger genius who revolutionized Italian figurative art in the Brancacci Chapel frescoes of the mid-1420s became, by this reading, the paradigm of all that was new in terms of spatial representation (perspective), psychological verisimilitude, and classical (antique) compositional equilibrium. It was Renaissance "gravitas" vs. Gothic "charm": obviously one was the prelude, rude and daring, of things to come and the other the echo, elegant and ephemeral, of things past. It was several decades into the twentieth century before this simplistic misconception was dispelled. Even into the 1950s as eminent and perceptive a scholar as John Pope-Hennessy still qualified Angelico as "reactionary."

Then, in 1955, on the five-hundredth anniversary of the artist's death, came two important and comprehensive exhibitions of Fra Angelico's work. They were held in Florence and Rome and prompted significant documentary and scholarly research. Of great importance was the finding that the artist may well have been born as late as 1400. This, of

course, made him an almost exact contemporary of Masaccio. A further, equally important revelation was the identification of a triptych in the remote church of San Giovenale of Cascia di Reggello as an early work of Masaccio. This, and another panel datable to Masaccio's beginnings, *Sant'Anna Metterza*, also reappearing in the 1950s, established unmistakable connections to very similar and almost contemporary paintings by Fra Angelico.

With these critical advances it became all too clear that the relationship between Masaccio and Fra Angelico was anything but antithetical as conventional wisdom had dictated. In a sense, these findings only proved what one of Italy's foremost art historians, Roberto Longhi, had already proposed in 1940; in a word, that the two artists may not only have known each other but may have been well aware of, and interested in, each other's projects. Longhi astutely intuited that Masaccio's evolving masterpieces on the walls of the Brancacci Chapel were closely observed by the Dominican friar and that he, probably more than any other Florentine artist of the time, knew how to draw from them important and far-reaching lessons. Longhi perceptively analyzed how these lessons were subsumed and transformed not only in Fra Angelico's paintings but also in the paintings of an entire generation of Florentine artists.

The more recent contributions to Fra Angelico scholarship, particularly by Carl Brandon Strehlke, Andrea de Marchi, Miklós Boskovits, and John Spike have greatly clarified this crucial Masaccio/Fra Angelico relationship and have helped to refine the latter artist's often confusing chronology.

It can safely be said that the sum of what these efforts have accomplished constitutes the subject of the recently inaugurated exhibition at the Metropolitan Museum, entitled simply "Fra Angelico." It comes exactly fifty years after

the Florence and Vatican events and, within the obvious limits of such an undertaking (the frescoes and altarpieces having remained in Europe), it fulfills its goal admirably.

Laurence Kanter, Curator of the Lehman Collection, and Pia Palladino, his partner in life as well as in art history, have, over the past several years, relentlessly pursued and garnered a total of upwards to seventy-five works, some of remarkable importance. These are the key pieces around which the extraordinary story of Angelico's art unfolds. Despite the oft-cited shortcomings of the Lehman Wing, its lower level affords a surprisingly efficient and attractive venue for a show of this kind, arranged as it is in a calm and reasonable chronological progression. Since many of the works are of modest dimensions, the visitor is afforded a certain visual "repose" between one item and the next. This is an unexpected and very welcome dividend for an exhibit of this kind: every one of the paintings is so demanding of intense and undivided scrutiny that there is no easy flow from one to the other.

Kanter and Palladino have been joined in their curatorial task by four colleagues, three of whom have contributed articles for the catalogue. Although one would hardly recommend viewing the exhibition with this book in hand, a brief look at its chapter headings might, in fact, be useful. The nine titles sketch a brief temporal résumé of Fra Angelico's career and include a substantial *coda* devoted to some of his assistants and followers. It is interesting to consider that, even after five-hundred-plus years, the work of one man can still be subjected to such careful dissection and analysis; justification, if one were necessary, of the validity of art-historical research, a discipline that practiced at this level of expertise and integrity offers rewards that can be, even for the uninitiated, truly surprising. In fact, the viewer is prompted at every turn to exercise his intelligence by

connecting strands of visible evidence into a coherent continuum that, when read correctly, invariably produces moments of thrilling revelation, the art historian merely providing the necessary sign-posts – markers of the kind that a grateful hiker might find on an alpine trail. Admittedly, however, on such excursions one should expect the oxygen to get pretty thin at times. It does, for instance, when deciphering the visual clues hidden in the five fragments of the exquisite Pilgrimage Roll to which Fra Angelico contributed in his youth.

One is met, early on, by the so-called "Griggs Crucifixion." Here, again, a deep breath is warranted, for this is a majestic and yet exquisitely wrought work of art that is visually satisfying in every millimeter of its shimmering surface. But is it by Fra Angelico? When Maitland Griggs purchased it back in 1925, Masaccio's elder and somewhat hapless assistant Masolino seemed a fair bet as an attribution, even though it was a bit like squeezing a square peg into a round hole. In such instances, art historians recur to the time-honored expedient of inventing a conventional name – in this instance, "The Master of [what else?] the Griggs Crucifixion" (later identified as Giovanni Toscani). And so it remained until recently, even garnering other works around it presumed to be by the same hand. We now happily dispel all doubts about its status as an early work by Fra Angelico, and even direct our gaze to what might well be this artist's only known "signature" (on the caparison of the horse at the far right). To weigh this, together with the other visual evidence, is a delightful exercise – particularly because here the clues are so plentiful and in plain sight. The satisfaction is truly complete when, just one step away, one finds the poignantly touching image of *Saint Jerome in a Landscape*. It is obviously by the same hand, but did its nobility and "gravi-

tas" prompt the curators to add "an unknown Florentine master" to Fra Angelico's side in the catalogue entry? One suspects it's just a way of saying: "look at what the young friar was capable of . . . even Masaccio could do no better!"

Beyond such intriguing problems, there are plentiful examples (and these are the ones that will probably sell the most tickets) where the artist is there in plain sight, doing what he does best: portraying splendidly attired saints, gorgeous Madonnas against richly brocaded cloths-of-honor, sublime winged creatures in heavenly choirs – all in settings of severe dignity and crystalline purity. Short of one of the great altarpieces still anchored firmly in San Marco, the so-called "Thyssen" *Madonna and Child* is here to flaunt its irresistible colors. Impeccably preserved (and despite its abominable neo-something frame), it virtually defines the paradox of Florentine Renaissance art: an apparition of otherworldly idealization, all the while solidly grounded in everyday, "tactile" reality. This uncanny ability of being able to create images that, so to speak, function on two levels, is also much in evidence in Fra Angelico's narrative paintings. Consider the five-part *predella* with episodes from the lives of Saints James, John the Baptist, Lucy, and Dominic. Here we have the artist as playwright, director, set designer, and wardrobe manager combined: each of the scenes unfolds within an admirably conceived environment defined, but not necessarily enclosed by, architectural elements. The perspective is faultless; the lavishly costumed figures occupy their discrete spaces with authority. Even the minutest detail of fabric, stone, flesh, and flora is lovingly described. Thus the prosaic reality of the story is elevated to the status of myth and inevitably commands our attention more forcefully. The pleasure of gazing at these five *tableaux* is increased with the realization that they have been reunited

here for the first time since the altarpiece to which they originally belonged was dismembered, probably two centuries ago. Indeed, one of the panels was identified correctly no more than a decade ago. Catalogue Number 36 is another example of how major exhibits succeed in luring together dispersed fragments, in this case two paintings – once joined front to back – that have not been seen together since the mid-nineteenth century.

Not long after entering this enchanted world, the viewer becomes aware of the superlative craftsmanship that came to bear in actually making *objects* that function also, coincidentally, as *paintings*. By 1400, the tools, materials, and techniques employed by Tuscan artists reflected a tradition more than two centuries old. The production of panel paintings, from huge altarpieces to tiny votive images, had been developed and refined over this long period to a point beyond which it was almost impossible to progress – a situation not unlike the art of casting, chasing, and gilding bronze which reached its zenith in the early nineteenth century. These were all collaborative undertakings: different crafts, each striving towards and, eventually reaching, perfection.

When confronted by such perfection, as exemplified by the astonishing *Dormition and Assumption of the Virgin*, wherein the quality and conservation of surface are matchless, one cannot but be awed by the craft, let alone the art, that created it. But time, alas, is not always so gentle. Within a limited range of tolerance, a certain amount of damage is acceptable; beyond that threshold, a painting retains, at best, a documentary, "archaeological" value. The sight of two *predelle* with episodes of the life of Saint Dominic is almost too cruel to bear, "skinned" as they are to a shadow of their former selves. To make matters worse, not even the slightest bit of charitable attention has been devoted to their ruined

surfaces. In the case of the Fogg Museum *Madonna and Child* and the *St. Anthony Abbott* from a California private collection, perhaps *too much* has been done in an attempt to reconstruct what remains of their equally ruined states. It's fair to wonder, in this context, what these paintings add to our understanding of Fra Angelico.

41

Other subtle questions are posed by two impressive and, actually, quite well preserved images of the *Virgin and Child*. In both, the flesh tones lack the clarity and transparency one has come to expect after admiring some of the works that hang in the immediate vicinity: a brilliance and translucence that Fra Angelico obtained by applying the palest of glazes over a bright, almost opalescent preparatory layer. Also troubling is the presence of very evident "scoring": it outlines a number of salient compositional features such as the hands, arms, and legs. Invariably this constitutes strong evidence for the transfer of a pre-existing design or "cartoon" over the gesso ground. It is, in other words, the typical process used by workshop assistants to duplicate or adapt a master's invention.

If the stated purpose – or conceit – of much of the visual art created through the twentieth century and continuing to the present, is to "raise awareness" in the viewer, then no painting will be more in tune with contemporary tastes than the *Christ Crowned with Thorns*. Rarely seen and totally unexpected, this moving, almost shocking image has deep roots in Christian iconography. In this version, it is transformed, as one would expect it to be by a Florentine artist of the Renaissance, into an idealized abstraction. A king, richly attired and impeccably coiffed, stares straight out with an agonized expression, as if uncomprehending of the torture to which he is being subjected. Details are lovingly and "realistically" rendered: every strand of hair, every droplet of

blood, the insanely hemorrhaged eyes; yet the verisimilitude is not of this world. It resides in the realm of the spirit – it is the true source of this image's power.

42 Perhaps a disappointing sign of how Fra Angelico is still misunderstood is that a rapid perusal of the inevitable merchandise stand attached to the exhibition appeared to display not a single poster of this unforgettable face.

December 2005

On the sublime artistry of Lorenzo Lotto.

CERTAIN ARTISTS, and not necessarily the most accomplished or significant, are occasionally accorded a privileged stature in the contemporary popular imagination. They inhabit an exalted realm of myth and romance – or as is fashionable today, "cult" – that places their reputation if not beyond criticism, certainly above it. Even a handful of Renaissance artists have been bestowed similar distinction (yes, Caravaggio is the obvious example). Identifying the circumstances that initiate and sustain this process of beatification is not difficult: certainly premature death (preferably suicide), a tormented sexuality or sociopathic disposition, posthumous oblivion and eventual rediscovery, extreme rarity of extant works. All these can play a part. Often, a spotty or incomplete historical record increases this aura of mystery and awe.

Lorenzo Lotto (1480–1557) fits this profile only imperfectly: the obscurity in which his reputation languished for nearly three centuries strikes a familiar note. Otherwise, he was a long-lived, exceptionally industrious, exceedingly God-fearing man, whom his contemporary Pietro Aretino famously (and with typically malicious irony) addressed as: "Oh Lotto, good as goodness and virtuous as virtue." Moreover, there is copious contemporary documentation, an account book that he kept for many years, and, most importantly, an unusually large number of surviving works, many of them signed and dated. Yet, despite this lack of mystery

and drama, Lorenzo Lotto is today accorded a reverence reserved for almost no other Italian High Renaissance artist. The reason may lie in the fact that when the twentieth century rediscovered this humble, provincial journeyman painter, it found a man not only of boundless imaginative resources but also of unparalleled artistic and spiritual integrity, a painter who embodied all the qualities of the modern artist-as-hero: fierce independence, almost obsessive self-awareness, and a robust disdain for the fleeting rewards of this world. Thinking of van Gogh or Modigliani? Yes, but for one crucial detail: Lotto, unlike his more recent colleagues, was moved and sustained by an intensely experienced and rigorously practiced religious devotion throughout his life.

Following Lotto's long career is a fascinating pilgrimage through northeastern Italy. It begins in Venice, his native city, and continues – with endless comings and goings – to Rome and other less important centers such as Treviso, Bergamo, Recanati, Jesi, and Ancona. There were also long detours to obscure villages in the backwaters of Lombardy and the Marche to which the artist consigned some of his most significant commissions. Being a young apprentice-artist in Venice at the beginning of the sixteenth century must have been a thrilling but also daunting experience. The established master, Giovanni Bellini, although approaching the end of a brilliant career, continued to re-invent his style and to cast a giant shadow; emerging from it may not have been easy, but it was a task at which Lotto's close contemporaries Titian and Giorgione succeeded all too well. Their genius, grounded in Bellini's sober classicism yet animated by an entirely innovative tonal approach to color, must have seemed, even then, a winning combination. Lotto's earliest works clearly show his awareness and understanding of

these developments, but even then he must have felt a strong urge to hew to a different course. A clue to the young painter's independent character was his next move: he simply threw in the towel and decamped to nearby Treviso. Here, from 1503 to 1506, with the patronage of a cultivated local bishop and some influential friends, Lotto got his start in earnest.

45

The commissions Lotto received in Treviso were not small change: he completed two large altarpieces and a magnificent portrait of Bernardo de' Rossi, his patron, in short order. The local churches and monastic orders, particularly the Dominicans, took notice and, by 1508, Lotto consigned to this order's conventual church in Recanati a huge, multipanel polyptich. In the same year, he also completed a *Sacra Conversazione* (that most Venetian of inventions: the Virgin and Child, flanked by two saints, seen in half-length). What does Lotto tell us of himself after this first, successful foray into the provinces? Clearly, that he was an extraordinarily gifted and assured interpreter of a slightly derivative, and perhaps old-fashioned, religious imagery with strong echoes of Bellini and Cima da Conegliano.

Yet on careful observation, there are elements that startle in his work: expressions of a surprising and relaxed naturalness, details observed with an almost obsessive precision, attitudes of the figures' posture or movement that are unusual and unprecedented. The color fields are precisely defined, the folds and anatomy crisply outlined – a technique decidedly at variance with that practiced by Titian and Giorgione at this moment in Venice. The *Sacra Conversazione* has a "Northern" expressive intensity and a palpably anti-classical cast which suggests Lotto's knowledge of Dürer, whether directly, via the German artist's presence in Venice in 1506, or through his engravings. Even the straight-

forwardly Quattrocento Rossi portrait belies its somewhat conventional simplicity by the penetrating and psychologically acute gaze of its sitter – a startling innovation at this early date. These are all clear hints that Lorenzo Lotto, with an almost fifty-year artistic journey ahead of him, had already struck out on an alternative path, one that would take him ever deeper into an intimately personal world of artistic discovery.

The Recanati altarpiece commission did not go unnoticed, particularly in nearby Loreto, a burgeoning sanctuary devoted to the Virgin and under the protection of Pope Julius II. That larger-than-life pontiff, besides attempting to rewrite the political map of Italy, was also in the process of rebuilding St. Peter's Basilica and the adjacent Apostolic Palaces. In 1509, the Loreto–Rome connection served as a calling card for Lotto to join the legendary *équipe* that added the most important chapter to the history of Italian High Renaissance art – an opportunity to collaborate with the likes of Raphael, Bramante, and Michelangelo and to be forever remembered as part of that heroic undertaking. But it was not to be. For reasons that may have as much to do with the artist's growing misanthropy as with conflicting artistic intents, whatever Lotto left on the walls of the Vatican *Stanze* was soon erased and replaced by Raphael's epochal frescoes. Although he never returned to the Eternal City, Lotto did not depart empty-handed. In his brief stay, he absorbed all he would need to enrich his visual vocabulary with weight, proportion, and spatial verisimilitude, a quick but valuable lesson in Roman classicism.

Ever restless, Lotto beat a path back to more familiar surroundings in the Marche. Soon opportunity beckoned elsewhere, this time from Lombardy in the form of a commission from Alessandro Martinengo Colleoni, a descendant of the celebrated *condottiero*. What Colleoni wanted was a

grandiose altarpiece for the Dominican church of Saints Stephen and Dominic in Bergamo. No doubt the artist felt at home with his beloved Dominicans and, with this tour-de-force, he more than satisfied both the friars and their patron. Nothing quite like it had ever been seen in Bergamo. The central panel towers to a height of nearly fifteen feet and must have inspired awe and admiration – as it still does, though in a different setting and shorn of its original frame and *predella*.

The scene's magnificent architectural setting, lofty and severe, is an exercise in Roman classicism, straight out of Bramante. A troop of saints (Dominic *primus inter pares*) crowd around the raised throne of the Virgin and her unruly Child. Below, two tiny, purposeful *putti* grapple with the impossible task of spreading a large carpet. But the attention is elsewhere: circling weightlessly in the air above are two winsome celestial creatures; two others, at even greater height, peer over a parapet as they arrange and display a variety of symbols and allegorical devices. A soft wind agitates the silken robes and long blond tresses of these otherworldly apparitions who, nonetheless, manage to cast quite corporeal shadows. There is a combination of the surreal and the utterly natural that pervades every detail of this heavenly carousel, a sense of paradox and even irony that becomes a continuing subtext in Lotto's art. It deepens the spiritual relevance of the image, facilitating a connection between viewer and subject, in effect reducing the separation between human and divine.

The success of the Colleoni Martinengo altarpiece assured Lotto of a continuing stream of commissions from the Bergamo community: wealthy landed gentry, prosperous merchants, and, of course, the local ecclesiastical hierarchy. This was a world with far different priorities than those of the Italian princely courts, the papal curia, or even the

Venetian Republic – not nearly as grand but perfectly aware of its identity and needs. Lotto filled those needs during a long sojourn interrupted only by short absences. It was his season in the sun. From 1513 to 1524, the artist completed three further altarpiece commissions, as well as an important fresco cycle. In the same period, he began to design a large series of *tarsia* decorations for the choir of the Church of Santa Maria Maggiore in Bergamo. These latter two projects, in different ways, perfectly illustrate Lotto's inventive genius for narrative and allegory.

The commission for the fresco decoration of a small country oratory in Trescore came from the Suardi, a prominent Bergamasque family. The figurative program appears to have been left to the inventive imagination of the artist. Ostensibly recounting the stories of four female saints – Barbara, Clare, Catherine of Alexandria, and the Magdalen – the walls (and ceiling) of the space are alive with teeming figures, all in contemporary dress, assisting or participating in the sometimes violent events experienced by the holy women. The narratives unfold with little interruption, almost informally, in outdoor and indoor settings that must have been instantly recognizable to the farming folk of the area. Moreover, it is those very rustics who populate the scenes on the walls – all busily at work in the typical tasks of an agricultural community. Dominating the proceedings is a giant figure of Christ from whose outstretched fingers grow vines leading upward to numerous roundels near the ceiling with figures of saints and martyrs – a totally unprecedented iconographic invention that joins the humble terrestrial existence of the protagonists to the supernatural realm of the soul. The language of Lotto's message is plain and direct, yet its intimate meaning is transcendent.

The challenge posed by the *tarsie* for the choir of the church of Santa Maria Maggiore is of a different order. The

commission required the artist to follow a carefully outlined narrative based on the Old Testament, not readily intelligible to many beyond the cultured circle of the chapter's canons. Despite the strict textual program, Lotto produced designs with a variety of settings and compositions; the episodes all occur in fantastically imagined landscapes or exuberant architectural structures. It was left to a brilliant artisan from Lovere to execute the tour de force in multicolored woods. He followed up the task by completing, again on Lotto's design, a series of corresponding covers for each of the narrative panels. In these further inventions, Lotto revealed another aspect of his artistry. Each of the covers bears a fanciful symbolic device that requires deciphering. Some lend themselves to a reasonably direct reading while the meaning of others remains in doubt. The project is a unique exercise in humanist allegory and symbolism. Lotto's interest in such esoteric word-games, typical of the Renaissance, had already become evident in the devices held aloft by the flying angels in the Martinengo-Colleoni altarpiece, but the choir stall covers offer a virtual lexicon on the subject. Moreover, the arcane collection of *emblemata* is rendered in design patterns of stunning freedom and elegance. Here, too, the inspiration may well derive from Northern sources. Dürer's presence in Venice has been mentioned; Erasmus of Rotterdam's works were being published there by the Aldine press.

Despite their placement, the choir-stall covers have a decidedly secular flavor. At around the same time during his stay in Bergamo, Lotto executed a painting with an even more overtly profane appeal, a *Susanna and the Elders* now in the Uffizi. The painting has a sumptuous setting in a lordly castle garden. The male figures are richly attired in the height of contemporary fashion and the chaste, naked lady who is the object of their lust has just shed her own

49

gorgeous fineries, including a pair of over-the-top green velvet sandals. The scene is depicted from above so that every detail of the landscape and the enclosed chamber in the foreground is in crisp focus.

It is an elegant vision of courtly life, devoid, however, of the powerful erotic charge with which Titian was wont to endow his female figures, particularly when nude. Lotto revisited similar, even more markedly pagan subjects, two or three times later in his career. They are, as with everything else he created, exceptionally inventive and unconventional images. Perhaps the most remarkable is a relatively recent addition to Lotto's catalogue; it is the arresting *Venus and Cupid* (*ca.* 1540). It is now, to New York's great fortune, part of the Metropolitan Museum's collections. Hardly a delight for the sensualist, the painting is, rather, a chaste and cerebral exegesis on the profusion of classical references scattered by the artist throughout the composition.

The breadth of Lorenzo Lotto's artistic vision cannot be understood without reference to portraiture, a discipline in which he had few contemporary rivals. The Bergamo years were, in this respect, as fertile as they were for his other pursuits. Lotto's temperament perfectly suited the interpretation of the aspirations, both worldly and spiritual, of his sitters. They were, after all, the secure, prosperous, and industrious gentry of a thriving community just beginning to recover from the ruinous consequences of a war fought on their soil by others (the War of the League of Cambrai). Lotto's somewhat stolid burghers affirm their presence with direct unselfconscious gazes, invariably conveyed by the artist with equal honesty. Particularly touching, as well as artistically innovative, are the double portraits of young couples; they are endearing expressions of intimate tenderness and domestic bliss – sentiments almost totally absent in sixteenth-century painting.

And then there is a supreme achievement of the genre: the *Portrait of Andrea Odoni* in the collection of Her Majesty the Queen. Completed in 1527 on the artist's return to his native city, the painting must have been a conscious effort to rival, in gesture and in grandeur, the paradigm set by Titian. The sitter was surely worth the effort: Odoni was a prominent Venetian oligarch, very much a part of the city's cultured upper crust. He was also a passionate antiquarian, and Lotto employs an atypical horizontal format to create a monumental image of the sitter surrounded by fragments of classical sculpture, only one of which apparently actually belonged to him. It's impossible to say whether these are included as recollections of the artist's time in Rome or simply as a metaphor for the sitter's cultural pursuits. In any event, Odoni proudly reaches forward to the viewer, proffering with his right hand a statuette of the "Diana of Ephesus"; he is the very model of the self-assured and influential Renaissance grandee, a world removed from the Bergamo gentry.

If Lotto had hoped to gain entry at last into the charmed circle of the Venetian elite with this great portrait, sadly, it didn't work. The artist remained on the margins of the city's art scene yet continued his stay on the lagoon for more than twenty years. It was never a settled existence: at first, he was a pensioner of the Dominicans, and later the guest of a nephew. He made constant detours – back to Treviso, then Ancona, Jesi, and other byways of the northeastern provinces.

The flow of commissions continued briskly until the mid-1540s, resulting in at least three masterworks: the giant *Crucifixion* for a church in Monte San Giusto near Macerata, the *Saint Lucy* altarpiece for the church of San Floriano in Jesi, and the altarpiece with *Saint Anthony of Padova Giving Alms* for the church of Santi Giovanni e Paolo in Venice. Only the last was destined for a significant Venetian venue –

not surprisingly, a commission from the ever faithful Dominicans. In each of his major endeavors, Lotto devised an entirely new and unexpected retelling of the story. Thus, the compositions are not only boldly innovative, but the protagonists are also portrayed with a deep psychological understanding of their role as part of the subject at hand. Lotto's intent was clearly to heighten the significance of the image in religious and spiritual terms – an effort that became ever more relevant and compelling to him in his later works.

A precious guide both to the continuous wanderings of the artist and to his daily projects and preoccupations is the *Libro di Spese Diverse* (*Book of Various Expenses*) that he kept between 1538 and 1549. It is a revealing document, not only as a record of Lotto's diminishing career but also – reading between the lines – of the hardship and disillusionment that must have caused him. The works produced after the mid-century leave little doubt that the creative stimulus that had energized Lotto was rapidly waning. The paintings of this period have a decidedly melancholy cast: the once-glorious color has become muted and dark, and the expressions and gestures of the figures no longer have their distinctive immediacy and verisimilitude. Worse still, the compositions appear tired and derivative. By 1550, Lotto presumably no longer felt it necessary to update his *Libro* – there was not much to add. He also seems to have been traversing trying financial times: he decided to make a public auction-like offering of his thirty-odd drawings for the Bergamo *tarsie* as well as six paintings. After years of lobbying, Lotto finally reclaimed his beloved drawings from the church and valued the entire lot being offered at four hundred ducats. The sale was a disaster; it fetched less than 10 percent of the estimate and – what is tragic for us – not one of the drawings has survived.

Two years later, presumably an exhausted and broken man, Lotto returned to Loreto and entered as a pensioner in the monastery of the Santa Casa. Soon thereafter, he took minor vows as a professed brother and, when he died in 1556, was buried there wearing his order's robes. As part of the agreement on becoming a member of the Loreto community, Lotto was to provide his artistic services. In fact, he completed several large canvases that can still be seen in the convent's museum. They provide a moving testament to the intense religious commitment and deep spirituality that now, more than ever, drove the creative process. Nowhere is this more evident than in the stark, almost monochrome *Presentation in the Temple* (1552–56) that closed the artist's career. Though executed with a trembling hand and almost careless disregard for finish, the painting is an unforgettable image of human participation in a sacred event.

Viewed from the perspective of our own agnostic era, what most fascinates and puzzles us is Lotto's steadfast devotion to his Christian faith. Not only did it condition every aspect of his art, but it also determined, in large part, the course of his life and career. The distinguished Lotto scholar Pietro Zampetti put it this way: "Rarely, as with Lotto, has an artist understood creation as such a totally interior commitment. . . . His story is not only an act of illustration, but an intensely experienced event; a phenomenon of conscience." The words "interior" and "conscience" in this keen observation touch on an issue that, of late, has been much debated: to what extent did Lotto become a "reformed" artist?

Renaissance Venice was a free and open port of entry, not only for goods but also for ideas; these readily found their way to the city's busy printing shops. Venice became Italy's gateway for the gathering whirlwind of Reform. Yes, the German details that pop up here and there in Lotto's art

are unmistakable. The report of the artist having given two portraits, of Martin Luther and his wife, to a friend is also intriguing. Of course, wouldn't an intensely religious man like Lotto have grappled with the fundamental and compellingly urgent question of the age: Christian Reform? By all accounts, he was a lonely, introspective outsider who never married, had no family, few friends, and lived much of his life in, or in a close relationship to, monastic communities. Such a man's life in the early sixteenth century would have been "reformed" by definition.

Lorenzo Lotto also had no school or pupils; his paintings were not engraved, and there were never any drawings to speak of other than the ill-fated *tarsie* designs. With his paintings scattered over a wide territory, often in remote locations, it's not surprising that the memory of his art and its greatness soon faded and eventually disappeared. Mention of him in Vasari and later chronicles, while respectful, is generally brief. The portraits, always admired, remained in private hands, many of the best immigrating to England and elsewhere during the eighteenth and early nineteenth centuries (some with Titian attributions – ironically, *Odoni* was one of them). It was left to that intrepid pathfinder Bernard Berenson to lift the veil on Lotto with a monographic study first published in 1895. One can only imagine the romance and adventure of that young American, the son of Lithuanian immigrants, threading his way on this quest through the dusty back roads of the Veneto and the Marche. A cascade of publications on the artist eventually followed, including Berenson's own revision of his epochal book. In 1953, Venice had accorded the artist a full-dress exhibition in the Palazzo Ducale, topped only this year by a grand parade of his works assembled in the Scuderie of the Quirinale in Rome.

As much as the art of Lorenzo Lotto is now admired for

its sumptuous surface qualities and convincing psychological, intensely human representation, there is an aspect of Lotto that remains beyond our reach or, at best, difficult to grasp. Over a century ago, Berenson put it this way:

> In his most sincere moments Lorenzo Lotto does not depict man's triumph over his surroundings; in his altarpieces, and even more in his portraits, he presents us with subjects who look for comfort from religion, from serene contemplation, from friendship and affections. He looks at us from the canvas as if seeking the charity of some bit of sympathy.

If this devotional aspect of Lotto's discourse is now so difficult to grasp, it is because it has, alas, become so rare in all forms of art – and for so long – that it now seems strange and foreign.

September 2011

On the artist's painting, poetry & work for the Medici.

AMONG THE TWENTY-ONE PAINTINGS by Titian displayed in that treasure-house that is the Kunsthistorisches Museum in Vienna, one of the finest and best preserved is a magnificent likeness of the poet and historian Benedetto Varchi (1503–65), a Florentine humanist. The handsome young man is portrayed wearing a dark, unadorned academic's gown; the object of his serene but oblique gaze is unseen at right. What Varchi nonchalantly holds in his right hand is probably a *petrarchino*, or small edition of Petrarch's sonnets. As in his best portraits, Titian conveys to the viewer a direct and natural glimpse of the sitter who was a confident, congenial intellectual. Executed about 1540, at the midpoint in the humanist's career, the portrait projects an aura of repose and equilibrium despite the fact that Varchi was in exile, shuttling between Venice, Padua, and Bologna after having run afoul of adverse political winds.

It is interesting to speculate how radically different an image we would have of this quintessential Florentine had he been portrayed by his compatriot Agnolo Bronzino (1503–72). The fact that this portrait never materialized is puzzling; not only were the painter and the humanist exact contemporaries, they knew each other well and their artistic and intellectual pursuits often intersected over the tumultuous decades that straddled the second, temporary, overthrow of the Medici in 1527.

This event was a brief and unsuccessful rekindling of the

republican embers that had smoldered in Florence since the days of the firebrand monk Savonarola late in the preceding century. Until his execution, the reformer had labored to revive the city's ancient traditions of representative govern- ment, a movement to which the young Michelangelo bequeathed its most potent symbol: the colossal giant-slayer, *David.* Despite sputtering progress and eventual failure, the Republic had its greatest champion in Niccolò Macchiavelli, whose political philosophy prepared a fertile ground not only for reform of the *polis* but also for the far more significant reform of the Church.

After the Diet of Worms of 1521 and Luther's excommunication, the questions being debated were no longer of purely local concern; the entire peninsula was now engulfed in a massive struggle for supremacy between two foreign sovereigns, the Valois King Francis I and the Spanish Habsburg Emperor Charles V. Freelance politicking and the erratic, shifting alliances cobbled together by Clement VII, the Medici pope, succeeded only in sparing Florence from foreign occupation. The French defeat at Pavia in 1525 led to the disastrous sack of Rome by Imperial troops two years later and the consecration of Charles V as undisputed arbiter of Italy's future.

Nowhere was the uncertainty of these trying times more keenly felt than in Florence. Political instability stimulated innovation but also produced acute tensions in the social fabric of the city. Heated political and theological debate permeated the air; Bronzino the artist and Varchi the humanist could not but have been affected as they were reaching their early twenties. One telling reflection of the city's highly strung nervous disposition is made palpable in the great decorative project of 1527–29, the Capponi Chapel in the Church of Santa Felicità. Here Jacopo Pontormo created his masterpiece, and here, too, his young assistant Bronzino

gave first evidence of his genius. The centrifugal energy animating the figures of the *Deposition* emanates as much from inner personal malaise as from divinity above. The noble, densely packed grouping is possessed of a conflicted spirituality, one not so easily resolved by the old conventional piety. Beyond the regard for its stylistic innovation, the epochal painting has also been seen as a first, overt visual profession of reformed faith.

In collaboration with his master Pontormo in Santa Felicità, Bronzino produced early unequivocal proof of his proficiency as a portraitist with a modest likeness of Lorenzo Lenzi as a young adolescent. The boy was of noble birth and of a precocious literary bent. He holds a book open to an ode dedicated to him by Benedetto Varchi and, on the facing page, a sonnet by Petrarch. The portrait was probably painted in 1527, when, among other misfortunes, Florence was beset with an outbreak of plague. Varchi served briefly as the youth's tutor, remained a lifelong friend, and, at the moment in question, was undoubtedly infatuated with him. The two, together with Bronzino, may have been in the country seeking healthier air. One can only imagine the spirited conversations enriched by a combination of erudition and humor that filled their days.

It's possible that Bronzino's first attempts at writing verse began in this setting. If so, Varchi surely influenced and encouraged him. The two friends also struck up a continuing dialogue on *Il Paragone* – the primacy of painting versus sculpture – an issue strenuously debated at the time, which gave rise to a celebrated exchange of letters prompted by Varchi's request for opinions to the leading sculptors and painters of the age. Since these artists wrote in prose as well as poetry, there was much discussion about *ut pictura poesis*, Horace's phrase from the *Ars Poetica* which famously compares art to poetry. Although the debate did not survive the

Renaissance, its liveliness was emblematic of the stature that artists had achieved in the culture.

Established as an independent artist, Bronzino returned to Florence from a brief sojourn in Pesaro and Urbino in 1532 and embarked on a series of commissioned portraits that have secured his fame. Two that are particularly well-known to Americans reside in New York, at the Metropolitan Museum (*Young Man Holding a Book*) and at the Frick Collection (*Lodovico Capponi*). As splendid as these are, the pair portraying Bartolomeo and Lucrezia Panciatichi, now in the Uffizi, are justly among the most famous and admired portraits of the entire Renaissance. The viewer is observed by these self-absorbed grandees as if they were inhabitants of another world. They remain inscrutable and look out impassively, encased in their marble-like flesh and metallic, silken robes, striking the ritualized and affected poses of courtly etiquette. The space surrounding them is airless, the hard-edged contours of the figures matching and complementing the crystalline clarity of the *cloisonné*-like color fields. When an architectural backdrop is depicted, its elements are combined with a purely formalist, almost surreal intent defying perspective and verisimilitude. It is a frigid and lapidary world, the temperature of Carrara marble. How far removed from that flesh-and-blood, here-and-now Benedetto Varchi as seen by Titian!

Considering the brilliance and originality of Bronzino's work as a portraitist, it's not surprising that virtually all early modern critics, from Jakob Burckhardt and Bernard Berenson to Herman Voss, considered this the artist's singular and overriding achievement. The perception was so narrow that no serious study of the artist's work appeared until 1911 (by Hanns Schulze) and none in English until 1928 (by Arthur McComb). In the preface to his book, McComb adduced as a reason for this neglect that "unlike

so many more 'primitive' artists – Botticelli for example – Bronzino has never suffered an eclipse and has consequently never stood in need of rehabilitation." He added the curious observation that the artist was "severe enough in style to win the suffrage of the aesthetic connoisseur, he was yet sufficiently representational to cause the Philistine with a 'fancy for pictures' no misgivings." Though McComb spoke as a true Bostonian, his assessment of Bronzino's critical fortunes may contain some truth. Whatever the reasons, this last year has seen his art – finally and for the first time – represented in two monographic exhibits. Virtually all the artist's known drawings were shown at the Metropolitan Museum earlier this year; now on view in Florence is a spectacular gathering of his paintings.

The title of the show, "Bronzino – Painter and Poet at the Court of the Medici," says a great deal about the more complete view we now have of this Renaissance master. It places almost equal emphasis on the three aspects which defined Bronzino's career. His success in these pursuits is a measure of how far intelligence and talent could carry one of less-than-distinguished birth (the artist was the son of a butcher). Great ambition, of course, played its part, but so did the rapidly changing perception of the artist's role in society – particularly pronounced in Cinquecento Florence – which followed the publication of Leon Battista Alberti's wide-ranging treatises in the fifteenth century. No longer confined to the guild and the craftsman's workshop, artists became legitimate participants in the intellectual discourse of the age. Florence saw the birth of literary and artistic academies; at first they were informal associations of like-minded spirits such as *L'Accademia degli Umidi* (Academy of the Humid Ones) but in time they became repositories of established power and orthodoxy.

Bronzino wrote a considerable amount of poetry, some

dedicated to contemporary figures and prominent artists such as Michelangelo, Cellini, and Pontormo. There is little that actually concerns art theory in these rhymes. Bronzino broached the subject only once in his unfinished letter to Benedetto Varchi about *Il Paragone*, where he somewhat pedantically makes the case for the supremacy of painting over sculpture. The poetic works, like those by Varchi, are much indebted to Petrarch. The sentiments expressed are noble and sincere, but the verses are cast in a language that is often contrived and layered with esoteric meanings. Bronzino also produced a substantial body of *saltarelli*: breezy vernacular rhymes deriving directly from the burlesques of Francesco Berni. In all his works, there is a conscious effort to refine a language defined by its *Fiorentinità* – its specifically Florentine character.

A number of original manuscript sheets of Bronzino's verses are displayed in the Palazzo Strozzi exhibition. His crisp calligraphy is a model of clarity and elegance. These precious and beautiful works on paper serve as the perfect complement to the similarly clear and elegant paintings that advance in chronological sequence through the palace's magnificent halls. That progress begins with the four ceiling roundels from the Capponi Chapel, here moved temporarily for the occasion and visible for the first time at eye-level. They have traditionally defied accurate attribution because the hands of master and pupil are still virtually indistinguishable. After the early portraits and devotional pictures (some of which have also teetered between Pontormo and Bronzino), the exhibition becomes a visual panorama of Medici ducal rule after its final restoration.

Emperor Charles's de facto suzerainty over the Italian states was finally consecrated in 1530, when he received the imperial crown from the hands of Pope Clement VII in Bologna. As part of Charles's grand design, Florence was

returned to the Medici. For several years, the city experienced the erratic and reckless stewardship of two descendants of that family's senior branch. When Alessandro was assassinated in 1534, the Emperor elevated Cosimo, the son of Giovanni de' Medici, a soldier of fortune who lived a short, violent life filled with episodes of equally great valor and great treachery.

Although Cosimo was, by birth, from the wrong side of the Medici tracks, he demonstrated while still in his teens that he possessed not only his father's *sang froid*, but also a ruthlessly calculating political mind, which served him well as he consolidated his grip on power under the mistrustful eye of the Emperor. A brilliant move toward this end was winning the hand in marriage of Eleonora, the daughter of Pedro Álvarez de Toledo, Charles's lieutenant governor in Naples. Combined with military victories that expanded the boundaries of the Tuscan state, this alliance allowed Cosimo to establish and develop what was to become Europe's first modern absolutist court. The ruler, as before, exercised supreme personal authority, but now this authority was transformed into an all-encompassing system of governance extending across every function of the public enterprise.

Crucial to the success of this model was the visual perception of the state as embodied in the image of its ruler, his family, and, by extension, his dynasty. The proficiency as a portraitist that Bronzino had already amply demonstrated assured him a privileged role in Cosimo's circle. He became the first in a long line of court painters who served European rulers until the early nineteenth century. Cosimo, Eleonora, and several of their nine children appear on the walls of the Florence exhibition in various attitudes, always projecting an air of cool regal detachment. Robes, jewels, and accoutrements, depicted by the artist with his habitual crystalline clarity, constitute a veritable iconography of power.

The facial features and hands are more akin to *pietra dura* mosaic than to living flesh, augmenting still further the sense of otherworldly detachment that characterize the subjects.

In the show's context, the portraits are appropriately surrounded by numerous image-enhancing artifacts specifically commissioned by Cosimo's regime. Most lavish are five from a series of twenty tapestries woven by Flemish masters specially commandeered to Florence for the task. Embellished with copious amounts of gold and silver thread and gleaming with color, the precious silk hangings tell the story of Joseph who, despite having been sold into slavery by his brothers, eventually prevailed to become patriarch to a dynasty. The subject was chosen to equate the Biblical father's ordeal and triumph with the modern Cosimo's perseverance through the hardships of youth to claim his birthright. Working drawings for the series were provided by Bronzino as well as Francesco Salviati and Pontormo.

By 1545, when the commissions were awarded, Pontormo was already beginning to lose favor at Cosimo and Eleonora's court – only two, perhaps three, of his cartoons were ever executed. His pupil Bronzino, however, continued to enjoy unalloyed favor and had, several years previously, received the most important commission of his career: to decorate a small chapel for Eleonora in the Palazzo della Signoria, the ancient seat of the city's republican government, which had been transformed into the ducal residence.

All visitors to the Bronzino exhibition in Palazzo Strozzi should be compelled to walk the few hundred yards to admire the Chapel of Eleonora nearby: it is the artist's supreme masterpiece. As with the tapestries, the Old Testament (specifically the life of the Prophet Moses) is the source for the three episodes depicted on the main walls, and, like the tapestries, they are to be read as a parable of

progress to a promised land under the guidance of a wise and charismatic leader. Being surrounded by Bronzino's heroic, gesticulating figures at close quarters in the tiny chapel is an unforgettable experience. Unlike the Sistine frescoes, where the complexities of the composition can be worked out calmly at a distance, here the viewer is literally overpowered by the explosive immediacy emanating from the walls. The narrative is virtually drowned out by a furious overlapping and intersection of planes that challenge a rational interpretation of the pictorial plane. On these walls, the art of the *maniera* achieves its consummate expression: composition and color are pure distillations of a formal, intellectual process which looks to the real world only for symbolic values. If there were ever a doubt that portraiture was Bronzino's sole legacy to the Renaissance, it would be dispelled handily by a thoughtful moment spent in the Chapel of Eleonora.

Two works in the exhibition, *Venus, Cupid and Jealousy* from Budapest and *Venus, Cupid and Satyr* from Rome's Colonna Collection, further expand, but in a different direction, our perception of Bronzino and his art. They are panels of audaciously profane themes and overtly sensual imagery, illustrating another, more private aspect of Florentine patronage: literate, sophisticated, and secular. The panels' ostentatiously naked bodies, immobile as if paralyzed within the tightly packed picture plane, assume poses that would be flagrantly lascivious were it not for the purely metaphorical sexuality they project. A third painting of this remarkable series, the London National Gallery's famous *Allegory of Love*, sadly could not travel. It would have added an even more stunning knot of nudes engaged in silent cerebral dialogue among Bronzino's demigods.

The disfavor which Pontormo experienced when he sub-

mitted his tapestry designs seems puzzling at first when one considers his acknowledged stature and the prestigious Medici commissions he continued to receive. But, just as a new model of governance was evolving at Cosimo's bidding, the Church of Rome was initiating its own theological renewal at the Council of Trent. Art eventually played a principal role in both realms. The inward-looking and intellectually ambivalent religiosity of Pontormo's images contrasted uncomfortably with Counter-Reformation strictures as they emanated from the Council. The artist's obsessive introspection and independence of spirit prevented him from ever adjusting; his last, massive project at San Lorenzo suffered severe critical opprobrium from his contemporaries and, a century later, eventual destruction.

Bronzino, surely more accommodating and possibly more ambitious, found ways to adapt that proved to be only partially successful. Two of his last works, *The Descent into Limbo*, absent from the show due to its immense size, and the *Martyrdom of Saint Lawrence* fresco in San Lorenzo, attempt to convey a more focused and intensely direct experience of the sacred narrative depicted, yet the resulting images are hopelessly overwrought, overcrowded, and confusing. After the Chapel of Eleonora, Bronzino rarely managed to achieve the expressive coherence which became one of the essential ingredients of Tridentine policy on pictorial representation.

There was an exception, and it proved to be one of the truly exciting surprises of the exhibition. Bequeathed in 1879 to a minor French provincial museum, a monumental panel depicting *The Crucified Christ* remained incorrectly attributed until five years ago. It made its debut at the exhibition not only as a full-fledged Bronzino, but also as one of the artist's most startling creations. The Savior's body hangs in stark solitude in a faultlessly rendered pietra serena niche,

its lovingly modeled contours a miracle of verisimilitude and sculptural presence. Although Christ's proportions and features are supremely idealized with nary a droplet of blood to mar their perfection, the image is compelling in its corporeal reality: a sacred image that is almost archaically orthodox.

As a complement to this tour de force, the exhibition provided another surprise: a double-sided painting having little to do with the spirit and everything to do with the flesh – a grotesquely misshapen body of a naked dwarf. "Morgante," as he was called, was a fixture at the Medici court and was a favorite subject of sculptors who relished the pudgy shape of this teddy bear of a man. Bronzino portrays him front and back in slightly different attitudes, surrounded by owls and other birds (the Italian word for "bird" distinctly refers to the male member). The painting had long languished in the backwaters of Bronzino attributions and was never exhibited at the Uffizi. Now, after an exemplary restoration, the work can be admired not only for its arresting imagery and exquisite execution, but also as a veritable thesis on the vexed question posed by Benedetto Varchi's *Paragone*.

Here the artist demonstrates with a flourish that sculpture has absolutely nothing on painting, even upping the ante by adding a temporal dimension to the representation (the dwarf is shown in two different poses, implying distinct moments in time). That Bronzino won his arcane argument with Varchi adds little to his legacy, but the greater part now hangs on the walls of Palazzo Strozzi. It tells the remarkable story of a butcher's son born in Monticelli, a suburb of Florence.

December 2010

Part II: Galleries & Museums

On the Museo dell'Opera del Duomo in Florence.

FOR MORE THAN two centuries, a period that lasted longer than the ancient *Pax Romana*, the city of Florence was the center of the political, financial, and – more importantly – artistic life of the Christian West. Unlike its imperial predecessor, this more modern hegemony was due to neither the efficiency of an authoritarian administration nor a military power. The preeminence of Florence was based on the almost miraculous vibrancy, inventiveness, and creative energy of a closely knit mercantile community whose innovations and accomplishments went on to bear fruit ever further beyond the city's borders and to transform early modern Europe with ideas, processes, and products.

By the beginning of the seventeenth century, however, other forces and circumstances spelled decline. This downward spiral continued uninterrupted through a long-lived Medici grand-ducal dynasty and finally ended with the incorporation of the independent Tuscan state into the nascent Italian nation in 1861. It was during the decades following unification that Florence lived its last moment on the world stage. As if preserved in amber, the art-filled city was "rediscovered" by an international coterie of late Romantic artists, writers, poets, and scholars as well as the wealthy aesthetes who thrived in their company. Waves of the European, Russian, and American upper-crust settled in the palaces and villas in which Florence abounds, imbuing

the city with an avant-garde, cosmopolitan character far beyond its status as a now-minor peripheral center.

The infatuation of the cultured and worldly with all things Florentine came to an abrupt end with the Second World War. The Renaissance was suddenly no longer *dans le vent*. Villas and palaces were reclaimed from the international elite by an emerging Italian entrepreneurial class enriched during the post-war *miracolo economico*, and the city slowly returned to its comfortable provincial existence, characterized principally by the hordes of tourists that incessantly besiege it.

Not surprisingly, over the last century a number of attempts have been made by city worthies to refresh and update Florence's image. The first and most memorable was the completion of the Central Station in the mid-1920s, an architectural design still universally regarded as one of the last century's most significant. In 1972, a magnificent display of Henry Moore's sculpture on the grounds of the Belvedere Fortress, overlooking Florence, rightly caught the world's attention. Unfortunately, these exceptions did little to outweigh the decidedly melancholy results of countless other cultural projects meant to have "contemporary relevance." The most disastrous – and unfortunately lasting – was the reconstruction of the ancient area around the Ponte Vecchio destroyed during the German retreat in July 1944. The supposedly "modern" idiom of these buildings is simply an abhorrent compromise, timid and now irreparably dated. A more ephemeral event (let us hope) in this curriculum of "back to the future" undertakings is the recent warm welcome bestowed by the city on a Jeff Koons concoction. A knock-off of Bernini's masterpiece, Koons's *Pluto and Proserpina*, a shiny bauble of a bilious iridescent gold/green now occupies space, front-and-center, among the likes of Ammannati, Donatello, and Bandinelli, in Florence's hal-

lowed municipal square. The mayor obligingly presented the artist with the keys to the city, and the happy event was pictured in the local press (with, inevitably, an even happier art dealer looking on). Henry James, who knew about such things, would have observed: "worse than provincial ... parochial."

Thankfully, in the midst of this prevailing and continuing cultural stagnation, Florentines have now, finally, something about which they can boast: the completion of a museum complex that is truly exemplary for the rigor with which its architectural, historical, and artistic guidelines were determined and executed, while at the same time conceding nothing, in these disciplines, to *du jour* fashions. This new and essential destination for any visitor to Florence is the Museo dell'Opera del Duomo, hidden behind a handsome sixteenth-century façade, directly at the rear of the cathedral's apse. (A selection of masterworks from the Museo dell'Opera shown in New York at the Museum of Biblical Art, "Sculpture in the Age of Donatello," was reviewed in *The New Criterion* of May 2015.) Founded in 1891 in a rambling series of spaces, the Museo dell'Opera served at first essentially as a warehouse for sculptures and works of art pertaining to the cathedral that were previously dispersed in various church and state institutions. In the past one hundred and twenty-five years, this vast trove of material has been displayed in a progressively more adequate museological arrangement. But despite a partial reconstruction a few years ago, the museum was without a director, and had to count on a small ad hoc staff and only a paltry smattering of visitors.

The Museo dell'Opera del Duomo, while "new" in so many significant and exciting ways, is actually part of an ancient secular foundation – the "Opera" or "works" – one of the city's foremost, though little known, institutions. It

was established by the Republic of Florence in 1296 to over-see the construction of a new cathedral to replace the church of Santa Reparata, dating to Carolingian times. The grandi-ose project was put under the direction of Arnolfo di Cam-bio (1240–1310) and took the name Santa Maria del Fiore to commemorate the lily, symbol of the city. Arnolfo's initial plan, though ambitious, was to be expanded still further by Francesco Talenti (*ca.* 1300–60). From the start, the Opera del Duomo incorporated the venerable and magnificent Baptistery, built two centuries earlier between 1059 and 1128. Eventually, it also assumed responsibility for raising, on Giotto's design, the majestic Campanile (the bell tower) in the years 1334 to 1359.

The surpassing achievement of the Opera del Duomo came in the early fifteenth century when, in 1420, it directed the forty-three-year-old genius Filippo Brunelleschi to under-take the covering of the gigantic void at the end of the cathe-dral's nave with a dome. This would become the defining engineering and architectural project of the early Renais-sance and remains to this day one of the world's great won-ders. In those same years, the Opera continued the huge ongoing task of decorating the exterior of both the Duomo and the Campanile with an elaborate marble revetment echoing the lavish pre-existing exterior of the Baptistery. The last and most ambitious chapter of this grand artistic program was to be the Duomo's soaring façade. Italy's pre-eminent sculptors – among them Donatello, Nanni di Banco, Luca della Robbia, and Andrea Pisano – were com-missioned to provide monumental in-the-round figures and reliefs to fill all manner of niches and tympanums. Finally, the ancient Baptistery was completed with three sets of bronze doors: the heroic size of the façade marbles would now be matched by these unprecedented feats of metal cast-ing and chasing. What the Opera achieved in the Duomo,

Campanile, and Baptistery was nothing short of a miraculous *Gesamtkunstwerk* that held the promise of the European Renaissance and then became its wellspring.

The Opera del Duomo has remained the faithful steward 73 and guardian of this immense patrimony for more than seven centuries. Governed by a board of seven lay *operai* (workers), the Opera is a thoroughly secular institution despite the fact that the shrines in its charge are religious. Florentines still consider the spaces of the Duomo complex essentially public forums where important civic events as well as liturgical functions have forever been equally at home. No one can miss, in the nave of the Duomo, the two huge cenotaph frescos (by Paolo Uccello and Andrea del Castagno) commemorating *condottieri* who fought for the Republic. Also, it was on the threshold of the cathedral's Sacristy that the cathartic political crime of the fifteenth century occurred: the brutal murder in 1478 of the dashing Giuliano de' Medici at the hands of the "Pazzi conspirators."

Naturally, integral to the very first plans of Arnolfo di Cambio for the new cathedral was the façade, the temple's triumphal gateway. The three entrances were to be surrounded by niches, friezes, and aediculae, all studded with sculptures and reliefs matching the sumptuous design of the nearby Baptistery and Campanile. Work on many of these important commissions continued, some into the fifteenth century. A number of pieces were even installed in the lower portion of the majestic façade. But then the entire project came to a halt, possibly as a result of two simultaneous calamities suffered by the city: a financial meltdown of two prominent banking and trading families, the Peruzzi and Bardi, just as the plague of 1348–50 was taking its deadly toll of almost half the population. A famous drawing by Bernardino Poccetti shows the partially finished Gothic façade in the mid-sixteenth century. Finally, in 1587, Grand

Duke Francesco I decided to start again from scratch, hoping to bequeath to the Duomo a grand, High Renaissance front.

Unfortunately, for more than two centuries and through several unrealized projects, Florentines had to endure the sight of their cathedral with a façade of crude, raw brick. At last, after the unification of Italy in the 1860s and a high-profile competition followed by endless controversy, the Opera del Duomo commissioned what millions of tourists admire today, probably unaware that it is an elaborate – but effective – Gothic fiction. Meanwhile, the tons of precious sculptural and architectural material that survived the Duomo's vicissitudes were safely, if somewhat haphazardly, stored in what would become the Museo dell'Opera. Included among these treasures are the two magnificent *cantorie* (choir balconies), which originally overlooked the main altar. Also mercifully preserved is the series of splendid bas-reliefs by Baccio Bandinelli that decorated the sanctuary enclosure until it was wantonly dismantled in 1842.

The twentieth century brought some order in the display of the Museo dell'Opera's holdings as well as further important additions. These were occasioned by the realization that the modern urban environment was causing rapidly increasing decay to countless irreplaceable exterior works of art in marble and bronze. This was brought dramatically to the world's attention when, in November of 1966, the river Arno breached its banks causing a calamitous city-wide flood. As the waters receded, parts of Ghiberti's miraculous Baptistery "Door of Paradise" were found dented and wallowing in the mud. It was one of the most painful wounds suffered by the city in its millennial history. The Opera del Duomo, already engaged in conservation, accelerated its program of removing original pieces and replacing them with copies.

The reality that the Museo dell'Opera's premises were no longer adequate to its mission had long been all too evi-

dent to the *operai del Duomo*, the Diocese of Florence, and the institution's infrequent visitors. About five years ago, the Opera foundation embarked on an epochal project to double its exhibition spaces and, essentially, re-invent itself. This was, in part, spurred by various adjacent buildings fortuitously becoming available in the cramped confines of central Florence. As any prudent board of trustees would do, the *operai* devised a detailed financial plan and engaged a number of eminent scholars and architects as advisers. Perhaps divine providence intervened with the presence in Florence of Timothy Verdon, a native of New Jersey who had lived in Italy since obtaining his doctorate in art history at Yale in 1975. In 1994, Verdon became a priest and eventually, as Monsignor, a Canon of the Cathedral. Clearly, the Opera del Duomo had no better qualified candidate to become the first director of its museum. Under Monsignor Verdon's stewardship, the Opera's carefully laid plans were executed in less than two years – virtually a record for such projects, particularly those never-ending ones run by the Italian state.

The centerpiece of the new installation is a soaring, light-filled hall, one wall of which recreates with dramatic immediacy how the unfinished Arnolfo di Cambio façade appeared before being dismantled. Some of the original sculptures have reclaimed their place and can now, for the first time in centuries, be seen as the artists intended. Several of the most significant – among them the arresting effigy of Boniface VIII and the *Madonna of the Glass Eyes*, both by Arnolfo – have only their reproductions high on the façade while the originals can be viewed at closer range. Directly opposite, in almost shocking proximity, are the two original Baptistery doors by Ghiberti: the earlier "north" door and the later, more celebrated "Door of Paradise." A third space is now fitted with a full-size photo reproduction

of Andrea Pisano's "south" door. In due course that door, too, will be removed from the Baptistery, restored, and placed in its allotted niche in the Museo. The lofty space is surrounded on three sides by two levels of galleries that cleverly allow views along significant sight-lines pointing to distinct areas: one devoted to the Campanile and its sculptural reliefs, the next to the great Brunelleschi Cupola, its models and engineering principles, then a level above, to the later projects for the façade.

Earlier visitors to the museum will recognize a number of galleries that, quite judiciously, have been only refreshed and updated. The largest and most familiar is the hall with the two *cantorie*, one by Donatello, the other by Luca della Robbia; each in its own very different but eloquent language celebrates the beauty and joy of childhood. A passage leads to a small octagonal space that recalls the cathedral's original octagonal sanctuary enclosure with the powerful, Michelangelesque reliefs by Baccio Bandinelli. Twenty-four of these masterpieces of Mannerist sculptures now encircle the room. From here, it's a step to another, larger, gallery with what are possibly the museum's most astonishing objects: the massive silver altar and cross that weigh a total of more than five hundred pounds and were exhibited once a year in the Baptistery on the feast day of John the Baptist, the city's patron saint. Work on these supreme examples of the goldsmith's art was begun in 1366 and lasted for several generations with the result that, in their sculptural and decorative elements, they reflect, as few other examples of Florentine art, the transition from the Gothic to the Renaissance idiom.

Unlike in other museums, one finds oneself surrounded here by only things Florentine, in every art form and of every epoch, and spanning the full range of human conditions, emotions, and attitudes, from the overwrought pathos of Donatello's harrowing *Magdalene* to the com-

posed thoughtfulness of Bernardo Daddi's erudite *Madonna of the Magnificat*. The one non-Florentine "visitor" is Michelangelo's late *Pietà* that the sculptor created in Rome for his tomb and that was only brought to Florence in 1674. After two different and unremarkable previous installations in the Duomo, the overpoweringly expressive sculpture now occupies an intimate space on the ground floor of the museum. As a work by the greatest of Florentine artists, it is finally in appropriate proximity to what is, without question, the densest and most satisfying compendium of figurative episodes bearing the stamp of the city's creative genius. Not even the storied Florentine works of the Bargello evoke such a palpable and coherent sense of *place*. More importantly perhaps, the masterworks of the Museo dell'Opera, as they now appear in their new arrangement, tell yet another story. It is the glorious epic of Christian faith recounted in compelling visual terms: from the heroic prophetic words and events of the Old Testament, through the life and works of the Redeemer, to the Living Church, its saints and miracles. Thus considered, the Museo dell'Opera can justly be called the "soul of Florence."

Happily, Monsignor Verdon, his architects, and his curators have avoided breaking the spell by over-designing the exhibits and cluttering them with the sort of audio-visual gimmicks that some museum professionals find irresistible but serve only to distract. In the larger galleries there is an abundance of natural light and even the piped-in ancient music, while mildly annoying, is tolerable. The paintings – and there are some magnificent early "gold-ground" panels – hang in each other's company with due regard to chronological and thematic relationships. The "main event" – the spectacularly recreated "Arnolfo façade" – has been unjustly criticized for being too stagey. But how else to display the foremost sculptural and architectural undertaking of early

modern times? Truly unfortunate, however, is the inability to get closer to the monumental in-the-round groups that once were placed, and are now again, atop the Baptistery's three doors; the earliest of them (1506–11), by Francesco Rustici, is an unsurpassed masterwork of bronze casting and chasing. Still, they had been even less visible as originally installed, and they are now at least protected from the elements.

The last chapter of the Duomo's story – the completion of the façade in the early 1880s – is treated as more than just a footnote in the new Museo dell'Opera. Several galleries on the topmost floor are dedicated to the fascinating succession of proposals submitted and the polemics they engendered. In a final "Florentine flourish," the visitor is prompted to ascend several short steps to an expansive terrace. From here – as probably nowhere else in the city – the view of Brunelleschi's Cupola is heart-stopping. Standing there, in its overpowering shadow, one feels dwarfed not only by the structure's sheer size, but also by the genius who, over five hundred years ago, had the temerity to attempt such a feat.

March 2016

On the museum's new Greek & Roman galleries.

WITH THE REOPENING of the Metropolitan's Greek and Roman galleries, the Great Hall of this museum has become a compelling visual metaphor for the Mediterranean. Entering Richard Morris Hunt's grandiloquent space is now not only a progress into the museum, but an introduction to the geographical center of where the art and culture of the West began: turn right and you are in dynastic Egypt; straight ahead and Byzantium is transformed into early medieval Europe; and on the left, mysterious little Neolithic and Cycladic figurines herald the start of it all – in the eastern Mediterranean.

Hunt was a decidedly better stylist when working with the Gothic and even Baroque vocabularies than that of the classical age. The Met's Great Hall of 1902, with its huge, oppressive arches sitting on their stubby pilasters, gives the impression of having somehow sunk deep into the ground. Manipulating the same style, Charles Follen McKim had a much surer hand: those New Yorkers fortunate to remember the old Pennsylvania Station will know about truly imperial proportions. That same deft sensibility was engaged by McKim when he was called by the museum to plan the extensions that were grafted onto Hunt's central hub in 1911. The museum's Greek and Roman holdings have been housed in the southern wing of that expansion ever since.

Occupying a substantial portion of the building's footprint, the classical galleries essentially comprise a long,

axial corridor with lateral rooms leading to a large rectangular peristyle court, opening, on two sides, to further rooms. Although the court serves as the focal point of the design, it is the exceptional proportions of the soaring corridor with its splendid coffered vault that control what surrounds and follows it. Many of the Greek rooms were renovated in the 1990s. The renovation of the Roman Court, which opened on April 20, completes the museum's master redesign of its Greek and Roman Galleries. It is, indeed, a dramatic reinvention: born in 1916 as the atrium of a mock-Pompeian villa, the court served for years as a deco-delight dining facility. The new design is intelligently planned and skillfully executed, subtly suggesting a Roman interior without imitating it. Above all, substantial new exhibition space has been created by reclaiming part of a mezzanine and four rooms on the second floor. As one enters off the Great Hall, the now complete container is airy, light-filled, and inviting – noble without being pompous.

Carlos Picón, for more than fifteen years curator of Greek and Roman art, was given the daunting task of filling the new space in a way that would be both historically coherent and pleasing to the eye. Complicating the curator's task was the fact that most archaeological objects have survived only as fragments; they derive from contexts that are often difficult to identify and are only very rarely attributable to a specific artist: aspects not particularly appealing to a younger, contemporary generation of visitors obsessed by names on labels, whether on museum walls or on their handbag or loafers. Moreover, dating can be uncertain, not only because the stylistic/historical record is incomplete, but also due to the widespread practice in the classical world of copying and reproducing prototypes, often on varying scales, and for extended periods of time. As a result, the concept of originality as it later emerged in Western culture is hardly appli-

cable. Nor are the sometimes brilliant "restorations" – more like reconstructions – performed on antique sculptures in the eighteen and nineteenth centuries.

Picón has come to grips with these "philological" issues and has managed to arrange and display the Metropolitan's vast collection so that the chronological, geographical, and typological connotations of the material can be easily understood. An already remarkable achievement. Beyond this, and more significant for the typical visitor, he has chosen placements and juxtapositions that dramatically highlight the purely aesthetic value of certain objects. Picón's solutions are, therefore, simultaneously modern in adhering to the careful precepts of art history and old-fashioned in not overlooking the occasional opportunity to add drama and romance to the staging. It is an undeniably successful compromise that, as with all compromises, will probably not please everyone. There will, however, be unanimous agreement that the new galleries should be considered a model of contemporary museology. They represent very much the last word – every bit as much for our time, as the display arranged by Picón's famous predecessor, Gisela Richter, in these same rooms in 1926, or the 1950s design for the Villa Giulia museum in Rome, were for theirs. Classical art is so intimately woven into our collective cultural fabric that we will keep "reinventing" it for as long as we remain aware of our Western identity.

A consideration that has been made in the past and that should be recalled in this context is that the philosophy, literature, and mythology of the ancient world survived remarkably well despite the advent of Christianity; the Benedictines, among others, saw to that. It was the art that disappeared, most of it buried underground. And what remained visible of the ruined cities and monuments was, for centuries, simply ignored or quarried for re-use. It's as if

the wonders about which Pausanias, Pliny the Elder, and Vitruvius wrote were part of a mythical past, a past that lived on only in its ethical and political connotations, to be, on occasion, revived, as during the so-called "Carolingian Renaissance." The visible past did not begin to be recognized and valued until about 1400.

Vasari tells the wonderful story of Donatello describing to Brunelleschi a fine ancient relief which he had admired in Cortona, about fifty miles south of Florence. This account so fiercely kindled Brunelleschi's curiosity that he instantly set off on foot to sketch it. By chance, the object of such attention and admiration still exists. It is now in the Museo Diocesano of Cortona – a Roman second-century sarcophagus of, at best, modest quality. The year was 1407; Donatello and Brunelleschi, were, of course, the giants of the first generation of Renaissance artists. With them, the reappraisal and rediscovery of the art of antiquity had begun in earnest – first in Florence, and, within a century, conditioning the creative consciousness of the whole of Europe.

By the late 1480s, Lorenzo de' Medici had already amassed an impressive and varied assortment of antique engraved gems and marble reliefs. It was in Rome, however, that classical art revealed itself in the full panoply of its marvels. After all, the Pantheon was there, in the middle of the city, with a stupendous cupola still intact. With a torch in hand, one could wander into the myriad rooms of Nero's Domus Aurea – now silted up nearly to the ceilings – and admire the exotic and delightful first-century stucco and painted decorations. As popes and cardinals built palaces, villas, and churches, the ground began to yield an ever more bountiful crop of wondrous surprises. The so-called Torso Belvedere, having already surfaced by 1450, became the virtual symbol of the antique once it took its place in the vast

Belvedere Court of the Vatican. This remarkable structure, itself a paraphrase of Trajan's Baths, was designed expressly by Bramante as the first large-scale repository of classical art. In 1506, the sensational rediscovery of the *Laocoön* quickened the pulse of an entire generation of Renaissance painters and sculptors, Michelangelo foremost among them. By the second half of the sixteenth century, virtually every major monument – the Apollo Belvedere, the Farnese Hercules, the Medici Venus, and countless others in every medium were already accessible, most in the Vatican. The Vatican today still houses the world's densest concentration of antique art.

The Enlightenment fostered new pursuits and desires: to explore, to learn, and to classify. It was the birth of archaeology. What fueled the emerging discipline's initial surge were two totally fortuitous finds: Herculaneum in 1707 and Pompeii in 1748, in the shadow of Vesuvius, the volcano that destroyed both cities in the cataclysmic eruption of 79 A.D.

By the mid-eighteenth century, Naples had been free of Spanish vice-regal domination for decades. Under the rule of its Bourbon monarch, Charles VII, it had blossomed into a thriving, cosmopolitan European capital. Charles was a true Enlightenment prince. The discovery of the two buried cities presented a unique opportunity for the advancement of knowledge: soon the search and recovery operations progressed in a reasonably systematic way under royal supervision. The sites became an obligatory destination for every European savant, among them Johann Joachim Winckelmann and Johann Wolfgang von Goethe. Sir William Douglas Hamilton happened to be British envoy in Naples from 1764 to 1800. He was an erudite and tireless collector, a true dilettante, utterly devoted to his studies, not only of the

past but also of natural phenomenon, Vesuvius among them. With the publication of Hamilton's collection and its subsequent sale to the British Museum, momentum to discover and acquire as much of the classical past as possible increased dramatically. Through Hamilton's purchase of it in Naples, the so-called "Portland Vase" came to England, inspiring Josiah Wedgwood to imitate its delicate cameo glass relief in porcelain. In Rome, meanwhile, the German artist Anton Raphael Mengs was developing an approach to painting that moved radically away from the brushwork flourishes characteristic of the Rococo style of near contemporaries such as Subleyras and Tiepolo. The measured equilibrium and tight execution of Mengs's compositions exerted a powerful influence on the young Jacques-Louis David who, in 1784, painted *The Oath of the Horatii*, considered the ur-icon of European Neo-Classicism.

More direct knowledge of the art of Greece had to wait until its emancipation from the Ottoman yoke in the late 1820s. This did not, however, occur in time to prevent the Parthenon marbles from migrating to England and eventually joining Hamilton's more modest trophies in the British Museum. Archaeology's horizons were widening, encompassing by the mid-nineteenth century much of the eastern Mediterranean. Chronological boundaries were expanding as well. The pre-Hellenic past revealed itself in the Cycladic, Mycenaean, and Minoan cultures, with origins far more ancient than had ever been imagined. At the other end of the time-spectrum, the varied and exuberant manifestations of later Hellenistic art were coming into sharper focus, particularly in Asia Minor. In 1887, the world learned about the discovery of what may be the most astonishing example of classical art ever unearthed: a huge, marble sarcophagus with figures and decorations exquisitely carved in high relief that was instantly dubbed the "Sarcophagus of Alexander."

Unearthed, together with other treasures near Sayda in modern Lebanon, it is now the supreme jewel of Istanbul's Archaeological Museum. The great fourth-century B.C. monument is no longer thought to have contained the remains of the Macedonian hero, but those of one of the satraps who continued Alexandrine rule in the area.

The twentieth century, thanks to the ever more refined tools and methods of modern archaeology, has seen its own share of sensational discoveries, adding immeasurably to our understanding of the classical world. One needs to recall only three examples to gauge the breadth of the progress: the "Riace Bronzes," Greek masterpieces of the fifth century B.C., recovered from the Adriatic Sea off the coast of Calabria in 1972; the magnificent treasures of the Macedonian kings found in their undisturbed burials in Vergina, near Thessalonika about five years later; and the "Ara Pacis Augustae," an unsurpassed example of Roman early Imperial art, reassembled near the Tiber in the late 1930s.

What has been collected and so skillfully displayed in the new galleries at the Metropolitan can be said to mark the latest installment of how the West reclaimed the visual heritage of its classical past over the last six centuries. The museum certainly cannot lay claim to having played a principal role in that story, even though among its first purchases, in the early 1870s, was the monumental eighth-century B.C. "Cesnola Krater" that is still regarded as one of the world's most important ceramics in the geometric style.

Nevertheless, moments of sheer delight and wonder await one when following even a rapid and random itinerary through the new galleries. For instance, four unprepossessing silver and electrum vessels, arranged with other Cycladic material, can claim affinity with one of the first and most memorable early chapters of modern archaeology: the excavations at Troy (the modern Hissarlik in Turkey) conducted

in the 1880s by Heinrich Schliemann, the Homer-obsessed German dry-goods merchant. His spectacular finds actually turned out to date to more than a thousand years earlier than the events recounted in the Homeric epics.

The Cesnola Krater finds itself in the company of three additional and equally monumental geometric vases. Together, they comprise a group unequaled anywhere. Vase painting evolved rapidly during the next two centuries, and reached what is considered its zenith at the turn of the fifth century B.C., in the work of artists such as Euphronius and the so-called Berlin Painter. Two fine and large examples of this latter impeccable draughtsman are in the collection, one given in honor of Dietrich von Bothmer, Carlos Picón's immediate predecessor, and rightly considered the unchallenged authority on Greek vase painting. But, for sheer perfection and exceptional conservation, one might do well to seek out a much smaller and somewhat earlier amphora attributed to the Amasios Painter. Depicting two moments in the fitting-out of a young athlete or warrior, it is a paragon of Attic pictorial art and technical proficiency. And for those who off-handedly dismiss the art of the Greek vase as an interminably repeated one-note exercise, a black-glazed fourth-century B.C. hydra on private loan will come as a refreshing surprise: the slender and delicately fluted body is entirely devoid of decoration. The top tapers gently at the neck – a neck around which is hung a light-colored chain, intricately worked in low relief: an anthropomorphic, and totally feminine, metaphor – with its original lid still in place!

Despite the artistic and historical significance of ceramics, the main event of classical art (ever since Brunelleschi's hasty excursion to Cortona) has unquestionably been sculpture in marble. Many of the celebrated prototypes by the Greek masters of the fifth, fourth, and third centuries B.C. are still known only through Roman copies, although a small

number of precious, earlier originals have come to light in modern excavations. One, an impressive and very significant striding kouros figure from *ca.* 590 B.C., dominates its surroundings by the noble simplicity of its anatomy, rendered with the greatest economy and subtlety. Hard to imagine, but the anonymous sculptor who fashioned this vibrant form lived well over a century before the tympanum of the Parthenon was begun!

It has been noted in the past that the principal obstacle to the full appreciation of Greek sculpture is surface. We may easily accept the fact that a statue or relief survives in a fragmentary state; what is so aesthetically disturbing is that the flesh and drapery that we see today are invariably worn and leached. Sculpture is, after all, a combination of form and surface. That is why, when we encounter, in a corner of the new court, a second-century A.D. Roman portrait bust of Lucius Verus, we are both startled and gratified. Here is a work of consummate craftsmanship but not of particularly lofty inspiration; what is so surprising, and utterly satisfying, is that the marble has come down to us virtually intact and with an exceptional surface; the word patina would be appropriate in this context, had it not, of late, become somewhat suspect. It comes as no surprise to learn that the bust has enjoyed a long history in the French royal collections (it is now a welcome, and, one hopes, long-term, loan from the Louvre).

It is in works in bronze and other metals that the eye finds those tactile qualities so conspicuously missing in marble. The hand of the artist can be far better perceived in the chasing and detailing that seem to survive so miraculously, even after centuries under ground or under water. Take the astonishing bronze first-century A.D. *Head of a Sacred Bull*, on loan from the Fondation Gianadda in Switzerland; or the pair of similarly dated silver-gilt scyphy

(cups): works on wildly differing scales, but with equally interesting surfaces wherein is revealed, in all its brilliance, the handwork of the artist: cutting, punching, filing, and polishing. A veritable tour-de-force of bronze craftsmanship is the set of three similarly designed plaques, each showing, in high relief, a grotesque mask surrounded by a vortex of rhythmically curled hair. The vigor and exuberance of these objects is almost shocking. Probably meant as handle attachments, their origin and dating still remains somewhat uncertain.

We can be grateful to Carlos Picón for having gathered a particularly rich assortment of bronze sculptures in the round; a few of the best, however, are on loan. Considering the great rarity of such objects, we are equally grateful to the lenders. Although measuring a scant few inches, the *Portrait Head of Ptolemy of Mauretania* is a riveting likeness of the grandson of Anthony and Cleopatra as a young boy. The gravity of his expression is troubling; obviously, the weight of royal inheritance did not fall easily on young shoulders in the first century A.D.

The nearly contemporary but slightly larger *Portrait of a Roman Matron* is no less incisive. The intricacy of her hair is masterfully rendered, with a chasing of which Cellini would have been envious. Possibly the greatest rarity on display is a pair of Hellenistic statuettes of Pan in similar, but not identical, poses. The great vitality of unbridled movement brilliantly suggests the music to which the figures respond. Again, the finish and surface qualities are beyond description.

Alas, the two bronze male figures on a monumental scale – standing nude portraits of Attalos II and Trebonianus Gallus – hardly compare to their diminutive companions. Though undeniably of great importance, they appear to have been created as pro forma props in the deco-

rative program of a public building – propaganda art of the classical age, and definitely not on the level of other large-scale Roman bronzes that have survived.

Fitted somewhat uncomfortably in the large hall to the east of the court are two precious souvenirs of the event which gave archaeology its start: the discovery of Pompeii and Herculaneum. The small rooms from two late first-century B.C. villas that were sited slightly higher on the slopes of Vesuvius take their name from the modern localities: Boscoreale and Boscotrecase. Not excavated until the early twentieth century, the chambers retain most of their original fresco decoration in a remarkably fine state. Although nearly contemporary and of equally high quality, the two rooms could not be more different: a fanciful progression of architectural and landscape vistas unfurls, with no particular connective sequence, behind a fictive colonnade on the Boscoreale walls. The artist exercises total freedom, inserting random anecdotes, such as the enchanting fruit still life in a glass bowl or the group of birds chirping to each other across a rocky divide. The elaborate townscape that opens the left wall with its colorful helter-skelter of loggias, terraces, doors, and windows immediately calls to mind the similarly imagined city in Ambrogio Lorenzetti's famous *Good Government* fresco in Siena. The fact that the two images are separated by thirteen hundred years and could not conceivably be related stylistically should prompt some interesting thoughts on the mysterious workings of the human imagination. The Boscotrecase room, by contrast, is of a chaste elegance that would have pleased Syrie Maugham – and probably did. One also needs to imagine it as it may have originally appeared: the smooth black surfaces left gleaming after an elaborate process of encaustic polishing, the color thus acquiring remarkable saturation and intensity.

A legitimate question arises after having visited, even

briefly, the newly dedicated Greek and Roman Galleries. Does the Metropolitan Museum's collection, as it is now displayed, give a reasonable account of the art of our classical past? The answer must certainly be in the affirmative. It is, of course not remotely a complete account, no more than can the paintings one admires in the first four galleries, upstairs, fully encompass the Italian Renaissance. Moreover, in both areas, the chances of further major acquisitions are becoming ever slimmer. We must, therefore, be content with the thought that the Metropolitan, in the roughly century and a quarter of its existence, has worked patiently and wisely, becoming, today, by far the most distinguished and encyclopedic repository of the world's art in the Americas.

Naturally, there have been some missteps in the past, of which the purchase and display (until the mid-1940s) of three huge, and hugely grotesque, Etruscan terracotta warriors, was surely the most embarrassing. Another faux pas occurred in the 1960s when the bronze prancing horse revered since its purchase in 1926 as a masterpiece of Greek second-century B.C. sculpture came under suspicion of being a forgery. That story, fortunately, has had a happy ending: the rare and beautiful statuette now, again, commands its due attention. But such is the process of acquiring knowledge and perspective, ongoing and ever deepening, in an institution such as the Metropolitan. The new galleries are simply the last manifestation of this evolution.

June 2007

On the newly renovated Wadsworth Atheneum.

IT IS DIFFICULT, when visiting Hartford today, to imagine that at the end of the nineteenth century this was one of the richest cities – per capita, *the* richest – in America. Samuel Colt and the manufacturing innovations that he and his contemporaries pioneered beginning in the 1840s fueled a remarkable prosperity that inevitably led to the success of merchandising enterprises such as G. Fox & Co. and Brown Thompson. The proud stores they built (designed by the likes of Cass Gilbert and H. H. Richardson), as well as parts of the Colt factory (whose blue onion dome is familiar to drivers on I-91) still exist and fortunately are protected landmarks, but they are now either partially shuttered or serve much-diminished functions, generating a fraction of the wealth they once produced.

Hartford is, in fact, a prototypical and depressing example of the decline that so many mid-size American cities experienced in the decades following the Second World War. Unlike Boston or New York, whose structural fabrics had sufficiently consolidated, these smaller centers were unable to resist the mindless highway construction that sliced through their urban cores and accelerated the headlong rush to suburbia. In Hartford, a population that numbered almost 180,000 in 1950 is now diminished by nearly one-third. The drop in per capita income has been even more dramatic. When and how this erosion may eventually be reversed is still being debated. There are encouraging signs, however.

One of the more conspicuous was on full view this September when the Wadsworth Atheneum – which claims to be America's oldest continually operating public art museum, founded in 1842 – unveiled its most ambitious project in decades. Although the focus was principally on the Morgan Memorial Building, the goal was also to integrate more rationally the institution's four other interconnecting elements, as disparate as the original Gothic Revival crenellated castle (1844) and the superb Avery Memorial (1934) with America's first International Style interior.

The deficiencies, both structural and functional, of the Atheneum complex had become so evident that planning for a major restructuring began fifteen years ago. The option of demolishing a 1960s wing and replacing it with a "bigger and better" building – preferably by a fashionable "name" architect – was seriously considered. It is a solution that so many other American museums have adopted and has so often led to such distressing results. It's fortunate that, by 2003, the museum's board prudently discarded it. Since then, with thoughtful rearrangement and careful redesign of existing spaces, hundreds of square feet have been reclaimed, allowing curators to exhibit a larger percentage of the more than fifty thousand items in the museum's collections.

The handsome Morgan Memorial Building was completed in 1915 in a rather chaste Spanish Renaissance style two years after the financier's death. Although J. P. was born in Hartford and received his early schooling there, his and his family's connection to the city remained tenuous. Despite this, the new building was endowed not only with a significant grant to complete it, but also with an important segment of Morgan's vast universe of collections: the European porcelains. This is still considered to be by far the most distinguished and complete representation of this art form in America.

A central and commanding feature of the Morgan Building is a Great Hall around which are arranged, on two levels, various smaller galleries. It is the kind of grand, classically inspired space that was a fixture in virtually all public buildings at the beginning of the last century; ideal, perhaps, for installing cavalcades of armored knights or for hanging tapestries, but impractical for much else. In the mid-1980s, Gregory Hedberg, a young, perceptive curator, alighted in Hartford fresh from a stint at the Minneapolis Institute of Arts. He found the Great Hall's soaring twenty-six-foot walls boringly whitewashed and hung, even more boringly, with large, dusky Trumbull portraits. Hedberg brilliantly reinvented the Great Hall as a princely European "picture gallery," the kind that was familiar to generations of visitors to Palazzo Pitti, Schloss Pommersfelden, the country seats of English lords, and countless other European noble residences. Here, the grand acquisitors of the seventeenth through the nineteenth centuries arrayed their real or imagined masterpieces cheek-by-jowl, in row upon row, generally on lush, colored silk wall coverings. Hedberg recreated this opulent setting, taking advantage of the particularly rich stock of Baroque and eighteenth-century works that are the bountiful legacy of a former director, A. Everett Austin (1900–57).

The story of Austin, universally known as "Chick," represents a capital chapter in the history of the Wadsworth Atheneum. Even as an undergraduate at Harvard, Austin delved headlong into the arts, first as an aspiring archaeologist and then, under the influence of the legendary Paul Sachs, as assistant to the Director of the Fogg Art Museum. Ruggedly handsome and dashing, he also married well: to a scion of Hartford aristocracy connected to, among others, J. P. Morgan. Appointed Director of the Wadsworth when he was barely twenty-six, Austin's career there spanned just

twenty years, not an unusually long tenure, yet his accomplishments read as an incredible litany of "firsts," and not only in the visual arts. Today, when these names are part of our fundamental cultural vocabulary, it is astonishing to discover that Austin set the stage at the Wadsworth for the first Balanchine/Kirstein ballet and premiered Gertrude Stein and Virgil Thomson's *Four Saints in Three Acts* (1928), the first American opera with an all-black cast. He mounted the first comprehensive Picasso exhibit; hung in 1936 the first Mondrian to be shown in an American museum, barely a year after it was painted; incorporated into the Wadsworth the first theater/auditorium in a museum; the list goes on.

Perhaps even more daring for its time than the Mondrian purchase was Austin's acquiring the first Caravaggio to come to these shores. In fact, Italian Baroque painting was, even as late as the 1930s, an unusual collecting pursuit in America; the often overtly Catholic iconography of the art as well as the continuing "Berensonian" taste for Early Renaissance still conditioned trustees and collectors in their choices. Austin, on the contrary, loved the theatricality, drama, and dynamism of Baroque art; after all, he lived his life as if on a stage. Even the house he and his wife Helen built in Hartford was a Palladian *folie*, an ephemeral backdrop for the many entertainments they hosted there.

A recently appointed Curator of European Art, Oliver Tostmann, young and perceptive as was Hedberg, his predecessor of the 1980s, has upped the ante in the Great Hall. It now has eighty-four paintings lining its four walls and, remarkably, approaches the sense of over-the-top Baroque exuberance so palpable in Giovanni Paolo Panini's *Picture Gallery of Cardinal Gonzaga* (1740), hanging front-and-center on the north wall. One interesting item that Tostmann brought up from the cellar and inserted into the mix is a nineteenth-century copy of Raphael's *Madonna of the Chair*

THE WADSWORTH ATHENEUM REBORN

(*ca.* 1513–14), complete with an elaborate version of the gilt frame in which it hangs at Palazzo Pitti. It is a sly *bon mot*, for if one turns to the Panini, one notices that a similar but larger format copy of the celebrated *tondo* appears to be the object of the Cardinal's attention. This speaks volumes about how copies were regarded until the early twentieth century – until, that is, the anathema of the philosopher Benedetto Croce descended on them. The color of museum walls, as every curator is aware, is a subject of never-ending debate. Suffice it to say that the blue/gray chosen for the Great Hall has an appropriate gravitas but may not convey the same sense of baroque luxe possessed by the earlier crimson.

Another innovation that may also leave some wondering is the creation (or re-creation) in an upstairs gallery of a *Wunderkammer*. It is meant to recall the pseudo- or proto-scientific pursuits of late-Renaissance princes, the most eminent of whom was Emperor Rudolph II. While aspects of such learned court enterprises produced nothing more than exotic curio-cabinets, figures such as Federico Cesi, Cassiano dal Pozzo, and Francesco Stelluti undertook serious research in botany, optics, and chemistry. They sustained and encouraged Galileo and were protected by none other than Cardinal Francesco Barberini, a nephew of Urban VIII. Cassiano was the Cardinal's secretary and, with his friends, founded the *Accademia dei Lincei*, Europe's first truly scientific confraternity. This was the same Roman environment to which Caravaggio, Poussin, Gentileschi, and Bernini, among others, looked for their patronage ... and, paradoxically, the same Counter-Reformation Rome that eventually silenced Galileo and saw Giordano Bruno die on a heretic's pyre.

Caravaggio's *Death of St. Francis* (*ca.* 1595) is not the only Italian Baroque masterpiece at the Atheneum; nearby hangs *Judith and Her Maidservant with the Head of Holofernes*

(1621–24) by Orazio Gentileschi. In this context, an overt reference to the *Wunderkammer* is perfectly appropriate, particularly since the museum's latest important acquisition is the haunting *Self-Portrait* (*ca.* 1615–18), by Artemisia, Orazio's daughter. Not only were they part of the Cardinal's "enlightened" household, but Artemisia later gravitated to the court of Cosimo II in Florence, a prince who in his short reign not only did much to advance the study of the natural sciences but was one of Galileo's staunchest protectors. It is unlikely, however, that the *Wunderkammer* conjured up here in Hartford will serve its intended art-historical purpose. As it is, with its touch-screen didactics, turtle shells, and mineral specimens, it has more the air of a children's science exhibit. Unfortunate that, with the elaborate stagecraft, one risks missing a handful of seriously important works of art, such as the exquisite and rare *Brazilian Landscape* (1656) by Frans Post, the seventeenth-century Dutch traveler to Brazil.

It's clear, as one progresses through the rearranged European galleries, that a significant new approach to exhibiting the museum's collections is afoot: a desire to "contextualize" material that was heretofore segregated typologically. This is particularly evident with the Morgan collection of European porcelains. They are of such quality, diversity, and depth that arranging these objects together in specific and coherent groups would be the conventional and art-historically correct solution. Indeed, they were so exhibited until recently. But art history and museology are as subject to fashion as hairstyles and pop music, only with slower pendulum swings. Until the 1940s the Metropolitan Museum's director Francis Henry Taylor continued that museum's tradition of presenting sculpture, paintings, and other works of art together, as long as there was some chronological or stylistic affinity: a vague "period room" approach. The great champion of this aesthetic was Wilhelm von Bode, the

hugely influential director of Berlin's Kaiser Friedrich Museum in the first quarter of the last century. In the last seventy years, however, such mixing and matching has become virtually extinct in American museums. It will be interesting to see if the Hartford Atheneum will again be – as it was in the 1920s and 1930s under Chick Austin – at the forefront of another swing of the pendulum.

The renewal of the Atheneum is still a work in progress; the refurbished Morgan Building is only the first phase of a larger undertaking. As the museum is transformed and renewed, there is hope that Hartford will, in the future, reflect with equal success its vibrant and distinguished history. Both the city and its premier cultural institution should firmly remain part of any serious New England itinerary.

October 2015

On recent renovations to the museum's European galleries.

ASK MOST KNOWLEDGEABLE museum visitors and they
would probably agree that the Kunsthistorisches Museum
in Vienna houses the world's most satisfying and brilliantly
conceived display of European Old Master paintings. By
comparison, the Metropolitan Museum's arrangement of
its own impressive holdings in the same field would until
recently have rated, at best, a polite nod. Those acknowl-
edged masterpieces so long admired in New York were
unfortunately exhibited in a confused, often irritating, part-
chronological, part-thematic, part-geographical layout that
made little sense in any of those contexts; one had to seek
out each painting and pay homage to it singly, for its own
merits. One of the marvels of Gottfried Semper's magnifi-
cent building in Vienna is that its *piano nobile* introduces
the visitor to a stately progression of Europe's great schools
of painting and acts as a steady, clear guide, invariably sug-
gesting illuminating insights and comparisons. The palatial
enfilade of galleries constitutes a totality – a *Gesamtheit* – of
design, function, and effect. As it happened, both buildings
were designed and built at about the same time and very
much in the same Beaux-Arts architectural idiom. At the
Metropolitan, Richard Morris Hunt's vision of a grand ascent
to the museum's core – the European paintings galleries –
and the subsequent deployment of these spaces in an
orderly, quasi-symmetrical pattern, was essentially no dif-
ferent from what Semper had designed in Vienna.

In New York, unfortunately, things did not work out as planned; there was, after all, no ready-made, existing paintings collection of prodigious quality and variety such as the Habsburgs had amassed over centuries. They eventually came, but slowly, unevenly, and not without difficulty or occasional controversy. In 1871, William T. Blodgett, a prosperous New Yorker who happened to be in Europe, dispatched to the infant Metropolitan a group of 174 mostly Dutch and Flemish works even before the institution opened its doors (about sixty remain in inventory today). Blodgett's "job-lot" purchase finally provided some company to the single item that the museum possessed at the time – a Roman sarcophagus.

The following century witnessed the rapid coming-of-age of the Metropolitan and a parallel growth and expansion of the European paintings collection, always intended to constitute its defining component. This intention, however, was not always so brilliantly fulfilled by successive generations of those in charge. In the late 1940s, with the munificent gifts of the great nineteenth-century merchant-princes already in hand, the Director Francis Henry Taylor and the curator Theodore "Ted" Rousseau embarked on a whimsical "contextual" disposition of the now-mature collection, mixing and matching paintings, sculptures, and furniture with results that were neither aesthetically compelling nor art-historically convincing. A number of sterling opportunities to acquire new art were missed: the *Death of Germanicus* by Poussin, an ex-Barberini picture, went to the Minneapolis Institute of Arts; the haunting *St. John the Baptist in the Wilderness*, at that time only the second work by Caravaggio to come to these shores, found its way to the Nelson-Atkins Museum in Kansas City; finally, and even more galling, the Toledo Museum of Art eagerly picked up the monumental *Crowning of St. Catherine* by Peter Paul Rubens after Ted

Rousseau judged it to be not entirely autograph. Now, every one of these works is considered an absolutely capital example of European seventeenth-century painting. Alas, Baroque art was deplorably late in being welcomed to the Metropolitan but, if this be any comfort, it was even later before the National Gallery in Washington took notice; indeed, probably too late for a Caravaggio ever to join its ranks.

Fortunately at the Metropolitan, for every miss there was a hit. In those post-war years, when so much extraordinary material became available, one super-hit came to the same church, though not exactly to the same pew: Robert Campin's *Annunciation* triptych, also known as the Merode Altarpiece. It entered the Cloisters in 1956 and is still regarded as the most significant early Flemish painting in America. Several years later, and not without some rumor as to its shadowy provenance, Georges de la Tour's *Card Players* succeeded, alone, in filling the museum's large gap in the area of earlier French painting. Soon, the Director James Rorimer added to this coup when he engineered the multi-million-dollar purchase at auction of Rembrandt's *Aristotle Contemplating the Bust of Homer*. Another, even louder, auction big-bang came about ten years later when the Metropolitan reached for Velázquez's *Portrait of Juan de Pareja*, outbidding the rest of the world thanks to Thomas Hoving's notorious flair for the superlative.

But, not surprisingly, these extraordinary purchases were, in fact, exceptions. As before, the Metropolitan continued to rely principally on its generous donor-collectors more than on the power of its endowment's purse. After all, New York was the city where many of the merchant-prince families resided and had made their fortunes. A spectacular example of this was Robert Lehman's 1969 bequest of his entire collection to the museum. The group of more than

two thousand six hundred items had been gathered by two generations of the family, over the course of nearly seven decades, in discriminating, scholarly pursuit of the finest and rarest. The range of different art forms is staggering: from medieval panels, to Renaissance drawings, to Post-Impressionist paintings with stops at El Greco, Rembrandt, and Ingres in between. Like the Campin triptych, the Lehman Collection came to rest in a slightly different pew at the Metropolitan; its own separate pavilion enclosing a weird recreation of some of the plush, Jansen-designed rooms of the Lehman mansion on Fifty-fourth Street. Perhaps this served as the unfortunate precedent for the new incarnation of the Barnes Collection on Benjamin Franklin Parkway in Philadelphia, where a similarly weird installation imitates (but not quite) the "original" hanging in Barnes's villa on the Main Line. These experiments ought never again to be repeated.

Apart from a few memorable events, the last thirty years have been a period of quiet, steady consolidation within the confines of the European paintings collection. A 1972 re-hanging under the stewardship of Sir John Pope-Hennessy significantly improved the clarity of the exhibited works in terms of their different schools and chronologies. A serious attempt was made to strengthen two notoriously weak areas: the Italian Baroque and the Venetian sixteenth century, the latter with decidedly less success, except for the acquisition of the magical *Allegory of Love* by Lorenzo Lotto in 1986. Pope-Hennessy and his pupil/successor Everett Fahy also initiated a policy of succinct, yet richly informative, labeling that is exemplary and continues to this day. The two eminent scholars, however, never seemed particularly dedicated to reaching out to the Metropolitan's larger constituency and stimulating interest in earlier European paintings ... potential younger collectors looked elsewhere.

Equally to blame, for decades the collection had been denied ten spacious galleries originally intended for its use. These had become the venue for large, temporary exhibitions, invariably described as "blockbusters" by their detractors yet essential in propelling the museum's attendance to ever higher records. A large majority of those visitors, unfortunately, found the permanent collection of European paintings at the Metropolitan simply too confusing or uninteresting. What *could* be achieved with great paintings, handsomely and intelligently arranged, became evident about eight years ago when the nineteenth-century paintings galleries were reopened after the thorough reconfiguration effected under the then-curator Gary Tinterow.

No one doubted that, sooner or later, the earlier European paintings would benefit from the same attentive care. Now we know that during these past several years a veritable reinvention of the department was in progress behind those annoying temporary partitions and closures. Born as an enlightened initiative of the former Director Philippe de Montebello, the project was brought to fruition in June thanks to the admirable energy and commitment of a host of specialists, foremost among them the curators Keith Christiansen and Andrea Bayer. As "purloined" galleries finally returned to the fold, there was a consequent increase of about one-third in the space available. With this huge benefit, the curators were allowed to rethink the disposition of the entire collection, in some cases radically altering the previous disposition of schools and periods. Even more striking is how these changes have once again – and so emphatically – reaffirmed the centrality of European painting in our Western culture. The new galleries, preceded as they are by that impossibly broad staircase, now truly preside as the core of Hunt's grand monument – at last a worthy parallel to Semper's Kunsthistorisches Museum.

The tour begins, as before, with Giovanni Battista Tiepolo sounding his unmistakable High Baroque clarion blast. Now, however, he has the expansive space all to himself: The three magnificent depictions of ancient Roman heroics from Ca' Dolfin still dominate but are now joined by various other decorative fresco panels by the master and his school. Together, they create a far more convincing *mise-en-scène* – perhaps not the ballroom of Palazzo Labia, but surely the best large-scale cycle of the artist's work this side of the Chicago Art Institute's *Rinaldo and Armida* series.

It used to be that, once energized by Tiepolo, the visitor would be met in the following large gallery by an odd mixture of mostly French Rococo and Neo-Classic portraits in no particular order – a decidedly low-energy experience. Now, the emotional tension is maintained by a stunning array of Italian seventeenth-century compositions that teem with dramatically charged gestures and expressions. The gallery is as much a display of Counter-Reformation triumphalism as it is of painting in its grandest manner: bold, self-assured, and irrepressibly extroverted. After this, things calm down as the visitor is given the choice of pursuing a "northern" (to the left) or "southern" (straight ahead) itinerary. The "southern," or Italian, path has separate Florentine and Sienese branches that develop in strict chronological order. These are the two centers in Tuscany where European painting actually began in the late thirteenth century, progressing from earlier sources in Byzantium. Both paths are joined in subsequent and adjoining rooms as the Renaissance blossomed to full maturity in the late fifteenth and early sixteenth centuries in Rome. Here one encounters for the first time a strategy employed repeatedly to great effect throughout the remaining galleries: the placement of key works in axis to sight lines that align with other significant examples of perhaps different schools or periods, but affords

valuable opportunities to discover, compare, and evaluate – yet another benefit of the physical plant's classic Beaux-Arts symmetry.

The Metropolitan has historically boasted a rich and deep inventory of Flemish and Dutch art – works from Northern Europe had always been singularly appealing to secular, mercantile New Yorkers, even before the Blodgett purchase. This significant portion of the collection is particularly well served by the newly acquired space and recent reinstallation. At the beginning of this "northern" axis, to the left of the Italian Baroque gallery, one is startled by a familiar image, now transformed. Placed prominently at center-stage is the great *Annunciation* panel from the 1917 Morgan bequest, fresh from a judicious cleaning. It now fully justifies the attribution to Hans Memling on which some doubts had been cast in the past. Together with the van Eyck *Crucifixion / Last Judgment* diptych along the same axis in the next room, these two capital works serve as the ideal introduction to the unfolding story of painting in Northern Europe. One can appreciate how the artist's eye, even at this early date, focused on landscape, architectural detail, and still life – a distant valley, a tiny leaf, or a humble wrought-iron door-latch are obsessively observed and minutely rendered.

Faces – faces of *real* people – are reproduced with similar diligence and unsparing realism. In fact, the story of Northern European art, well into the nineteenth century, is mostly about these three themes: landscape, still life, and portraiture. Now, expansive separate galleries are devoted to each of these topics with the addition, in the seventeenth century, of the *genre* subject. It is a peculiarly Dutch invention that assumed an almost mystical dimension at the hands of Johannes Vermeer.

Wisely, historical context was not forsaken in the inter-

est of aesthetics. At an appropriate interval in the galleries'
progress, a prominently placed, though not artistically com-
pelling, mid-sixteenth century triptych serves as an explicit
metaphor for the Reformation, the period's tipping-point
event. It is a large and meticulously executed representation,
by an unknown Saxon artist, of Christ giving a blessing –
the well-known *Salvator Mundi* iconography – with a family
arranged about him. The human participants of this gather-
ing, including a six-year-old youngster, peer out at the spec-
tator with austere self-aware expressions. They seem to find
it perfectly natural to share the space with their Savior. The
spiritual discourse is direct and unmediated by ritual or lit-
urgy; no doubt Luther would have approved. A man not
insensitive to worldly beauty, he might also have been
beguiled by the stunning flower still life arrayed on the
table before the group.

One of the most welcome surprises in these galleries is
the presence, after its rescue from virtual oblivion in a deco-
rative arts corridor, of the imposing *Allegory* by the so-called
"Master of the Dinteville Allegory" (this being, in fact, the
allegory in question). The huge and remarkably preserved
panel depicts, in the guise of an Old Testament episode,
members of the Dinteville family, among the most promi-
nent at the court of Francis I of France. It is, on its own mer-
its, a stunning and virtually unique paradigm of Renaissance
humanism in a northern artistic and intellectual context.
Enhancing the painting's significance is the fact that it was
originally paired with Hans Holbein's celebrated double-
portrait *The Ambassadors* (now in London), one of whose
subjects is, not coincidentally, a Dinteville.

The fact that parts of Germany and Flanders resisted the
Reformation (not without copious bloodshed) becomes
abundantly clear once the large, final "northern" gallery is
reached. In the Catholic Lowlands, where long Spanish

dominion had left its mark, two great painters received the bountiful patronage of monarchs, princes, and prelates. As young journeymen, both Peter Paul Rubens and Anthony van Dyck became acquainted with Caravaggio, Reni, and the Carracci. They easily absorbed the lessons of the Counter-Reformation in Genoa, Mantova, Rome, and as far south as Naples, eventually developing their own grandiloquent translation of the Italian Baroque. Thanks to his boundless energy and countless commissions, Rubens became an artistic satrap presiding over a palatial Antwerp residence and huge workshop. In his majestic *Self-Portrait with Helena Fourment and Son Frans*, the artist shamelessly flaunts his grandeur for all the world to admire; it is not a picture of Protestant restraint. The masterwork, once at Blenheim Palace, passed to the Rothschilds in the mid-nineteenth century and was given in 1981 to the Metropolitan by Mr. and Mrs. Charles Wrightsman, whose generosity over the decades has hugely enriched the museum, and continues to do so. The painting's relatively late arrival more than compensated New York for the loss of the *St. Catherine* to Toledo in 1950.

While the "Rubens/Van Dyck" gallery may not hold too many surprises in terms of location and hanging, what comes next constitutes a major and brilliant innovation. Two large rooms have been combined into one grandiose space to display the grandest of the grand: the Venetian sixteenth century, wellspring of all later European painting. Entering either from the double axis of the earlier Italian Renaissance to the "east" or from the "Rubens/Van Dyck" gallery to the "south" affords a perfectly orthodox reading of the art-historical record. Happily, this works equally well going "north" into the regional Italian schools of Bergamo, Brescia, and Milan, and further still progressing into the new Spanish galleries. If the reconfigured European Paintings collection now constitutes the core of the entire museum,

then Venice becomes its *genius loci*. What, alas, will forever remain absent is the central, informing deity: Titian. As good as the *Portrait of Filippo Archinto* may be, it does not – nor could it – represent the all-encompassing, heroic, vision of Titian's *poesie* or his larger religious compositions. These represented for contemporary and later European art an inexhaustible source of inspiration; for an idea, one needs to go to Boston and contemplate the Gardner Museum's *Rape of Europa*, possibly the artist's greatest work in America. As far as Titian portraits go, there are two far more compelling examples just down the street at the Frick Collection.

Some will argue that the Italian schools of painting are the great beneficiaries of the museum's renewal project. This may be true in terms of square-foot space occupied. French painting, however, now in near-perfect symmetry with the Dutch and Flemish galleries on the opposite side of the quadrangle, is as much of a winner considering how illogical and confusing the prior configuration used to be. Five spacious connecting rooms allow for a precise chrono-logical reading of the exhibited works. This clarity is vitally important in understanding a pictorial tradition that, unlike in Italy, developed so exclusively around the central fulcrum of Paris and the Court. Works from what has become known as "the age of revolution 1780–1820," have finally come together from different locations to surround the magnifi-cent *Portrait of Lavoisier and His Wife* by Jacques-Louis David and the artist's other pivotal, early *Death of Socrates*. Both paintings, executed just as the storm clouds were gath-ering, can be read with ominous sub-texts: the former because of the scientist's tragic end during the Terror and the latter as a powerful indictment of tyranny. The artist was to become, himself, an important protagonist in the unfolding drama of the Revolution.

In a stunning feat of art-historical triangulation, the

museum has recently righted the balance with the addition of two emblematic post-revolutionary works: a superb *Portrait of Charles Maurice de Talleyrand* by François, Baron Gérard, and a fascinating piece of contemporary reportage by Louis-Léopold Boilly. They date from 1808–10 – years during which Napoleon's Empire reached the meridian of its course – and both are gifts from Mrs. Charles Wrightsman, as was the *Lavoisier* portrait, donated in 1977. In the first of these recent acquisitions, Talleyrand sits for Gérard shortly after quarreling with the Emperor. It was a brief parenthesis in the minister's influence which the ever-resourceful political chameleon overcame, eventually going on to serve the two French monarchies that followed Napoleon's fall. Talleyrand seems not a bit humbled by his disfavor at the imperial court; he is comfortably seated – upright and defiant – magnificently turned out and with the smug, impenetrable expression we have come to know in many other likenesses, including the fine, later portrait by Pierre-Paul Prud'hon, hanging nearby.

The second recent addition is a remarkable painting-within-a-painting by Boilly, a prolific portraitist and master chronicler of Parisian life during the Empire and Restoration. The title says it all: *The Public Viewing of David's "Coronation" at the Louvre.* The unveiling of the gigantic canvas commemorating Napoleon's apotheosis was a sensation, but one wonders whether there is not a dose of tongue-in-cheek humor in Boilly's choice of subject; no one at the time would have forgotten that Jacques-Louis David had been, after all, one of the Revolution's staunchest propagandists. (Not as clever as Talleyrand, he waited in vain for *his* forgiveness after the Restoration.)

Having begun with Giotto in Florence – and with Duccio in Siena – and ended (more or less) with Waterloo, the grand panorama of earlier European painting comes to a

close at the threshold of the Romantic Movement. With the new installation, no visitor will be left wondering how and where the events unfolded along the way. The complex Metropolitan project, however, is not only a success as a didactic guide along the route. The new galleries also satisfy the basic desire of every museum visitor: enjoyment of beautiful objects in a setting that is nobly proportioned and handsomely arranged. The curators have wisely not lost sight of the fact that the museum is as much a spacious pavilion for pleasure as it is an uncompromising environment for learning.

Keith Christiansen, who was associated for more than two decades with the Department of European Paintings as a curator and now serves as its Director, has wisely nurtured a new generation of collectors with his foresight and personal charisma. They have repaid his guidance by making available for long-term loan a choice assortment of fine works that fill certain gaps or enhance particular comparisons. No, alas, a Titian or a Masaccio is not among them, but a few are veritable stop-in-your-tracks attractions. A *Baptism of Christ* by Jacopo Bassano was painted about fifteen years after Titian's death but could well serve as a worthy stand-in for any of the great master's late works. Monumental in scale, it is a breathtaking yet disconcerting image – possibly an unfinished canvas that was on the artist's easel at his death in 1592. The unbalanced composition breaks most of the rules, as does the raw, rapid application of gobs of paint on the pitch-dark background, but the result is unforgettable. Happily, the loan is listed as a "promised gift."

Works of the seventeenth century on loan from private collections are particularly in evidence in the Italian and Northern paintings galleries. A very significant presence, occupying its rightful place center-stage on the long wall of the "Rubens" room, is a rare early work by that master

depicting an unidentified *condottiero* being fitted with a gleaming breastplate, presumably prior to engaging in a battle or joust. Since the armor appears decidedly vintage in design, the subject may possibly be read as an allegory. The painting adds a valuable dimension to the understanding of Rubens and the influences he absorbed during his youthful visit to Italy. The reference to Titian is unmistakable, but Caravaggio's presence is equally felt in the dramatically close-cropped composition and harsh, oblique lighting. Here, as in most paintings on panel, the rich oil *impasto* has survived as vividly tactile as if it had been worked up the day before yesterday.

The seventeenth-century Dutch artist Paulus Potter lived to be barely twenty-four, never straying from his preferred subject: open landscape populated by cows, other animals, and occasional shepherds. Despite this description, Potter's alluring and incredibly rare paintings are anything but boring; the attention to detail is obsessive, the execution – in short brisk strokes – enlivens every millimeter of the surface and the animals depicted often wear weird, humanoid expressions; inevitably with somewhat surreal results. The loan of this perfectly preserved Dutch landscape is proof of how discerning and fastidious New York private collectors have become and how generous they can be to part, even temporarily, with such precious and intimate possessions. Another good friend of the museum who must be missing a recent acquisition is the collector who has graciously lent an enchanting genre scene depicting *A Turkish Boy Cutting Tobacco*. A refreshing and very unusual curiosity in the panorama of Italian Baroque painting, it is by Mattia Preti, a master of the grand manner but hardly known for his spontaneity and intimate charm.

Dutch "golden age" painters brought the art of the still life to prodigious heights; many unrivaled examples have

been in the museum's permanent collection for decades and, though well-known, have now acquired new coherence and meaning thanks to their judicious rearrangement. It is a transformation that has also worked its magic on the superb holdings of Dutch portraits, including those by the giants Rembrandt and Frans Hals. Temporary loans in these areas were therefore rightly considered less urgent. Italian still life painting, however, has never figured prominently in the story of European art nor, as a consequence, on the walls of American museums. Fortunately, the curators have succeeded in filling the gap by securing the loan of a veritable jewel. It is a small, exquisite study of assorted fruit in a plain bowl against a uniform background – simplicity itself, not difficult to guess that the delicacy and sensitivity of execution suggest a female hand. In fact, the precious panel is by the Lombard Fede Galizia; she was one of the rare women to wield a brush in the seventeenth century and also a pioneer of the genre. The painting's 1607 date places it very near the dawn of independent still life painting in Europe.

Many other factors contribute to the success of the European Painting Department's undertaking. The ongoing effort to find better quality and more appropriate frames for the collection has already produced impressive results. Its more visible – and positive – effects are to be seen in the Dutch seventeenth-century galleries, where a number of celebrated paintings are now exhibited with proper smooth or "ripple" ebony moldings in place of the former carved and gilt "Louis-something" frames that were standard *circa* 1900. One hopes that sooner, rather than later, the re-framing will catch up to the four Old Testament prophets by Lorenzo Monaco – *Abraham, Noah, Moses, David* – absolute masterpieces of Florentine Early Renaissance painting. The panels were removed in remote times from a larger altarpiece whose original configuration is unknown; in this sense, they

are, technically, "fragments" and, as such, pose difficult framing issues. Any reasonably pleasing solution, however, would be an improvement over the clumsy mock-Gothic tabernacles in which they still languish.

Count Giovanni Secco Suardo, a discerning mid-nineteenth-century Italian commentator on art conservation and aesthetics, once remarked that the ideal restoration is that which is least visible. That maxim ought always to guide the decoration of museum spaces, their principal function being the undisturbed and enhanced enjoyment of the exhibited material. The Metropolitan's new European Paintings galleries are proof that this is a winning approach. Simple, classical design prevails in all the architectural elements; their execution in various appropriate materials is equally unadorned yet elegant. Minimal variations of color and texture were allowed between the individual components (walls, moldings, etc.) of each gallery and between one gallery and the next, the colors themselves being artful blends of – by turn – warm grays, muted earth tones, and cool sepias. Fascinating, in particular, to observe how the differing effects of ambient light affect the same colors.

Progressing through these handsome new spaces, one has a distinct sense of completeness and permanence: this is the way this great collection *should* be shown – now and for years to come. In short, this is how it's meant to be: not a small accomplishment and one that, alas, so many other equally prestigious institutions fail to achieve. A comparison is useful in this instance. Not to pose a "Which is better?" question – meaningless in judging museums – but rather to ask, "Which institution more effectively manages its principal resources: physical plans and collections?" By this measure, consider the Uffizi Gallery in Florence, the constellation's undisputed reigning deity. For over thirty years, successive fine arts administrations, both local and

national, have grappled with the laudable concept of creating the "New Uffizi." Dancing around the incontrovertible reality that Vasari's palace – the museum's physical plant – is, in itself, a work of art, those responsible have compromised, revised, annulled, and resuscitated solutions, inevitably with deplorable results. The most egregious example among many: proclamation of a grand, international competition for the planning and execution of an absolutely essential egress gateway intended to be placed in an area of little architectural interest at the rear of the building. In the running were, among others, Hans Hollein, Sir Norman Foster, Mario Botta, and Gae Aulenti. A distinguished jury unanimously picked Arata Isozaki's soaring "portico" project, firming things up with a signed contract and an expected completion date of 2003. The place is still a confused construction site, and no one in the know is betting that Isozaki's design will *ever* be realized. Other, equally bungled, "innovations" inflicted on the venerable Florentine museum will merit a detailed, future screed in these pages.

How not to count our blessings in New York? Even though masterworks of the Kunsthistorisches such as Titian's *Portrait of Jacopo Strada* or his monumental *Ecce Homo* may justifiably be objects of our envy, the Vienna museum no longer seems a distant planet. As far as European paintings are concerned, the Metropolitan is now firmly in the same orbit and constellation.

September 2013

Who owns the past?

On the legal tribulations of treasure.

THERE WAS A TIME – it seems so long ago – when New Yorkers awaited the arrival of their Sunday *Times* with a distinct sense of anticipation. In the arts, literature, and cultural sections of the bulky package, one invariably found a variety of interesting insights and opinions, delivered by a team of perceptive, well-informed commentators. On Sunday, November 12, 1972, the paper once again did not disappoint its readers. On the front page was a brief report that the Metropolitan Museum had made a spectacular acquisition; its Director, Thomas Hoving, announced the purchase of a magnificent Attic sixth-century *kylix krater*, signed by the potter Euxitheos and the painter Euphronios. That Sunday, *The New York Times Magazine* also featured the fabled artifact on its cover in glowing color – an unprecedented case of double-exposure on the same day. Inside, a long article spared no superlative: the hitherto unknown masterpiece would, in Hoving's words, "re-write the history of Greek vase painting."

Even readers with the most superficial knowledge of classical archaeology and the antiquities market must have smiled wryly at the museum's disingenuous assertion that the thrilling discovery emerged from a "European collection formed at the time of World War I." Although no further details were forthcoming, the real provenance of the great vase was only too easily imagined: it must have been found

in an Etruscan necropolis, probably somewhere north of Rome and, in all likelihood, only months before.

Indeed, by early February 1973, a bit of clever investigative reporting by Nicholas Gage and others had forced an embarrassed Metropolitan to reveal not only the name of the seller of the vase but also an almost comical montage of fictitious circumstances surrounding its presumed earlier "history." The Italian *Carabinieri*, on their own, quickly got to "their" truth, no doubt aided by the disgruntled local diggers who realized they had only gotten pennies of the reported $1 million paid by the Metropolitan.

And there things stood, for decades, in stalemate and in perfect equilibrium: the Italian authorities occasionally clamoring for the return of the great treasure and the museum steadfastly defending the legality of its ownership. And so the splendid Euphronios *krater* remained – immovable and firmly perched on its pedestal on Fifth Avenue – until February 3 of this year. That day, New Yorkers learned the distressing news that they will no longer be able to participate in the lament over the noble Sarpedon's death. That masterfully rendered episode of the Homeric legend, and the monumental vessel on which it was painted, will, in fact, soon be departing for Italy; the Euphronios *krater* is returning "home." The event is so significant and fraught with implications for the future that serious thought ought to be given, not only to the concept of "home" as expressed above, but also to the reasons why, from 1972 to 2006, everything changed. Then, we were secure that the vase was ours; now, it is theirs; indeed, its present label reads "on loan from the Government of Italy."

That Italy should have always been considered a home for art is hardly surprising. More of it was created there, brought there, and exported from there, over the last three

millennia, than anywhere else. Put another way, Italy is the ultimate source country. Quite understandably, it was in Italy – in the Vatican State to be precise – that the concept of artistic patrimony was first given legal standing in 1820. This occurred via a remarkably innovative decree promulgated that year by Cardinal Bartolomeo Pacca. Serving as Secretary of State to Pius VII in the tumultuous years of the French occupation of Rome and of the Pope's exile, Pacca steadfastly defended the sovereignty of his state, and was keenly aware of the relentless depredations of artistic treasures carried out by Napoleon and his minions. These experiences surely prompted the Cardinal, after the Congress of Vienna, to enact the edict that bears his name and which, for the first time, established a state (as opposed to a private) procedure to catalogue, protect, and preserve artistic properties within the Church territories.

The Pacca Code was soon followed by similar laws elsewhere in Italy: in 1822 in the Bourbon Kingdom of the Two Sicilies, in 1827 in the Veneto, and, in 1857, in the Grand Duchies of Tuscany and Modena. The first comprehensive law covering artistic properties in the newly united Italian state was adopted in 1909. Most subsequent legislation, not only in Italy, but in other states both in Europe and elsewhere, is based, at least conceptually, on these early codes.

Central to every discipline seeking to regulate works of art, whether movable or immovable, is their identification; in other words, their description and the subsequent recording of that description in some form of general register. Artistic (or cultural) properties, identified and catalogued as such, will then, inevitably, fall in two general categories: those that are privately and those that are publicly owned. This aggregate – this *known* and catalogued body of works – is generally referred to as artistic patrimony, a term that has, more recently, been expanded to include also so-called cul-

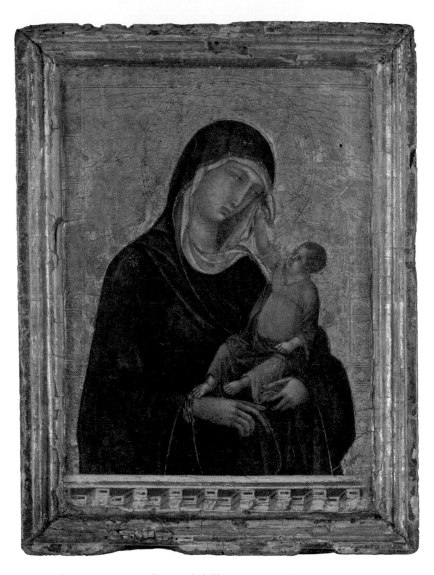

Duccio di Buoninsegna, *Madonna and Child* (*ca.* 1290–1300)
The Metropolitan Museum of Art, New York

Lorenzo Lotto, *Venus and Cupid* (1520s)
The Metropolitan Museum of Art, New York.

OPPOSITE:
Fra Angelico, *The Dormition and the Assumption of the Virgin*, (*ca.* 1430)
Isabella Stewart Gardner Museum, Boston

Bronzino (Agnolo di Cosimo di Mariano), *Portrait of a Young Man* (1530s)
The Metropolitan Museum of Art, New York.

Bernard Berenson at the Villa I Tatti, 1947
Biblioteca Berenson, I Tatti – The Harvard University Center for Italian Renaissance Studies,
courtesy of the President and Fellows of Harvard College.

Francisco de Zurbarán, *Still Life with Lemons, Oranges and a Rose* (1633)
The Norton Simon Foundation.

Baron Hans Heinrich "Heini" Thyssen with Cristina Grassi (left), at the Italian Consulate in New York

Marco Grassi addresses friends of *The New Criterion* (2010)

tural patrimony. The laws and regulations, as they have evolved from the Pacca Code in Italy and elsewhere, have sought to protect this known quantity according to varying local needs and traditions. Over the last century they have done so with uneven success, at best. The inherent asymmetry and great complexity of dozens of individual national, even regional, codes has often hindered, rather than facilitated, the reasonable administration of the patrimony to be protected.

What has particularly muddied the waters, certainly in every source country, is that, in addition to the known patrimony, there exists an often very substantial unknown body of works: these may have either been forgotten through neglect, may have languished unrecognized through ignorance, or simply may have remained undiscovered, generally buried underground. As a result, this unknown, unrecorded material can only theoretically be considered as pertaining to an artistic and cultural patrimony. Regulating such a theoretical, and unknown, patrimony has, for obvious reasons, always presented inherent problems, and, in this sense, archaeological finds comprise the most conspicuous and troublesome category of such patrimony. A Greek vase or a Roman bronze is unknown until it is discovered somewhere underground; however, they exist, and have always existed, in a juridical sense, according to Italian and other European jurisprudences. Although these undiscovered and unrecorded artifacts may have never been seen, they are, nonetheless, considered very much part of these nations' artistic and cultural patrimony.

In Italy, as in most of continental Europe and Latin America, modern civil law developed from the Napoleonic Code, which itself was based on earlier Roman law and the *Corpus Juris Civilis* of Justinian. One of the fundamental tenets of Roman law, as it applies to land, or "real," property

is that possession does not extend beyond its surface. In other words, jurisdiction above and below a property pertains to the state. An owner is not entitled to material emerging from below his land, be it gravel, petroleum, or . . . ancient artifacts. The Euphronios *krater*, if, indeed, it was unearthed in Italy, was therefore regarded, in Italian law, as stolen property because it was removed from below the ground and not turned over to the state. Had this principle guided American law, restitution would simply have been a matter of reciprocal recognition of a similarly applicable statute in a similar circumstance. Theft is everywhere regarded as a crime; the product of a theft remains, within the statutes of limitations, subject to seizure and return everywhere.

But, in the context of international law, things were not so simple. Even if the Italian authorities had been able to demonstrate with absolute certainty the origin of the *krater* (never an easy matter, after the fact), there was no reciprocity in the law. The *krater* might well have been a "hot pot" in Rome, but it was only lukewarm in New York. The case would have had no standing here. Jurisprudence in the United States (except for the state of Louisiana) essentially descends from English common law as it was institutionalized in the twelfth century by the first Plantagenet king, Henry II. It is basic to the concept of "estates in land" or "real" property in common law that possession, jurisdiction, and, hence, enjoyment of the land extend above and below the surface of the property. "Treasure trove," is, in fact, a well-recognized principle in England, and most of its former colonies. What else, then, if not "treasure trove" was the Euphronios *krater*? And, as such, was it not the legitimate property of the owner on whose land it was unearthed? Indeed, in American law, the vase was not considered stolen property and consequently was not subject to seizure and restitution.

It is a crucially vexing paradox that virtually all source

countries base their jurisprudence on Roman law and that, in the primary destinations (the United States and Great Britain), these principles are generally not recognized. Beyond this, there is the subsidiary but no less important issue of export regulations. These may be more or less restrictive, but are almost invariably an integral part of most nations' art-patrimony codes. It stands to reason that if an object is criminally obtained through digging, it is highly unlikely that it will turn up at the government's export office for a legal license.

By the middle of the last century, the problem had, indeed, become so vexing that, in 1970, the United Nations Educational, Scientific and Cultural Organization (UNESCO) drafted what is still today the most important instrument dealing with cultural property. Its title, in typical U.N. hyper-speak, says it all: "Convention on the Means of Prohibiting and Preventing the Illicit Import, Export and Transfer of Ownership of Cultural Property." In 1972, the United States joined the other hundred signatories in adopting the Convention. This may well have occurred on the very day that the Metropolitan sealed the deal on the Euphronios *krater*! The coincidence is undoubtedly amusing but not as egregious as it seems.

The Convention is actually a very prudently worded and even-handed document, the purpose of which was certainly not to shut down the circulation and collection of art objects. It does not impose automatic observance of restrictive export laws and, most importantly, it narrowly limits the definition of "stolen property," clearly excluding items not described in existing inventories of collections, museums, or religious institutions. Although it took another ten years for the U.S. Congress to pass legislation implementing the provisions of the UNESCO Convention, there was general agreement that, by so doing, a fair balance was being struck

between the needs of source countries and the legitimate aspirations of U.S. cultural institutions and collectors. In fact, part of the Implementation Act passed by the Congress was the establishment of the Cultural Property Advisory Committee, an appointed body to which applications from source countries would be referred and which, in turn, would advise the president and other federal agencies on specific actions to be taken.

Unfortunately, five years before the Implementation Act was passed in 1983, a case involving some Mexican artifacts was argued before the U.S. Court of Appeal for the 5th Circuit. The objects had been obtained from an illegal but undocumented site in Mexico and had been brought into the United States. for sale. In *United States* v. *McClain*, the court convicted the defendant on the basis of the National Stolen Property Act, a 1940s omnibus federal statute covering interstate traffic in stolen property (everything from cars to counterfeit tax stamps). It was a stunning feat of judicial over-reaching: in *McClain*, the court, in essence, recognized a patently dubious claim of theft on foreign soil, and then adopted this claim in support of punitive action on American soil. And this, on the basis of a statute (the NSPA) that is entirely silent not only on artistic and cultural properties, but on the interpretation of possible illegality in a foreign jurisdiction!

The ominous implications of *McClain* were, of course, not lost on lawmakers as they were drafting the Implementation Act. There was even an attempt, by Senators Dole, Matsunaga, and Moynihan, to introduce a bill modifying or annulling *McClain*, but it came to nothing, mainly as a result of opposition from the State Department and U.S. Customs.

In matters pertaining to artistic and cultural patrimony, the past quarter-century has witnessed a progressive erosion of the carefully crafted international bi- and multilat-

eral agreements such as the UNESCO Convention and legislation such as the Immunity from Seizure Act (enacted in the 1960s to assure foreign lenders to American exhibits that their works would be returned). A striking example of judicial preemption affecting the orderly progress of cultural exchange is the deplorable episode of the Egon Schiele painting known as *Portrait of Wally* that had been lent to the 1997 MOMA exhibition of works from the Leopold Museum of Vienna. Seized moments before its return to the lender in Austria, the painting has been for years tied up in a harrowing series of court battles. In effect, it has been considered illicit property by the U.S. Attorney's Office – fruit of a presumed theft that (perhaps) occurred more than a half century ago, and half a world away from our shores.

More recently still, prosecutors in the New York jurisdiction again employed *McClain*; this time as the bludgeon to convict a well-known and respected antiquities dealer – on the basis of Egyptian law! It was yet another example of an American court asserting its role as arbiter of foreign law, in contrast to existing international treaties and domestic legislation. If this, indeed, is an inexorable trend, it would probably have been only a matter of time before an activist local magistrate issued an injunction to seize the Euphronios *krater*. Conveniently, a gentleman named Giacomo Medici made that unnecessary.

Medici, working from Rome and Geneva, had for years been one of the foremost dealers of classical antiquities in the world. Because of the legal complexities mentioned earlier, Medici, his associates, and clients were obligated to operate carefully and discreetly, if not downright secretly. Unfortunately, Mr. Medici, true to his Italian nature and perhaps due to his great success, boastfully and quite carefully documented his career in words and photographs. He was like Louis Mazzini (the part played by Alec Guinness)

in *Kind Hearts and Coronets*, memorializing his life of crime in pursuit of the D'Ascoyne earldom and then being undone when his writings were discovered after he had forgotten

them in his cell.

In 1995, Medici's "gallery," located in a duty-free Swiss warehouse, was searched. Its contents were surprising, to say the least. Investigators found a welter of mostly nondescript archaeological specimens. The real interest, however, resided in the countless images, notes, and references identifying works of art – many hardly nondescript – that, through Medici's ministrations, had found their way to museums and collectors everywhere, but mostly in America. For the first time ever, the Italian authorities had irrefutable proof (as opposed to the disgruntled confessions of diggers and farmers) that certain objects – yes, including the *krater* – were unearthed in Italy. As an almost ludicrous vanity, Medici had himself photographed standing proudly next to a series of lovely objects, now beautifully restored and installed in museums including, besides the Metropolitan, the Getty and the Cleveland Museum.

The return of most of these objects was now only a matter of negotiating a polite way out. Unfortunately for a former curator of the Getty Museum, it has also meant criminal prosecution in a "show trial" in Rome. A combination of legislation by judicial *fiat* in America and fortuitous chance in Europe had, in these thirty years, made the loss of our prized and priceless *krater* inevitable.

At issue now is: where will this all end? Rest assured, it's a fair bet the Elgin Marbles will not be returned to Athens. Nonetheless, it's clear that cultural institutions, collectors, and an entire category of scholarly, dedicated professionals cannot be held hostage to the misguided conviction that artistic and cultural patrimony is sacredly site-specific.

Above all, we in the United States must not become enforcers of that principle in jurisdictions other than our own.

Most knowledgeable curators, academics, and collectors are well aware that unknown or undiscovered artistic wealth, even in the richest source areas, is limited. It is particularly limited in that topmost category of quality and importance that elevates an object to the status of a national treasure. Finds of this magnitude are exceedingly rare, yet they are the ones that promise the greatest rewards for the seekers and constitute the greatest losses to the artistic patrimony from which they are subtracted. These discoveries are now almost invariably criminalized. Pursuing such events criminally, both locally and abroad, cannot be the answer.

An answer does exist, and it exists by virtue of the one ingredient that is habitually cast as villain along with the other usual suspects (greedy dealers, unscrupulous curators, rapacious collectors, et al.): money. But money, in this instance, is not the problem; it may well be the solution. We know that great discoveries seldom occur. Three, possibly four, objects comparable in importance to the Euphronios *kylix* have turned up in Italy in the last thirty years, an average of one every eight or ten years. Is there any reason why a nation should not simply purchase its national treasures if these are deemed so important to its cultural patrimony? Put another way, is there an economy so bereft of financial resources that it is incapable of allocating sufficient funds for such occasional acquisitions?

Even less sophisticated bureaucracies should not find it impossible to devise appropriate mechanisms so as to intervene effectively and at market rates when necessary. As a fundamental priority in such schemes, the local authority would manifestly declare itself the buyer of first resort, promising to assess value fairly and promptly reimburse the

IN THE KITCHEN OF ART

finder. That authority would also be given access to the site of the find, if previously unrecorded, and be given first choice on other material of lesser importance. Those items, if not purchased, would be recorded for scientific purposes and then be allowed to circulate legally and freely on the local as well as the international market. Not even Italians have suggested that their nation might not have been able to afford the purchase of the *kylix* when it was discovered. Had this occurred along the lines suggested above, the money would have been equitably divided between the finders and the landowner, the site would have been properly excavated and studied, and Mr. Medici would have been out of business long ago. In other words, poverty is no excuse for a nation that is serious about protecting its heritage; it simply needs to implement an efficient and realistic procedure to legalize the management of its yet-to-be-discovered artistic heritage. What is more important is that the stewardship of that heritage should not be delegated *post facto* to foreign courts, in the United States and elsewhere. Source nations will have no one to blame but themselves if they remain incapable or unwilling to enact adequate yet liberal preventive measures; the exodus will simply continue.

An exemplary legislation that incorporates this principle was recently adopted in Great Britain. Although rooted in English common law, the concept could easily be applied in nations with a Roman law tradition. Called the Treasure Act of 1996, the law obliges finders of objects legally defined as "treasure" to report such finds to the local bailiff. An appropriate committee of experts is then asked to determine the importance of the find and to recommend either purchase by the nation or free circulation in the market under the so-called Portable Antiquities Scheme. It is no coincidence that, among other successes, the Ringlemere gold cup entered the British Museum since enactment of the law.

The title of this article – "Who owns the past?" – is taken from a recently published book, edited by Kate Fitz-Gibbon. The volume was produced in collaboration with the American Council for Cultural Policy and is a collection of articles by a diverse but well-informed group of contributors on subjects that range from Native American burial grounds to preservation in the Kathmandu Valley. Yes, the Elgin Marbles put in an appearance. This excellent anthology should be required reading for anyone engaged in a serious discourse on the disposition, protection, and exchange of artistic or cultural material. It would particularly benefit those journalists who, on the pages of the *Times* (both in New York and Los Angeles), habitually use such terms as "looting" and "plunder" in their accounts of the acquisition policies of their local museums. Consider, as a typical example, *The New York Times* art critic Holland Cotter's mindless essay (March 29, 2006) wherein he glibly states: "the history of art is, in large part, a history of theft," ending with: "So the Euphronios *krater* will be in Italy instead of New York. Do we really care?" Alas, Mr. Cotter, we do care, passionately!

A careful reading of *Who Owns the Past?* is highly recommended. One can begin to understand that, if a society is serious about maintaining and preserving its artistic and cultural heritage, it cannot hope to do so simply through restrictive and punitive legislation. Doing so only keeps the clandestine markets healthy and the courts busy.

December 2006

Part III: Collectors & Connoisseurs

On some of the preeminent collectors
of the twentieth century.

ONE WAY TO UNDERSTAND the history of art is through a
history of collecting. We can divide the last century into
four periods, each exemplifying a certain attitude towards
art collecting. The first might be called the *imperial* phase; it
encompasses the period from about 1880 to 1920. This era
saw the headlong rush of an emerging industrial and mer-
chant grandee class to acquire status, legitimacy, and social
distinction. Collecting art was an obvious strategy; the
example had already been well established for at least two
centuries by the English aristocracy. By now, we have gotten
to know the characters that animated this world of excess
and display. Excellent biographies, occasionally more than
one, have been written about the über-dealer Joseph Duveen,
about Bernard Berenson and Wilhelm von Bode, the age's
art oracles, and, of course, about the great accumulators
Morgan, Frick, Altman, and even about lesser lights such as
Clarence MacKay.

The period and events that follow the flamboyant, over-
reaching – and very substantial – accomplishments of our
home-grown Edwardians are far less familiar. The story,
however, merits closer attention, not least because it marks
the beginning of a different approach to collecting. What
set the process in motion was surely inauspicious: a chance
encounter of a very young man and a slightly older woman
in the park of Milan's Castello Sforzesco. The year was 1897

and the meeting forever changed their lives. Alessandro Contini was tall and fair-haired – and he cut an imposing figure. Born in Ancona in 1878, he was in Italy pursuing a growing philatelic business, mostly sold out of his well-stocked briefcase. The woman, unmarried but with a young child, was from the Lombard hinterland and of the most modest origins. It would be difficult to imagine a less adequate counterpart to the dashing and enterprising young stamp dealer than the short, stocky, and dark Vittoria Galli. Social convention alone should have discouraged a man such as Contini from taking the slightest interest in the impoverished *paesana*. And yet he must have instantly recognized in this woman such immense resources of intelligence, ambition, and capability to have made her attraction irresistible – all qualities that would propel the improbable pair to unimaginable heights of influence, wealth, and notoriety.

The Continis were soon married and traveling far beyond Italy in the adventuresome pursuit of rare stamps; to Spain, to the United States and, finally, to South America, where they uncovered endless rarities of the ex-colonies' early postal services.

Having returned to Italy shortly after World War I, Alessandro Contini went to Bergamo to collect on a rather large debt from a colleague. Short of cash, the colleague convinced Contini to settle by taking some paintings instead of *lire* – paintings that soon proved to be an even more profitable commodity than his accustomed stock-in-trade. In quick order, the newly minted art dealer and his wife returned to Spain, liquidated their considerable stock of South American stamps, and purchased about forty canvasses by El Greco, Murillo, Velázquez, and Zurbarán, all then quite obscure.

In 1921, the Continis rented a grand villa in Rome and

arranged the first public showing in Italy of the art of Spain's "Golden Age" – an epochal exhibition with a memorable catalogue. It was a pioneering exploit that confirmed the couple's emergence onto the art world stage. Museums and collectors everywhere quickly realized that seventeenth-century Spanish art could not be absent in any serious anthology of European painting. The visit by the king, Victor Emmanuel III, crowned their efforts. The titles of Count and Countess soon followed for the enterprising pair (Contini having previously already doubled his barrels by adding "Bonacossi" to his surname).

Count Alessandro Contini-Bonacossi, with the redoubtable "Donna" Vittoria never far from his side, now plunged headlong into the international art trade. To aid in his future purchases and, again guided by his keen perception, Contini sought help from the struggling young scholar Roberto Longhi, generously helping him to complete his studies. It was an investment that repaid the Count handsomely: Longhi went on to become one of the twentieth century's most accomplished and influential art historians. Contini was also quick to understand the importance of conservation. The talented Roman restorer Stefano Pichetto was the first (of many) craftsmen who benefitted greatly from his business.

By the mid-1920s, the two Contini, undeterred by their halting grasp of any language other than Italian, set out for New York. At that time, the art trade was fiercely territorial, and New York was very much the preserve of long-established concerns such as Duveen, Wildenstein, and Knoedler, the traditional purveyors of fine art to the "imperial" gilded age collectors. Contini, of course, understood this and devised an effective strategy. He and Donna Vittoria arrived in New York with a varied assortment of recently discovered (by Longhi) and restored (by Pichetto) master

paintings. Taking a large and commodious suite at the Plaza, they arranged their wares in their rooms and discreetly made them available to collectors, scholars, and curators, some of whom may have been as much attracted by Donna Vittoria's expertise in the kitchen as by the pictures on the walls.

It was an entirely new way to do business – no lavish gallery, no large staff or huge inventory, no costly advertising, and, above all, no threatening foot in enemy territory. Throughout many fruitful and successful years, there was never to be a "Contini Gallery." Even when the couple later moved to Florence into an imposing neo-classical pile surrounded by a lovely park, the only place of business was to remain their home – simply "Villa Vittoria." Perhaps without realizing it, Contini had become the first, and arguably the most successful, "private art dealer" in the world. It was an innovation far ahead of its time, anticipating, as it did, the mobility, ease of communications, flexibility, and accessibility to information which are so much part of today's globalized art trade.

On their second visit to New York in 1926, Count Alessandro Contini-Bonacossi and Donna Vittoria met a lady who later visited them for tea in their apartment at the Plaza. Impressed by their expertise in artistic matters and their good sense of style, she asked them if they might not help her arrange some furniture in a friend's apartment. The lady's name was Delora Kilvert, and her friend was Samuel Kress. In no time at all, Kress's apartment was transformed, and substantially enriched, not only with furniture, but with tapestries, bronzes, and paintings – lots of paintings. At the time he and the two Contini crossed paths, Kress was in his early sixties and had achieved preeminence as a mass-marketing genius to rival the legendary Woolworth. Kress emporia had multiplied across the country from a first, humble dry-goods store in Allentown, Pennsylvania. Samuel

Kress was now a very rich man – a veritable emblem of the classic American saga of relentless dedication to hard work, honest dealing, and entrepreneurial risk-taking.

It became obvious to Count Contini and the somewhat 133 dour, single-minded Kress that their collaboration resulted in something quite different from the obligatory ornament for a *grand seigneur*. The works of art would never be accompanied, as might have been expected, by the hundred-meter yacht, the racing stables, the vast country house, or the other accoutrements of princely life. With Kress, the collection became a single epic enterprise: an attempt to assemble as ample and comprehensive an anthology of Western European art as resources and availability permitted. Painting, sculpture, works of art, furniture – everything was considered pertinent to the grand design. The progress of this massive accumulation was guided by criteria specific to the new and rapidly evolving discipline of art history. More significantly, the collection reflected an awareness that even a modest, obscure, or aesthetically displeasing item can possess great value in providing the tissue and texture that connect all the chapters of the art-historical record. There would, of course, be many masterpieces, but these were never the exclusive focus.

Innovative, as well, was the way the Kress collection was assembled: both the collector and the dealer went about it as serious businessmen. There are accounts of endless sessions at the Plaza and at the Kress home during which the two titans would go toe-to-toe exercising their unparalleled negotiating skills in what was occasionally described as a *souk*-like atmosphere. Kress, with Contini, can be thought of as exemplifying the second phase of collecting in America.

What was accomplished by Samuel Kress and subsequently continued by his younger brother Rush is simply astounding. By the early 1960s, the collection comprised

over one thousand paintings, thirteen-hundred sculptures, and conspicuous holdings of drawing, furniture, and works of art. The disposal of this vast cultural patrimony is even more remarkable. Starting in the mid-1930s, and under the stewardship of the newly formed Kress Foundation, museums in eighteen cities received significant portions of the collection's principal inventory of paintings. Less important paintings were arranged in "study collections" and gifted to twenty-three colleges and universities. New York's Metropolitan Museum and the Philadelphia Museum of Art received specific bequests of paintings, tapestries, and furniture, while the Morgan Library was enriched with a multitude of Old Master drawings and medieval manuscripts. The greatest beneficiary of all, however, was to be the National Gallery in Washington. One hundred of the Kress Collection's most important paintings joined the Mellon, Widener, and Dale bequests, at first on loan and then, finally in 1961, as permanent gifts. Thanks to the magnificent generosity of Samuel Kress and the foundation that he initiated and that lives on to this day, the entire nation benefitted from the enlightened dispersal.

The Contini-Bonacossi saga, however, concludes on a rather more melancholy note. After the war, Contini's contacts with Hermann Göring were severely criticized, although no illegal dealings between the two were ever uncovered. When the Count died in 1955, he may well have been one of the richest men in Italy, leaving significant real-estate holdings, industrial concerns, philatelic collections, and a superb art collection. Virtually all of this huge estate disappeared through years of wrangling over death duties and litigation among heirs. The grand endowment of the entire collection to the city of Florence, which Donna Vittoria had imagined, was never realized. The only vestige of this noble intention is a handful of paintings that the Italian state was able to

wrest away from the estate in lieu of concessions on the export of the collection. They are now housed in rooms attached to the Uffizi Gallery but that have proven, over the years, to be almost impossible to visit. Sadly, they remain as the only, and inadequate, memorial to the remarkable career of the Count Contini-Bonacossi.

The finest and rarest Spanish picture to have been acquired, and always kept, by Contini was the famous 1633 *Still Life with Lemons, Oranges and a Rose*, signed by Francisco de Zurbarán. This memorable icon of seventeenth-century art passed out of the Contini estate and into the hands of Norton Simon in 1972. The California industrialist, to be sure, was no novice collector; in 1965 he had already appeared on the cover of *Time* magazine with his record-setting purchase at auction of Rembrandt's *Portrait of Titus*. And yet, Zurbarán's *Still Life*, with its specific Contini / Kress associations, serves as a fitting milestone in the transition from one era of collecting to the next. If Kress had been businessman-as-collector, Simon was collector-as-businessman. Whereas Kress's loyalty to his dealer Contini never faltered, Simon was loyal to no one. Although he knew and respected all the major players of his time – dealers, auctioneers, scholars, and conservators – and was famous for seeking advice from all of them, in the end, Simon remained always his own best advisor.

Another, and particularly significant, aspect of Simon's new approach to collecting was his pitiless and relentless negotiating style. If Kress has occasionally been described as "tough," the adjective invariably attributed to Simon is "brutal." A favorite strategy was to ask that an item be sent to California for approval, whereupon months of silence would ensue. This would generally rattle the seller sufficiently so as to give Simon the strong advantage he needed to beat down the price. Buying an option in offered works was

another way to prolong the process and exhaust the opposition. On occasion, Simon did not hesitate to unleash his company's lawyers on a hapless dealer – all in pursuit of tactical superiority and leverage. What is also revealing is the fact that Simon always lived in relatively modest homes, first in Hancock Park then later in Malibu. Never in all those years was more than a small fraction of the art he owned actually displayed in them; his collection was, quite aptly, called "a museum without walls." The bulk of the collection was usually in storage, on loan to museums, or traveling in temporary exhibitions.

Nothing could be further from the image of the traditional grandee-collector than the carefree, wheeling-and-dealing Simon; in the end, he cared not a whit about the social status and cachet that collecting had bestowed on generations of his predecessors. It was the art and the process of acquiring it that mattered, and whether it is a tribute to Simon's intuition, cunning, or the thoroughness of his research (or, probably, all of these combined), the result he achieved can only be described with superlatives. In the early 1980s, it all finally came together in what had been the Pasadena Museum of Art. The quality, rarity, art-historical range, and sheer beauty of the now-renamed Norton Simon Museum is as much an enduring monument to the man as the Kress Foundation's gift to the nation is to its namesake.

It is interesting to consider that after the museum found its "walls," the collecting virtually ceased; for the last dozen years of his life, Simon simply enjoyed endlessly hanging and re-hanging his fabulous collection. Perhaps the thrill of the chase (and the kill) had become too expensive or not sufficiently rewarding.

The model that Simon perfected has cast a very long shadow in our contemporary art world. Ever since Simon,

the last trace of romance, commitment, and vision seems to have drained from the pursuit and purchase of fine arts. If Norton Simon's style and methods can be described as those of a *modern* collector, how else but *postmodern* could one describe the Saatchi brothers? Through these advertising magnates, the exploitation of art for speculative and headline-grabbing self-aggrandizement has become the norm. Museums, rather than being final destinations for lifelong collecting endeavors, have all too often become useful marketing stopovers for lender-entrepreneurs who exercise *droit de seigneur* over their holdings. Trustees and curators, in their pursuit of ever-increasing attendance figures, have become willing partners in this minuet, occasionally mortgaging the future of their institutions to build huge "signature" buildings designed by headline architects. The thousands of cubic feet added recently to the Denver Art Museum by Daniel Libeskind is a perfect example: this addition exudes as ephemeral an air as the materials from which it is constructed and the installations it contains.

A visit to the yearly Miami-Basel *kermesse* should serve to convince a serious observer that the progression noted during the past century will, almost certainly, not be reversed in the course of the next. Drawing a line, in this time frame, from Frick through Kress and Simon, and ending with Saatchi, one sees all too clearly how these collectors embody the aspirations, myths, and ideals of each period; and how – in an ascending curve – the function of money has played an ever-increasing role. Wealth, of course, has always been important, but now it has become, finally, the only protagonist – the ultimate reference of merit, quality, content, and meaning. A stroll through the cavernous exhibition hall during Miami-Basel, not to mention the score of satellite marketplaces that spring up around it, cannot exactly be described as a

life-enhancing experience. This has little to do with the material on view – the artistic validity of which may or may not be confirmed in decades to come. What reverberates through the myriad stands and tumultuous crowds is the urgency of the speculative imperative: a refrain endlessly repeated – now is the moment to cash in, now is the moment to buy or to sell. And this drumbeat of blatant venality – as obsessive as the disco rhythm that seems to permeate the entire town – becomes, itself, the main event. Depressing as this would appear, there can be little doubt that it is entrenched, at least for now.

Were it not for the welcome and occasional exception, the prospects, looking ahead, would appear bleak indeed. The small but remarkably comprehensive collection of American pop art, a promised gift from John Wilmerding to the Princeton Art Museum, is that rare and reassuring point of light in the darkening sky. A distinguished scholar of American nineteenth-century painting, Professor Wilmerding has, over many years, exercised his unerring eye and thorough understanding of the period in choosing not the largest, not the most obvious, not the flashiest, nor, assuredly, the most expensive examples of all the major pop artists – but they are the right examples. And seen together, as they recently were at Princeton, the effect was nothing short of illuminating and delightful, even for one not charitably disposed toward the genre. The Wilmerding Collection is also, above all else, an object lesson on taste, intelligence, knowledge, and time – so indispensable to the gathering of works of art. The problem, today, appears to be the money. Not only is it not lacking (if one considers current auction price levels), but it has also positively swallowed up other considerations of collecting art. This being the case, there is ample reason to doubt whether a future generation of American collectors

will bring the same intensity and dedication that propelled the Kresses and Simons of the last century to such memorable achievements. One can only hope that a few of those friendly ghosts from the past will be there to guide them.

December 2007

Bernard Berenson revisited

On the art historian's life & influence.

AN AMUSING STORY used to circulate in Florence about the late summer of 1944, a few months before the Allied armies of General Clark pushed the Germans northwards to ultimate defeat. Bernard Berenson, who had been in hiding for over a year, was finally able to walk again along the picturesque country lanes of Settignano that he knew and loved so well. On the first day out, a United States Army vehicle stopped alongside the diminutive, bearded, and impeccably attired gentleman. A G.I. leaned out and, in dreadful pidgin Italian, asked for directions. Mr. Berenson obliged, but naturally in the subtly nuanced and inflected phrases for which his English was famous. Stunned, the G.I. asked: "Hey, buddy, are you American?" When Berenson politely confirmed that he was, the soldier could hardly believe it – "Then what' you doin' in a dump like this?"

Whether apocryphal or not, the vignette perfectly captures the sense of the jarring encounter between the supremely cultivated Jamesian savant – then almost eighty years old – and a visitor appearing as if from a distant planet. By the end of the war, the world with which Bernard Berenson identified was rapidly disappearing. By the time he died in 1959, at the age of ninety-four, he was regarded as a precious relic, a surviving curiosity. Such a vivid sense of temporal dislocation is not uncommon to people whom providence allows a life that extends two decades beyond the average; an "epilogue" that encompasses almost an entire genera-

tion. In Berenson's case, the time warp was enhanced by the transformations and calamities that the world experienced during his lifespan: two world wars that deprived Europe of its central cultural and political roles. These traumas were accompanied by technological leaps that fundamentally changed how people moved, communicated, and acquired information – also, and equally important, how goods and wealth were created and distributed. What continues to fascinate about Berenson's long life, even more than fifty years after his death, is that throughout it all he was ever the perceptive observer and thoughtful commentator. Moreover, as a much younger man, he had not only observed but also actively participated in and contributed to the intellectual debates that accompanied the early development of art history, a discipline that he helped to define and on which his fame rests.

When the irrepressible and wealthy Isabella Stewart Gardner ("Mrs. Jack") first crossed paths with the young Berenson at a Harvard lecture, their backgrounds could not have been more different: She was, by the mid-1880s, the undisputed doyenne of Boston society despite lingering resistance from some Back Bay grandees. Berenson was the son of impoverished Lithuanian Jewish immigrants and was, at the time, applying his fierce powers of concentration to "Talmudo-Rabbinical Eschatology," an unlikely subject to attract the grand lady's attention. Coupled to Berenson's intelligence, however, was a very pleasing appearance, a gift for brilliant conversation, an insatiable literary appetite, and a dose of robust ambition, just what Mrs. Jack looked for in the youths, mostly men, who were invited to the charmed circle of her salon. Bernhard (the "h" was to disappear some years later) eventually received from Mrs. Gardner a one-year European traveling grant to which the Boston aesthete and collector Edward Warren also contributed.

Berenson's subsequent travels were to be life-changing: now it would be art rather than literature to which his talents would be devoted; and the young scholar, under the spell of Charles Eliot Norton's Harvard lectures and Walter Pater's *The Renaissance*, became singularly interested in Italy.

What followed in remarkably rapid succession was the publication by Berenson of several books that were to shape his legacy and fame: the "triptych" of *Venetian*, *Florentine*, and *Central Italian Painters of the Renaissance* that appeared between 1894 and 1897; the innovative monograph *Lorenzo Lotto: An Essay in Constructive Criticism* of 1895; and, in 1903, the monumental three-volume *Drawings of the Florentine Painters* that has always been considered a milestone and masterwork since its appearance. What sets these studies apart from every other prior endeavor in the field of art criticism was that Berenson, perhaps in an echo of his youthful Talmudic studies, directed attention to the myriad visible *details* of the images he was describing. These he methodically, almost obsessively, classified, compared, and memorized. It was akin to building the precursor of a visual database, with the aid of which he would then patiently sift through the work of a given artist, slowly dissecting and refining. The distillate of this analytic process would then constitute the core of that artist's essential qualities – his *style*. Berenson's predecessor and mentor, the Bergamasque connoisseur Giovanni Morelli (1816–91), had first understood the value of this method, but never extended its application in a systematic way.

From his earliest time in Italy, Berenson realized that the ability to distinguish one artist's style from another's and the possibility of arranging such observations into a coherent chronological pattern was of significant potential value – monetary value. Indeed, it was just in these waning years of the nineteenth century that wealthy American col-

lectors were beginning to turn away from the Barbizon and French Salon works that were the stock-in-trade of well-established firms such as Knoedler in New York and Goupil in Paris. Their new interest was the Italian Renaissance. Mrs. Gardner was one of the first to cast an acquisitive eye in this direction and so ... who better than Berenson, the bright, discerning observer on the scene, to provide information and advice? Besides, she had helped to pay the fare and continued an intense correspondence with him (also regarding his commission structure). Edward Warren, Berenson's other patron, also sought advice from him, but he eventually delved into classical art. After Mrs. Gardner's first tentative nibbles, Italian Renaissance art became her all-consuming passion. She acquired voraciously with an insatiable passion, aiming higher and higher. In 1896, on Berenson's advice, Mrs. Jack purchased Titian's great *Rape of Europa* from the London dealer Gutekunst. It was to be the crown jewel of her dream museum/residence, a mock-Venetian *palazzo*, completed in 1903.

That same year, Berenson was photographed posing in a jaunty double-breasted suit below the masterpiece *he* had just acquired – the magnificent *Virgin and Child* by Domenico Veneziano. Standing in the large drawing room overlooking the gardens of Villa I Tatti in Settignano, above Florence, the young scholar was beginning to reap the rewards of his genius for identifying and classifying works of art. Isabella Gardner was to continue her acquisitions through Berenson until the values of important available paintings outstripped even her considerable purse. In 1912 she was obliged to plead lack of funds on an offer from Berenson to acquire another of Titian's masterpieces, the earlier *Sacred and Profane Love*. A princely bankruptcy obliged the Borghese family to sell, but, fortunately for Italy, a deal was eventually struck with the state and the painting stayed

put in what is now the Villa Borghese Gallery. By fortuitous coincidence, just as Mrs. Jack was abandoning the field, Joseph Duveen began calling on Berenson to aid him in servicing an ever-expanding base of American clients for whom Italian Renaissance art became an ultimate badge of distinction. Duveen, of course, was the flamboyant and extravagantly successful English art dealer with whom Berenson was to establish a close professional – indeed, contractual – relationship. This ended in 1937 with their famous quarrel over the attribution of the so-called *Allendale Adoration of the Shepherds*. It was an emblematic event that reveals the exalted level of regard to which an opinion by Berenson had risen – indeed, to the point that Duveen found it impossible to convince Andrew Mellon to purchase the splendid panel. The dealer had recently bought it from Lord Allendale, but Berenson refused to underwrite an attribution to Giorgione.

Authority of such persuasive power was accumulated and nurtured by Berenson over decades of intense study and observation. What is often overlooked is that, by the time he undertook his researches, not only had photography evolved sufficiently to become a practical and accurate recording tool but also, by the turn of the last century, two Italian firms, Anderson and Alinari, were building impressive image inventories of paintings, sculptures, and architecture. The capital role that photography played in Berenson's career cannot be overemphasized: His appetite for images was insatiable. They arrived at I Tatti by the hundreds, solicited and un-solicited, from all over the world. The *fototeca* – really the first of its kind in the world – eventually grew to thousands of items, each carefully examined, annotated, and classified in a vast array of files that to this day continue to yield precious information on attribution, provenance, and condition. This is the resource that allowed Berenson to draw

up the famous "lists" that are an integral part of his publications on Venetian, Florentine, and Central Italian paintings and that were revised over several successive editions. They constitute "art history" of a very peculiar variety, certainly far more compelling than the airy aestheticizing musings of many of Berenson's predecessors and contemporaries – and yet, quite different from the rigorously documented and historically contextual accounts given to works of art by later scholars. The academic Roberto Longhi, possibly the last century's most brilliant and prolific writer in this more "modern" vein referred with unforgiving humor to Berenson's "lists" as the "railroad schedules of Italian art." He also tauntingly referred to "Professor" Berenson – a title Berenson abhorred. The environment at I Tatti was decidedly *un*-academic. Rather, life and work there were as if in a grand Edwardian country house, presided over by a munificent, cultured dilettante.

The fact that the "lists" are still mined by scholars for useful information is a measure of their author's often uncanny insight. One illuminating example is the exceptionally rare and fine *tondo* representing an *Adoration of the Shepherds* by the Florentine High Renaissance artist Piero di Cosimo. The Roman dealer Sestieri had identified it in the home of an Italian nobleman in 1960. But there was a problem: Another, virtually identical version of the painting had hung in the Uffizi for decades. The collector Count Vittorio Cini, to whom the rediscovered work was offered, was understandably reluctant to purchase a painting that had every probability of being considered simply a later knock-off of a well-known prototype. Further research, however, revealed that Berenson had carefully (in 1915) annotated on the back of the Uffizi photograph his reasons to file it away: as a "copy after a lost original"! Even after he died, Berenson

had the final word; the painting is now part of the Cini Foundation in Venice, and the other version in the Uffizi's storage.

Another famous photograph of Berenson was taken in the early 1950s when he visited the Villa Borghese gallery in Rome; no, not the one where he gazes wistfully at Canova's voluptuous nude Paolina, but the one where he leans forward toward a Cranach, peering at it through a fine, silver-rimmed looking glass held gracefully in his fragile yet nobly sculpted hand. It is the very image of worldly, refined connoisseurship: the scholar wearing a precious Panama, his handsome, aged features seen in lost-profile. It must have been a moment like so many others endlessly repeated throughout Berenson's life; an intense, quiet pause as his companion Nicky Mariano, and possibly others accompanying, looked on in expectation for the sage to draw back slowly from the painting and pronounce an opinion of dense significance. Of course, the question has always hung in the air: What did he actually *see* through that elegant *loupe*? For paintings of certain schools and periods, the answer is: probably more than anyone alive, before or since. Something that he surely did *not* see was the state of conservation of many of those paintings. From the time, probably around 1915, when he fell for a *Trecento* concoction by the great Sienese forger Federico Ioni, Berenson nurtured a profound mistrust of skillful artisans and restorers; he simply felt uneasy about painted *surfaces* – as opposed to painted *images* – and when possible, he always sought the advice of the one conservator he trusted implicitly, the Florentine Giovanni Marchig.

Interpreting Berenson's life and accomplishments in terms of art history is really the easy part. He came on the scene at a time when the criteria for judging paintings, especially Italian ones, were hopelessly confused, despite the early spadework done by Morelli and the combined efforts

of Giovanni Battista Cavalcaselle and Joseph Archer Crowe. The huge task of classifying and arranging these paintings by artists, schools, and periods must be his greatest contribution, equaled only by the criteria he developed for the understanding of earlier Florentine drawings. "Discovering" Lorenzo Lotto was also an innovative and valuable achievement but, like many of his other more extended texts on matters of style and content, the monograph is still replete with aesthetic musings that now have a very dated ring, not to mention the famous – but now virtually ignored – ruminations about "tactile values" and "life-enhancing" properties sprinkled throughout his other writings. There is really no need, at this late date, to wonder what to make of Berenson's "place" in art history: every time an Italian Renaissance work is analyzed or catalogued, his name invariably reappears. This, of itself, is remarkable enough in a discipline that is still rapidly evolving.

The many other facets of Berenson's life and intellectual pursuits pose far more complex, and often fascinating, questions than the obvious art-historical ones. This is perhaps one reason that the subject continues to stimulate research and produce books; a seemingly endless stream of them. In 2004 there was even a play (*The Old Masters* by Simon Gray) that ran successfully in London, and, for a time, a producer seriously considered a musical version of this biographical pastiche! Between 1979 and 1987, Ernest Samuels published a thorough and scholarly two-volume account of Berenson's life, while, almost simultaneously, two further books appeared: the gossipy and lightweight *Being Bernard Berenson* by Meryle Secrest in 1979 and, in 1986, the scurrilous *Artful Partners* by Colin Simpson. The latter was justly savaged in these pages (March 1987) when reviewed by Michael Thomas. Berenson also plays a leading role in a vast range of articles, memoirs, and biographies such as his pupil

Kenneth Clark's *Another Part of the Wood*, S.N. Berman's *Duveen*, and the story of Villa I Tatti as told by William Weaver in *A Legacy of Excellence*. It would seem legitimate, at this point, to ask: does the world need another book on Bernard Berenson?

148

It was in an attempt to delve more deeply and perceptively in those other facets of Berenson's life and intellectual pursuits that the author Rachel Cohen returned to the subject in her new biography, *Bernard Berenson: A Life in the Picture Trade*. And, as to the question above, the answer is – yes; there is still much to learn and to savor about this remarkable man. Were it for the title alone, one would be hesitant to peer beyond the cover, fearing a re-digested version of Colin Simpson's screed, a feeling reinforced in the in-leaf blurb by Cynthia Saltzman, the author of *Old Masters, New World: America's Raid on Europe's Great Pictures*. Her book is remembered, if at all, as a not very thoughtful indictment of the dealers, collectors, and experts who collaborated (she would say "conspired") to fill America's museums with the great European art that we now have the privilege to admire every day. The trope of American buccaneer millionaires and their cohort of plunderers is, of course, a horse that has been thoroughly well beaten over the years and will probably continue to suffer abuse well into the future. On the same cover (but not elsewhere in the volume), there is a subtle suggestion that Cohen's book may be different; the publisher, Yale University Press, discreetly indicates that the volume is part of a series on "Jewish Lives." This promise – and it is a promising start – is fulfilled in the first chapters as Cohen traces the migration of the Valvrojenskis from the Pale of Settlement to Boston. The family's problematic adaptation, and eventual assimilation as "Berenson," is a classic story of fortitude, endurance, and fierce intellectual engagement. As it concerns the young Bernard,

it is a story with which we were heretofore unfamiliar and it is told in fascinating and moving detail.

As the brilliant young scholar progresses ever forward and upward, the ambiguities he experienced about his "Jewishness" surface again and again. While this is an aspect of his later life that is better known, it is fascinating to learn how it affected him in childhood and adolescence. Revealing as well is the author's account of how Berenson survived the later years of the Fascist regime and, crucially, the year during which the Nazis occupied Northern Italy and he was obliged to live in hiding. There are other details that might have added depth and texture to the harrowing tale. One is the almost forgotten heroism of Gerhard Wolf, the German Consul General in Florence, a cultured and humane civil servant who attempted desperately to save the city's bridges from the Wehrmacht's dynamite and was a willing accomplice in "covering" Berenson, the Villa I Tatti, the art treasures and library it contained, as well as those who remained there. Another unsung hero is Ludwig Heinrich Heydenreich, the Director of the German-financed Kunsthistorisches Institut (Institute for Art History), a close friend of Berenson, who also protected him and was instrumental in preventing an even worse fate for Florence's art treasures during the closing months of the war.

Perhaps the most illuminating passages of the Cohen biography are those that describe the long and colorful parade of exceptional women with whom Berenson shared some of the critical chapters of his life. The list begins within the family with his sisters, particularly Senda. Then, of course, there was Mrs. Jack who set the young scholar on his way, and Mary Smith Costelloe whom he married and to whom he remained intellectually – if not otherwise – close for the rest of her life. A great love blossomed, and was perhaps even consummated, with the beautiful and exotic Belle

da Costa Greene, guardian angel of J. P. Morgan's great bibliographic undertaking. A surely chaste, but no less intellectually rewarding, relationship with Edith Wharton endured for years. There were others, of course: the writers Janet Ross and Vernon Lee (Violet Paget), the socialites Lady Sybil Cutting and Baroness Alda Anrep; but it was the latter's sister, Elizabeth "Nicky" Mariano, to whom Berenson became most attached and owed the most. Beginning as an assistant in the growing I Tatti library in 1919, Mariano gradually became the soul of the villa and remained so until Berenson's death. She and Alda were of Baltic origin and spoke several languages fluently. Nicky's perfect German literally saved Berenson's life in the darkest hour of the Nazi occupation, and, apart from her stalwart guardianship of the house in his absence, she assisted in all manner of logistical details including the management of the continuing and massive flow of correspondence. After Mary's death in 1945, Nicky became Berenson's constant companion in his studies, on his travels, and, finally, by his side when he died. She emerges from the pages of Cohen's biography as a heroine and the scholar's truest paladin.

Berenson's life was a great deal more than one spent "in the picture trade." Although this trade undoubtedly financed the quality and style of how the man lived, it also allowed him to make remarkable contributions to our culture; in his writings and vast correspondence, in his guidance to younger scholars, and, finally, in the unparalleled value of his bequest to Harvard University. The splendid Villa I Tatti with its gardens, its great art collection, and, above all, its library and archives is a resource that continues to further humanistic scholarship at the very highest level; it is a legacy worthy of the man.

December 2013

On the Italian art critic & scholar.

THE RECENT GIORGIO MORANDI EXHIBITION, so artfully installed in the Lehman Wing of the Metropolitan Museum, was for many an opportunity, perhaps for the first time, to discover a surprisingly unfamiliar Italy – not the Italy of Roman antiquity, nor the Italy of the Renaissance city-states, not even the Italy of Baroque splendor – cultural landscapes with which an American public is reasonably enough acquainted. With Morandi, instead, we entered a far less well-traveled territory: the Italy dating from the threshold of the twentieth century through the end of the Second World War. It was a period during which, for more than twenty years of Fascist government, the country existed in a self-inflicted isolation willed by a purposeful, nation-obsessed, but fundamentally provincial, regime that is euphemistically referred to as the *ventennio* (twenty-year span). This, of itself, would have been reason enough for our Anglo-American culture to pay scant attention to "modern" Italy. Philosophers such as Benedetto Croce, Giovanni Papini, and Giovanni Gentile, writers of the stature of Pirandello and D'Annunzio, and a number of accomplished and significant artists, including, of course, Giorgio Morandi, are, to this day, little known beyond Italy's borders; or, more accurately, not well enough known. Perhaps only Giacomo Puccini, by virtue of the universality and magic of his music, has been genuinely embraced and understood everywhere from the very beginning. Whatever the cause, Italian culture, from 1900 until

the post-war *Miracolo Economico* and the fashion and design explosion of the 1960s, has remained somewhat removed and out of focus.

152 The period has now been vividly recalled with the Morandi exhibition. It should, however, be pointed out, *not* by virtue of the visual evidence revealed in the paintings; these have invariably, and correctly, been described as suspended in a timeless, magical vacuum, devoid of information and reference – sufficient unto themselves. To understand the historical context, therefore, one must turn to the excellent catalogue that accompanies the exhibition. Various essays, particularly those dealing with the years 1913 to 1940, provide the necessary perspective – the *milieu* – within which Morandi's art developed and matured.

One of the first names encountered, not only in this catalogue but on the wall labels as well (eight paintings and drawings on view had belonged to him), is that of the art critic and scholar Roberto Longhi, interestingly, an almost exact contemporary of the painter. Recalling his presence in Morandi's environment is amply justified for they were friends and nurtured boundless admiration for each other. The perceptive essay by Neville Rowley, "A 'Light without Color': Giorgio Morandi and Piero della Francesca," is particularly revealing of the relationship between artist and art historian. In the event, the latter now warrants separate attention.

Almost forty years have passed since Roberto Longhi died at "Il Tasso," his villa on the southern outskirts of Florence. With his death, the world of art history lost one of its most original and memorable voices. The word "voice" is particularly appropriate because Longhi had, to an astonishing degree, the perception, knowledge, and wit to *enunciate* his art-historical and critical pronouncements with a style and language that are, of themselves, works of art. Lamenta-

bly, even today, only a fraction of Longhi's vast bibliography is available in English translation. The delight of reading him is necessarily a privilege reserved not to the merely fluent but rather to the highly proficient in his native tongue. Yet, despite this, Longhi's stature remains undiminished.

153

Roberto Longhi, whose family roots were in the Piedmont and Emilia regions, gravitated to Florence shortly before the Great War after university stints in Turin and Rome. This may have been at the suggestion of his teachers, the art historians Piero Toesca and Adolfo Venturi, but it was also undoubtedly prompted by the lively energy generated at that moment in the city's intellectual, artistic, and literary circles. Not surprisingly, the young saw the new century fulfilling the promises of renewal engendered during the previous fifty years – the Italian Risorgimento. Longhi's generation was keenly aware of the headlong and almost reckless innovation that, after the Impressionist and Post-Impressionist revolutions, confirmed Paris as the wellspring of modernity. Marinetti, Caro Carrà, and Gino Severini were there in the thick of things during those years but, more importantly, so was Ardengo Soffici, a Florentine artist and writer of prodigious energy who served as megaphone and gazetteer. *La Voce* and, later, *Lacerba*, two periodicals that were published in Florence after Soffici's return there, became clearing houses for information and battlegrounds for endless heated debate. Futurism, Cubism, and Symbolism were the harbingers of the New, and the proponents of each engaged in ceaseless and often overheated polemics in Soffici's pages. The young Roberto Longhi appeared frequently in those same pages with the trenchant, perceptive observations and inimitable style that became hallmarks of his later writings. It is important to note, however, that Longhi never marched under this or that modernist banner. In other words, despite his youthful

enthusiasm and boundless curiosity, he was perceptive enough not to allow his eye to stray too far from Cézanne, the one artist whom he recognized as being the essential point of reference for so much that followed later in the century. It was an insight that served him well when he turned to the Italian Renaissance in the aftermath of the Great War.

That tragic calamity precipitated a violent, almost schizophrenic, rupture within the ranks of Europe's intellectual and artistic elite. On the one side, there was a rush towards ever more radical and "disruptive" expressions of the *avant-garde*; on the other, there was a predictable reaction, forcing the pendulum to swing back towards "order" – and to the roots of European culture which were perceived as being undermined and in danger. By the end of the war, Roberto Longhi had irrevocably chosen this second path; he understood that his remarkable gifts were ideally suited to the task of *seeing* the past through the lens of art history, a relatively young discipline which, at this point, had not yet fully developed into the rigidly structured intellectual pursuit that has since become the norm in lecture halls and specialized periodicals. Longhi, therefore, was free to practice art history unfettered by academic orthodoxy, bringing to it a free-wheeling style and literary flair that owed much to D'Annunzio and a fresh modernity that echoed the irreverence and innovative exuberance of *La Voce* and *Lacerba*.

Longhi's precursor from an earlier generation was Bernard Berenson, by 1920 very much the absolute arbiter of all that pertained to earlier Italian Renaissance painting. Berenson, a Harvard-educated and gentlemanly dilettante, was the reigning seer of Villa "I Tatti" in Settignano. True to the tradition of Edwardian aestheticism, "BB" studied and wrote about art as a life-enhancing occupation – indeed, he always studiously avoided the lecture podium and abhorred the title "Professor." Longhi, an irreverent and lifelong

enfant terrible, never lost an opportunity to tease his elderly colleague, north across the Arno. One of the more stinging barbs aimed in that direction was his calling Berenson's massive compendium of Italian Renaissance paintings – laboriously assembled over decades and first published in 1932 – "The Railroad Timetable of Italian Art."

But their differences ran deeper and were more significant: Berenson, as did many of his contemporaries, saw the birth and early development of Italian Renaissance art as predominantly "Florence-centric" – a relentless march along the Giotto-Masaccio-Michelangelo axis. Of course, other regional schools were studied and understood, but Florence inevitably remained the point of reference; even the greatest of non-Florentines – Raphael – was given little room to stray from the scenario. Demonstrably, drawing (*disegno*) and perspective had been the tools that had allowed Florentine artists to re-create the world in man's image, a world that was clear, rational, *true*. Only Venice, with its color (*colore*), was considered as being distinct and apart – a hoary notion born with none other than Vasari. Significantly, Berenson's first major art-historical contribution was his seminal study of Florentine drawings, first published in 1903.

Roberto Longhi engaged the issue of Italian Renaissance art from quite a different perspective, armed as he was with aesthetics and perceptions conditioned by his early proximity to the "moderns." It was as if the very soundness and reasonableness of Florentine art irritated him – perhaps those careful, well-behaved *professori di disegno* (as he half-mockingly called them) simply bored him. Longhi cast his net far beyond Florence and far beyond the sacrosanct fifteenth century (Quattrocento). An overview of his writings is virtually impossible given the breadth and variety of those contributions. This immense body of work, however, could be condensed to three capital chapters of Italian art

that Longhi essentially rewrote and reinvented: Piero della Francesca, Caravaggio, and the art of Ferrara. It is fair to say that, although there has been considerable clarification and revision of these subjects since his time, Longhi's accounts of them still stand; they remain the foundation of all subsequent studies.

Our contemporary understanding of Caravaggio, for instance, perfectly illustrates this point. Before Longhi, the great Lombard painter was only dimly perceived, and even more scarcely appreciated. He was an artist summarily lumped among the "tenebrists," which, at the time, was as pejorative a term as "baroque." In 1922, however, the enlightened efforts of two influential art-world figures, Ugo Ojetti and Carlo Gamba, resulted in a massive gathering of seventeenth- and eighteenth-century Italian paintings that filled dozens of rooms in Florence's Palazzo Pitti. The exhibition is remembered as an epochal event in the evolution of modern art history, bringing, as it did, "later" Italian art emphatically center-stage. Fifteen masterpieces by Caravaggio were rightly placed as the opening trumpet-blast to the great parade that followed: from Cavallino, to Gentileschi, Piazzetta, and Crespi – all names that, with this event, also began to emerge from the shadows.

Interestingly, a further eighteen paintings were either attributed to Caravaggio or his school, a clear indication of the uncertainties surrounding his name. In fact, after almost three centuries of silence and neglect, the outlines of Caravaggio's art had become confused and indistinct. Although his genius was recognized and his works were copied and endlessly imitated by legions of his own contemporaries, the infatuation did not last long; by 1650 "Caravaggism" had virtually disappeared in Europe as a style, every one of the artist's followers having soon mastered the technical tricks and then moved on. What remained was a welter of widely

dispersed, mostly undocumented, look-alikes, occasionally of exceedingly high quality. This was further complicated by the artist's own biography; the romantic story of a notoriously misanthropic, belligerent loner, often on the run, yet ceaselessly at the easel. The unfortunate result was that, by the turn of the last century, the world was replete with "Caravaggios" only a fraction of which were by the master himself. Happily, the reconstruction of a credible profile for such an elusive artist proved to be an ideal task for a critic with Longhi's unique gifts; it was, as they say in Italy, "bread for his teeth." His masterful review of the 1922 exhibition immediately corrected numerous wayward attributions but, more importantly, it was a prelude to the scholar's further studies which culminated, more than three decades later, in the 1956 Caravaggio exhibition held in Milan. It is still referred to as the "Longhi show" and remains the point of reference for an avalanche of critical literature on the artist that has since poured onto bookshelves. No need, therefore, to stress the importance of continued access to his insight and the impressive scholarship underlying it.

Fortunately, the lamentable scarcity of important Longhi texts in English translation is finally and painstakingly being corrected. To date, only two have appeared; *Piero della Francesca*, and a set of shorter but no less important studies. These last are typical of much of the critic's bibliography; they are relatively short, incisive investigations focused on specific artists or works that first appeared in periodicals or were transcribed from university lectures. *Paragone*, the prestigious bi-monthly journal that Longhi had initiated in 1950 and that survives to this day, became after that date the principal vehicle for his writings.

Bringing Longhi texts to English-speaking readers is a collaborative undertaking, initiated more than a decade ago between the art dealer and author Stanley Moss and the

translator David Tabbat. One hopes the arduous task will continue and will extend to other groundbreaking studies, in particular *Officina Ferrarese* (The Ferrara "Factory"), the Caravaggio monograph, and perhaps *Lavori in Valpadana* (Works in the Po Valley). Ideally, the list should be far longer and might one day even include the remarkable 1914 review of Boccioni's sculpture.

The Piero della Francesca translation appeared in 2002 and serves as an ideal point of departure. Longhi had published a provocative article on the artist as early as 1912, and, by 1927, this study was transformed into a full-fledged monograph (which saw further editions in 1942 and 1962). When the scholar first turned to him, Piero was an artist whose stature, although generally acknowledged, was still considered "marginal" simply for his having been a non-Florentine. The virtual disappearance of his name from antique textual sources after Vasari had also contributed to this relative obscurity. This changed dramatically with Longhi's monograph: it boldly reconfigured the progress of Italian Renaissance art by placing Piero at the very center of that phenomenon. It did this while giving an unforgettable account of the artist's genius. No doubt Longhi's early encounter with Cézanne, an enthusiasm that never abated, served as essential preparation, suggesting to him formal analyses that have withstood the test of time and have propelled Piero's achievement to an absolute pinnacle in today's historiography – not to mention popular mythology.

But such fashionable excesses aside, a correct and essential perspective can be found in the brief but incisive introduction to *Piero della Francesca* by Keith Christiansen of the Metropolitan Museum. In it, he cites Longhi's assessment of the great fresco cycle in Arezzo (*The Story of the Cross*) as having "formed the basis for the twentieth century view of Piero as a forerunner of modernism." For Christiansen,

Longhi "remains the key Italian critic of the twentieth century." It is surely not an idle compliment, although lingering questions remain regarding a basic premise of the Piero monograph; that the artist was a determining influence on contemporary and later Venetian painting – what Christiansen calls Longhi's "pan-Piero thesis." In advancing this startling proposition, the scholar drew on his vast knowledge of the visual as well as the documentary record pertaining to Central Italian painting, establishing previously unsuspected connections across geographical and temporal boundaries – all the lines pointing towards Venice. As radical and controversial as the notion may be, the reading of it, even in translation, is immeasurably enriching. The critic does what criticism is meant to do: instruct, surprise, reveal, and occasionally confound.

159

Christiansen comments further on the other important aspect of Longhi's stature as a critic – his prose: *Piero della Francesca* "will come as a revelation to English-speaking students who think of art history as an arcane discipline heavy with the musty air of the archive." And with this, he introduces Longhi the literary stylist. In fact, no one familiar with his writings has failed to comment on their brilliance; read in the original Italian, the delight is increased by a language that bristles with exotic and unexpected counterpoint culled from sources as diverse as Dante, Cennino Cennini, Ariosto, and D'Annunzio. The effect can be dizzying. Some years ago, an enterprising young researcher even compiled a glossary of terms used – and occasionally invented – by Longhi. It contains hundreds of entries and runs to one hundred and seventy pages!

A small example is the invented word lunato, derived from the word *luna* (moon) and twice used as an adjective to describe certain shimmering reflections depicted in the Arezzo frescoes: odd, but wonderfully appropriate. Another,

more memorable neologism coined for *Piero della Francesca* is *formacolore*, a combination of two distinct words: "form" and "color." It served the author admirably in identifying another core proposition of the book: that Piero's great merit was to create form and substance in a spatial context (yet on a two-dimensional picture plane) by subsuming drawing and outline in a structure defined principally by color. In Longhi's far more evocative words: "understanding that it was necessary to contain the snaky meanderings of functional line within the inexorable pipelines of perspective so that, properly irrigated, the vast fields of color might all burst into flower together." No one would disagree that, while speaking of Piero della Francesca, Longhi might just as easily have been referring to Cézanne or Morandi.

Obviously, putting Longhi in another language requires very special skills: a solid grounding in art history, impeccable command of Italian, abundant imagination, and a fine ear for the author's linguistic exhibitionism. David Tabbat, the *Piero della Francesca* translator, possesses all these skills in abundance. In his introduction, he declares the task "hair-raisingly difficult," correctly identifying those grammatical characteristics of Italian which allowed Longhi to construct sentences replete with "ecstatic labyrinths of dependent clauses" – unthinkable in English. Despite the obstacles, and thanks to Tabbat's commitment and intelligence, both the substance and the style of these valuable texts are now within reach. One day, we may even be able to savor the endless variety of Longhi witticisms, mostly to be found in pitiless reviews of colleagues' work, such as the one aimed at Ellis K. Waterhouse, identified on this occasion as "that English dilettante who, with better linguistic and Italian accuracy, we shall call the *Casalacqua*."

And, after the language, what recollection of Roberto Longhi would be complete without an account of the man in

person? – that gangly, six-foot-plus, disheveled, and gesticulating giant whose pinched, owlish face was overshadowed by a disproportionally huge nose? Encounters with Longhi were likely to yield memorable examples of his wit, imagination, and talent as a mimic. Once when he was confronted with a painting attributed to Tiepolo, but with rather weaker passages, the critic created on the spot a hilarious dialogue (in impeccable antique Venetian dialect) imagining the great master scolding his son Giandomenico for his below-par performance. Or the time, when examining a representation of the fifteenth-century Saint Bernardino of Siena, Longhi was asked what the curious little wooden contraption hanging from the friar's rope-belt might be. Instantly, and with total improvisation, the critic replied, "Why, don't you see? . . . it's obviously a castanet!" thereupon breaking into a spirited flamenco and transforming the ascetic and saintly Bernardino into a cabaret dancer! As Jacques Barzun, that other great twentieth-century critic, once observed: "the lovers of puns have always been the men with the largest minds, who can afford to be silly."

With Longhi, one might well add "afford to be silly *and* moderately corrupt." For even Longhi's most ardent admirers will admit that his legacy remains tarnished by all-too-human weaknesses. One was a passion for poker (at which he must not have been terribly proficient). Losses were more often than not financed by the production of curiously short, handwritten letters which claimed lofty attributions for paintings of – at best – questionable merit. Yet, even these unfortunate scribblings, if read between the lines, are not devoid of the great critic's astute and even malicious wit, an edge that surely must have been lost on their recipients.

Despite this small footnote, Longhi will be remembered for having transformed the discipline of art history and molded it to suit his own remarkable gifts. Although he

applied to it immense erudition and a firm grip on the historical and documentary record, Longhi relied first and foremost on the visual evidence that works of art afforded him. In this important aspect he was ever as much the consummate connoisseur as Bernard Berenson, paradoxical as that may have seemed at the time.

Longhi's remarkable powers of memory allowed him to retain voluminous visual information, putting it ceaselessly to the task of comparing, of matching it against this or that new or unforeseen counterpart. Significantly, he entitled the periodical he founded *Paragone* – "comparison." Works of art, he said, "observantly examined in the relationships between one work and another, inevitably dispose themselves in a historically developing series." To this, he added the truly radical statement: "criticism of the figurative arts has no real intellectual need of biographical or chronographical assistance." Connoisseurship practiced at this exalted – almost mystical – level is very seldom encountered. Yet recalling Roberto Longhi with this in mind and at this moment affords an opportunity to reflect on an issue closer to home: the imminent passing of the baton at our own Metropolitan Museum. The retiring Director of this great institution, in more than thirty years of leadership, never averted (as so many of his colleagues have) his attention from, nor dedication to, the essentials of art criticism: scholarship, intuition, and taste – in a word, connoisseurship. Although this lesson may not have derived directly from Longhi, it's probable that Philippe de Montebello would readily acknowledge its value. Throughout his stewardship he practiced its dictates diligently and demanded no less of his curators. The results have recently, and justly, been celebrated. May that tradition continue well into the future!

December 2008

On Norton Simon's legacy in the art world.

ON A WARM SPRING DAY in 2007, hundreds of people from the business, academic, and art worlds filled the auditorium of the Norton Simon Museum in Pasadena. They were there, summoned from near and far, to pay homage to the memory of the man whose name was, and remains, on that institution's door. The occasion marked what would have been Norton Simon's hundredth birthday. It's interesting to speculate how the centenarian would have reacted, had he been on stage (he died in 1993). Chances are that all the participants would have been taken to task by the notorious contrarian whom everyone in attendance had known. He would have, no doubt, relentlessly challenged, questioned, denied, or justified the bountiful outpouring of accounts of his extraordinary career. Many of these recollections were warmly admiring, almost hagiographic, others quite disparaging – but all, for better or worse, helped to reveal a man of singular temperament and character.

The symposium, as the event was described, was arranged in separate "chapters." During the morning session, a number of business associates and executives of Norton Simon, Inc., one of the nation's first conglomerate corporations, recalled interesting episodes from their participation in building an empire that eventually comprised Hunt Foods, Canada Dry, Avis, and Republic Steel. We learned that, though these later Simon holdings represented huge capital assets, they were by no means the fruits of a self-made man's

undertaking. Simon's father, Myer, had been a successful wholesaler of agricultural products in northern California whose firm, Simon Sells for Less, served as the springboard for the son's career. It's amusing to consider that "Simon Buys for Less" might well have described even better Norton's approach to buying anything, especially art. Art was, in fact, the focus of the afternoon's proceedings. It was also the reason I was pleased to have been called on stage with such a prestigious group of dealers, scholars, and museum professionals; all of us had experienced, and occasionally suffered from, the intense, unrelenting pressure of Simon's fierce, probing intelligence.

By the mid-1950s, Norton Simon had already achieved a significant level of business success and personal wealth. At that point, he had probably never set foot in a museum nor cracked the cover of an art book. In fact, he later admitted that he viewed the "art world" from a decidedly philistine perspective: it was nothing more than a haven for phonies, queers, and fraudsters. Despite this strongly held prejudice, Simon was now a very rich man, and owning art was part of the script. He and his first wife began to line the walls of their Hancock Park home with paintings. In the process, Simon – a notoriously quick study – began to understand how the art business worked and how its imperatives related to the academic and museum worlds. Art had real value; it was a real business. He soon became acquainted with the principal dealers and auction house functionaries in New York and London, expanding his own notoriety as a collector beyond California. Might the time have come to go for the brightest of gilt-edged names – Rembrandt? It was an irresistible temptation and the moment proved auspicious because, by 1965, the distinguished collection of Sir Herbert Cook was being dispersed by his son, Sir Francis. The star lot in the Christie's sale that March was the captivating *Por-*

trait of a Boy (1655–60), thought at the time to be a likeness of the artist's son, Titus. Simon was in the room and, from a semi-unknown, was instantly transformed into a celebrity. Counting on remaining stealthily anonymous, he had previously instructed the auction house in writing:

> When Mr. Simon is sitting, he is bidding. If he bids openly, he is also bidding. When he stands up, he has stopped bidding. When he sits down again, he is not bidding until he raises his finger. Having raised his finger, he is bidding again until he stands up again.

This tricky ploy may have been just too much to absorb for Christie's chairman, Peter Chance, a very old school gentleman-auctioneer. He missed the signal and knocked down the picture to the Marlborough Gallery for £700,000, whereupon Simon leapt out of his seat and loudly demanded that the bidding be reopened, an unheard-of request. Not surprisingly, Simon won the day, and the painting (for a £70,000 premium). It was his to keep, and the art world took notice. Simon was now off and running, becoming in due course the world's most acquisitive collector. It was a distinction that would remain unchallenged for the next two decades. What Simon accomplished during those twenty years is truly astonishing. In quick succession, the range of his interests expanded exponentially to include Impressionist and Post-Impressionist painting, Degas sculpture, Italian Renaissance and pre-Renaissance painting, and Indian and Far Eastern sculpture, not to mention all manner of graphic art.

The saga began with an early, modest step: a visit Simon paid to the legendary Duveen Gallery in 1962. During the first decades of the last century, Sir Joseph Duveen (later, Lord Duveen of Millbank) had been the purveyor of the

finest of fine arts to the likes of Frick, Mellon, Widener, and an endless roster of other, lesser nabobs. Although Duveen had died in 1939, the business, formally, still existed, no longer in its original Fifth Avenue palazzo but in Duveen's private residence, a no-less-grand townhouse on East Seventy-ninth Street. Simon was welcomed into this rather melancholy grandeur by Edward Fowles, to whom Duveen had bequeathed the premises and its contents. Fowles had been the gallery's factotum for decades and was charged with liquidating what was left of the storied firm's holdings. Simon, sensing an opportunity, began nibbling at Duveen's remaining stock, little by little becoming so assiduous in his purchases that the elderly Fowles finally suggested that Simon "buy the store." No quicker said than done: the canny financier almost instantly recouped his costs by flipping the real estate to Nick Acquavella, the über-dealer William's father; the townhouse still serves as home to the eponymous gallery. The splendid Duveen library was sold to Williams College, a move that Simon later came to regret bitterly when he established his own museum. These transactions left Simon holding a motley assortment of works with distinguished provenance but of uncertain attribution and often in questionable physical condition.

Sorting things out for Simon's art properties was a young man called Darryl Isley. A bright, hyperenergetic recruit from one of the Simon tomato-canning enterprises in Fullerton, Isley soon teamed up with Sarah Campbell, another Hunt Foods graduate. Neither was a fine arts professional; both were instead chosen for their clear-eyed efficiency, honesty, and what turned out to be unshakable loyalty. Isley functioned as Simon's roving eyes and ears. His cheerful, unaffected manner soon earned him the trust and even friendship of the art market's machers as he skillfully and

diplomatically navigated the rough waters that Simon inevitably left in his wake.

It was thanks to Isley that my first contact with Simon occurred. Since 1961, I had conducted a paintings conservation practice in Europe, dividing time between a private studio in Florence and Lugano, Switzerland, where I was serving as a visiting conservator to the storied "Villa Favorita" collection of Baron H. H. Thyssen-Bornemisza. In early 1970, the Italian political climate promised only chaos, what with the Red Brigades and the Communist Party dominating the news. It was not exactly an ideal environment for a freelance professional catering to the "ruling class." As a result, I decided to devote my "Florence time" to pursuing work in New York, doing so from the dining room of a rented apartment on upper Fifth Avenue. This is where the ever-enterprising Darryl found me not long after my arrival. Untested as I was on these shores, Simon was wise to consign only bits and pieces of his "Duveen remainder stock," some of which had serious, even fatal, condition problems. Restoring these was a sure way of adding value, ever a compelling motivation for Simon. What could be rehabilitated, together with items previously collected, became a kind of "museum without walls." Sarah Campbell would diligently arrange loans to cultural institutions across the country, thereby garnering recognition and prestige for the works as well as their owner.

When my abilities must have been deemed sufficiently tested, I received a commission of great moment: the restoration of a stupendous altarpiece by Giovanni di Paolo, the Sienese Early Renaissance "expressionist." It was a painting that held unusual significance for me. The monumental panel had belonged to my grandfather Luigi, a prominent Florentine art dealer, until his death in 1937. He had sold

the imposing *Angels Surrounding the Virgin and Child* (*Branchini Madonna*) (1427) to Robert von Hirsch, a Swiss connoisseur whose collection ranged from twelfth-century Limoges enamels, to Rubens oil sketches, to Cézanne watercolors. The 1978 Sotheby's sale that followed his death is still remembered for the excitement it generated and the many record prices achieved. Simon's purchase of the panel was one of those records.

Direct contact with Simon became continued and intense as soon as the Giovanni di Paolo arrived on my easel. I joined that large and expanding constellation of professionals and scholars whose brains were relentlessly picked – any time, anywhere. Simon's thirst for information seemed insatiable. Even calls in the middle of the night were not unusual. As flattered as I was to be sought out by the world's leading collector, I soon realized that whatever insights I volunteered would immediately be compared and weighed against those offered by others. Simon had a way of collating the gathered information and then "distilling a resulting answer" that generally turned out to be correct. Value – monetary value – was, of course, of capital importance to Simon, and his approach to acquisitions was brutal and sometimes even sordid. Works of art were requested on approval in Pasadena, whereupon the seller would be subjected to an endless process of attrition, delays, and coercion. I remember accompanying Simon to examine a nearly eight-foot-high painting by Francesco Guardi, the celebrated Venetian eighteenth-century view painter; it was a remarkably impressive and colorful picture. There was, however, a problem: the totally anomalous subject was based on the *Gerusalemme Liberata* by Torquato Tasso – hence, no water, no gondolas, no billowing crinoline skirts ... in short, a tough sell. The painting was one of a handful of works remaining with Kate Schaeffer, the widow of a distinguished Viennese dealer who

had immigrated to New York before the last war. I remember Kate as a charming, gentle, and cultured lady with impeccable "old world" manners. By this time (1976) she was quite elderly, living alone in a large and dusty Park Avenue apartment, clearly looking to close things down. Simon was quick to realize not only the distinction of the Guardi but also the vulnerability of its owner. Sending the painting to California on approval was the beginning of an agonizing and protracted negotiation, punctuated by repeated calls to me by Mrs. Schaeffer imploring my help. It seemed that the lady's distress lasted for months, surely every bit as long as Simon could prolong the process and the pain.

It is for such tawdry episodes, and many others like it, that Norton Simon has left a legacy of personal conduct that is universally deplored (though one which was not too loudly emphasized during the memorial symposium). In my mind, despite the obvious devilry, the man did possess a unique merit: his forays in the art world were manifestly never prompted by considerations of status, social or otherwise. Simon, unlike all his predecessors, hardly gave a thought to "class." For him, art was neither a required ornament of civilized life nor a means of social advancement. *Au fond*, tycoons like Frick, Widener, even Mellon, lived and collected according to a model epitomized by the English grandee; they were all make-believe Dukes of Sutherland. Simon, in his double-knit leisure suit and rough manners, shunned all affectation and pretense.

There is an episode that I still vividly recall with a twinge of discomfort. In the fall of 1973 Simon and his second wife, the actress Jennifer Jones, were traveling in Italy and stopped to view an important exhibition of Lombard Baroque art in Milan. Aware of their presence there – only an hour from Lugano – I immediately informed my "boss," Baron Thyssen. The two had long competed as collectors

but had never met. "Heini" wasted no time in arranging a dinner at the splendid Villa Favorita, even sending his gigantic Mercedes limousine to fetch his guests. As they arrived, I proudly felt at the very epicenter of the art world. After dinner, we proceeded to the adjoining series of galleries where almost two hundred paintings were hung in stately array. Alas, my euphoria soon evaporated as I realized in what radically different realms the two collectors lived. Simon's was emphatically a *now* world: he insisted on knowing the cost of this or that item; would its value *now* be less or more than when purchased?; if there were two or more works by the same master, why not sell one *now*?; wouldn't restoration extract greater value? – all questions to which Heini could hardly respond and about which he became progressively more irritated. He had, after all, inherited a number of those pictures and long forgotten the prices of the rest. The evening was *not* a success.

Needless to say, I was bitterly disappointed, and, not surprisingly, the two collectors never crossed paths again. Fortunately, I enjoyed the privilege of the friendship and trust of both until their last days. In 1990, my wife, Cristina, and I visited California on a weekend "museum trip." By Monday, when we were scheduled to fly back to New York, we had still not been to the Norton Simon Museum in Pasadena. Naturally, it was closed; undeterred, we pleaded with the staff member at the door, hoping for a favor for such long-distance travelers. At one point, she asked for our name and told us to hold a moment while she made a call. Within minutes, a large van-like car pulled up, from which Simon was carefully lifted in his wheelchair. The debilitating illness afflicting him had progressed to the point that he could no longer move. It was shocking to see a man of such vigor so diminished, but also astounding to realize how laser-sharp his intellect and memory still were. The three of

us wandered slowly through the empty halls admiring the wealth of masterworks that had been gathered there in barely more than two decades of furious acquisitions. Favored works received special attention with Simon commenting, questioning, comparing. As he had done at the Villa Favorita, Simon remembered every price and debated every value. Particular reverence was paid to what was without doubt his favorite painting: Zurbarán's *Still Life with Lemons* (1633). Not only had it been one of the most expensive acquisitions, it consistently sold more postcards than any other at the front desk, a statistic that Simon followed closely, and one he never tired of repeating.

December 2019

On Baron Hans Heinrich Thyssen-Bornemisza &
J. Paul Getty.

THERE WAS A TIME, within living memory, when million-aires were considered in some quarters "enemies of the people." Today, the consonant M has been replaced by the consonant B and billionaires are now folk heroes; one is currently president of the United States. Moreover, until the recent past, possessing great wealth meant also visibly, even ostentatiously, enjoying it (thereby attracting the opprobrium just mentioned). One millionaire in particular may have enjoyed it more than any other: partying more, marrying more, and, in general, spending more – his name, straight out of a Franz Lehár operetta, was Baron Hans Heinrich Thyssen-Bornemisza. Vacuous and ephemeral as he may have been, "Heini" Thyssen remained, nonetheless, a passionate and very perceptive collector of European paintings and works of art throughout all of his adult life.

The grandson of the "German Carnegie," Heini was the heir to that portion of the Thyssen fortune that had been divided between his uncle Fritz, an early Hitler supporter, and his father, "old" Heinrich, who instead wanted no part of the new regime – going so far as to assume his wife's Hungarian name, title, and citizenship. He went one step further in the early 1930s and immigrated to Lugano, Switzerland. There, on a splendid lakeside property, he built a multi-gallery annex to house a collection of paintings that would eventually rival Henry Clay Frick's in New York. The

timing was surely right: a thumping buyer's market reigned for years in the wake of the Wall Street Crash of 1929, allowing Thyssen an opportunity to purchase, among others, two absolute masterworks from the Otto H. Kahn Collection in New York: Frans Hals's *Family Portrait in a Landscape* (*ca.* 1648) and the *Standing Knight* by Vittore Carpaccio (1510). The latter is the first full-figure portrait in Western art and the subject has been credibly identified as a likeness of the adolescent Francesco Maria I della Rovere. If this is true, the Renaissance grandee can posthumously boast of having sat for three of Italy's greatest artists: Carpaccio, Raphael, and Titian. The latter two portraits are in the Uffizi in Florence, one showing the victor of the Battle of Fornovo as a mature warrior in full military regalia.

Not surprisingly, "Thyssen" and "Villa Favorita," as the Baron's villa was called, were names familiar to me as I was growing up in Florence in a family that, on my father's side, had been involved in the arts, as dealers, for three generations. So, still in my early twenties, and fresh out of university and military service, I accompanied my parents to Lugano to view the storied Thyssen Collection, naturally as paying visitors. I was just beginning my apprenticeship at the Uffizi Gabinetto del Restauro, and my father never tired of accompanying me on my expeditions to see as many paintings in as many museums and exhibitions as possible. I passed another four years in more formal, academic training: first at the Istituto Centrale del Restauro in Rome and then at Zürich's Schweizerisches Institut für Kunstwissenschaft. At last, by 1962, I felt the time had come to start my own private conservation practice. Fortunately, Florentine palazzi have an overabundance of cubic feet – huge rooms no longer suitable for domestic use. In one such space I arranged the surprisingly few essential tools and materials needed to start work – work that began trickling in, mostly

from family friends. It was hardly a flourishing enterprise. Even then, Florence was rapidly disappearing from the "art world" map, a victim of the Depression, the War, and a waning interest in the Renaissance (Mannerism and Baroque were now the new flavors). Historic firms such as Bardini, Volpi, and even our own "Luigi Grassi & Sons" were long since shuttered, leaving only a smattering of small-time antique shops along the Via dei Fossi whose proprietors were anything but ideal clients for an ambitious paintings conservator at the outset of his career. I was even beginning to consider a move to London, or, possibly, New York.

Then, one day, *mirabile dictu*, things changed: an old friend called asking if she could visit my studio with someone she knew. The friend was a beautiful young German-Argentine woman whose father had retired to a villa in Fiesole, above the city; her friend turned out to be Heini Thyssen, the son of the originator of the Thyssen collection. The Baron was in the midst of paying furious court to the young lady – probably the only one who was to steadfastly refuse his marriage proposals. When the pair turned up at my studio door, I noticed that Thyssen was carrying a canvas tote bag. After some preliminary pleasantries, a polychrome wooden female portrait bust emerged from its ad-hoc packaging. Even as it was being placed on my work-table I recognized it at once as an almost comical late-nineteenth-century imitation of a Florentine Renaissance sculpture – the real item being so rare that Sherman Lee, the renowned director of the Cleveland Museum, described one as "the cow with five legs." Not wishing to play the smart aleck in my first encounter with one of the world's greatest collectors, I furrowed my brow and suggested that if he would consent to leave the object with me, I would carefully "study" it and render my opinion in due course. My visitors thanked me and departed. I thereupon immediately set to work preparing an

elaborate "technical," and unequivocally damning, report, replete with macro-photographs and comparative images from similar (genuine) objects in the Bargello museum and the Louvre. The thick dossier was dispatched to Lugano, not long after which I was invited to visit the "Villa Favorita," naturally in the company of the German-Argentine young lady. I never doubted for a moment that her ready acceptance was predicated by my presence as "chaperone."

When I turned up at the Villa Favorita for dinner on the appointed day, I was particularly pleased to note that I was being ushered admission-free through the garden gatehouse. An after-dinner tour of the gallery allowed me to demonstrate to my host some fancy attribution footwork, which, sadly, seemed to be lost on him, focused as he was on his other guest. We three reconvened the following day for lunch, at the end of which, quite nonchalantly, Thyssen offered me the position of resident conservator to the collection. After stammering something about needing to "think about it," I returned to Florence virtually walking on air. Breathlessly, I relayed the momentous news to my father. He instantly brought me back to earth by counseling me to refuse. In his wisdom, he well knew that there is considerable risk in putting oneself in the employ of an enormously rich and powerful person. One can be "in" one day and, just as arbitrarily, "out" the next – the fate famously suffered by Charlot in *City Lights*.

On the Baron's next visit to Florence, I had carefully rehearsed my reply to his offer: I proposed to him that I serve as "visiting" rather than "resident" conservator, proffering valid, but not necessarily convincing, reasons. I still vividly remember my excruciating anxiety as the three of us sat at Harry's Bar. I imagined my future career instantly evaporating should Heini's answer begin with "well, in that case ..." Instead, for more than twenty years – until 1990,

when the collection was relocated to Madrid – I was to enjoy the distinct privilege of having in my care a handful of masterpieces and dozens of other highly significant works. Particularly exciting for me were the instances when I was asked to examine items at sales or with dealers. Occasionally, these encounters resulted in works being added to the Thyssen collection. Several times, I was given the opportunity, by lesser-known private sources, of presenting the Baron interesting properties that might complement the collection's existing holdings. In one such event, an incredibly rare and sublime example of early Sienese art found its permanent home with Thyssen. It is the great and almost miraculously preserved *Crucifixion with the Virgin and St. John* by Ugolino da Siena (*ca.* 1330–35). The painting had not surfaced since the 1890s when it was published in the Toscanelli Collection catalogue. Another privilege afforded me was the pleasure of strolling at will, often entirely alone and undisturbed, through Thyssen's incomparable anthology of European art. After a year or two, I was on intimate terms with virtually every centimeter of those painted surfaces. I never learned, nor did I ask Thyssen, if his bringing that phony sculpture to my studio in Florence was simply a "test."

By 1971, Thyssen had been married for several years to Denise, his fourth wife. She proceeded to enliven the otherwise deserted Villa Favorita with frequent invitations to the international "jet set," as it was then called. One card-carrying member of that group – who, ironically, never flew – was J. Paul Getty. In June of that year, the insular world on the shores of Lake Lugano was astir with the news that the so-called "richest man in the world" would be paying a visit. The Thyssens, of course, arranged a suitable welcome at a lunch; dinner evidently didn't suit the nearly eighty-year-old magnate. Getty had taken a room at the old Hotel Splendide in town and planned to stay overnight. At the appointed

hour, two oversize Cadillacs drove up to the villa; one with the lone Getty and the other with his retinue comprising Mary Tessier, an elegant lady friend "of a certain age," Henry d'Abo, an upper-crust Brit, and two other women whose names I no longer recall. I was deputized to greet the guests at the end of the villa's winding driveway and was somewhat surprised to see Getty, entirely alone, in the back seat of the first car. I couldn't help but notice that this vehicle was, despite its immense size, only a two-door coupe. Chatting briefly with the driver, I learned that Mr. G. traveled very reluctantly and then only by the sort of robust conveyance from which he would not fall if a door accidentally opened.

The lunch, served on the villa's leafy terrace, was pleasant enough – with the conversation turning at one point to matters pertaining to the Soviet Union. Thyssen, in fact, had recently returned from a visit there. Later, he changed the subject and asked Getty his thoughts about shipping, a business in which Thyssen was deeply involved. The older man's eyes lit up. What followed was a rhapsodic account of how marvelously young people behaved in the Russian socialist workers' paradise, never, ever, asking for a tip. Mme. Tessier gently nudged him with a reminder that the subject was shipping. "Oh," Getty said, "I thought we were talking about *tipping*." For the notorious tightwad, the definition of paradise was clearly a place where one never needed to spare a dime.

Another, more serious, topic at the lunch was the upcoming Christie's sale in London where Titian's *Death of Actaeon* (*ca.* 1559–76) would be coming on the block from the collection of the Seventh Earl of Harewood. The huge canvas was the last of the artist's famous *poesie* (poems) remaining in private hands. Even though the work was not in stellar condition, and was clearly inferior to the others of the same group, there was little doubt that the bidding would soar.

Thyssen good-naturedly chided Getty about not ever having bought a really decent painting; this Titian was his big chance. The long, careful visit to the Favorita Gallery that followed must have made a powerful impression, because it was later learned that Getty had purchased the picture from the London dealer Julius Weitzner. "Julie," as he was universally known, was the reigning auction-room *capo* at the time. He won the lot for £1,700,000, telling everyone after the sale "yeah, I bought it for stock." That may not have been as much of a joke as it sounded, because Julie eventually pocketed a profit of more than £80,000 when Getty at last decided to go for it. In the end, the California skinflint was spared the agony of writing a huge check when the painting was denied an export license (it is now in the National Gallery, London). In fact, Getty was to become identified with great paintings only after his death – when his lavish bequest became available to the museum bearing his name.

After our lunch at the Villa Favorita, it was expected that I would lead a gallery tour and continue further conversations about art. Mr. Getty must have become convinced of the depth of my connoisseurship – a decidedly optimistic impression. In any case, he promptly invited me to join him that evening at the Splendide for more chat, but after dinner, naturally. I found him occupying what must have been the smallest room of that grand hotel, probably one originally reserved for a maid or butler. There was only a bed and two chairs, and so, within minutes, every surface, including the floor, was covered with large photographs of a painting about which Getty obviously cared passionately. The artist and composition were easily recognizable: it was one of the versions of *The Madonna of Loreto*, also known as *The Virgin of the Veil* (*ca.* 1508–09), variously identified as a late work by Raphael, or, more probably, his pupil Gianfrancesco

Penni. The best of these variants has always been identified as the one in the Musée Condé in Chantilly. Getty had purchased his version from Agnews Gallery before the War, and there was no disabusing him of the notion that he owned not only the "prime" version, but that it had to be by Raphael himself. I patiently listened to an interminable and convoluted argument about provenance, original documentation, "internal" evidence about the panel and its markings, and all manner of other "proofs" that scholarship had uncovered. Having had neither the expertise nor the inclination to express an informed judgment, I continued to nod my assent and eventually left Mr. Getty in his tiny room, hopefully a happier man.

June 2018

E. V. Thaw, 1927–2018

Remembering the life & legacy of Eugene V. Thaw.

TWO WHOLLY UNRELATED EVENTS in the realm of the visual arts marked this winter season. Impossible not to have noticed one – the sale of Leonardo's *Salvator Mundi* for nearly half a billion dollars. The oily, slug-like features of the Pantocrator even found their way onto T-shirts, a sure sign of success in the one process elevated to an art form by our consumer society: branding.

The other event, in sharp counterpoint to the da Vinci media circus, was the death of Eugene Victor Thaw. Though hardly front-page news, it nonetheless elicited universal sadness and reflection in those who were fortunate to have known and worked with him. A comprehensive *New York Times* obituary detailed how the ninety-year-old Thaw, from modest beginnings, became one of the last century's greatest art dealers and collectors. How he might have judged the *Salvator Mundi* phenomenon is unrecorded, though his aversion to chasing "names" was well known: an attitude evident from the astonishing diversity, in value and significance, of the material he sold or collected.

Though not a scholar himself, Thaw thoroughly understood the value of academic art history in resolving issues of attribution, provenance, and iconography. He maintained a close personal and working relationship with most leading specialists but, ultimately, his decisions remained true to his remarkably perceptive instinct or "eye": that god-given gift of intuition that needs to be nurtured, cultivated, and

continually tested vis-à-vis the art object itself. That Thaw could use this precious tool in judging material as diverse as Renaissance drawings, Impressionist paintings, and Native American artifacts – just to mention a few of his collecting interests – epitomizes the very ideal of connoisseurship.

The cornerstone of Thaw's legacy as a collector will remain the spectacular group of more than four hundred drawings bequeathed to the Morgan Library over the years on behalf of himself and his wife, Clare Eddy Thaw. Roughly half of that number have recently been exhibited there together and published in a handsome scholarly catalogue. Not surprisingly, a number of the Thaw sheets are deemed superior to the museum's other holdings in the field, and the group, as a whole, is considered the institution's single most important accession since its founding.

Unlike most long-active dealers and collectors, Thaw rarely carped about the scarcity of first-class material compared to "the good old days"; he simply sought out items he knew to be masterworks in different, less frequented, fields. Even without the essential academic credentials, Thaw might well have pursued a successful career as a museum professional, continuing a long American tradition that included Hartford's legendary "Chick" Austin, Cleveland's Sherman Lee, Toledo's Otto Wittmann, and, happily, New York's own Philippe de Montebello. But buying and selling art – as pedestrian as that sounds – was the activity that enabled him to generate the profits to buy more and, consequently, collect more.

His timing could not have been better. In 1961, the Metropolitan's purchase at Parke-Bernet, New York, of the ex-Erickson Rembrandt (*Aristotle Contemplating the Bust of Homer*, 1653) was the clarion call that proclaimed the start of the post-war bull market for art. It would now be possible to reckon value in the millions, rather than in the thousands,

of dollars. (The Rembrandt fetched \$2.3 million – today, that number would require at least two more zeros.) And Thaw was there for the entire run, witnessing – and generally greatly benefitting from – the continuing upward spiral.

He participated in the concluding chapter of another, more complex multi-million-dollar saga that had begun in the 1930s. It was in those relatively lean years that the American dime-store entrepreneurs – the brothers Samuel and Rush Kress – took advantage of a buyer's market to amass a gigantic hoard of European paintings and works of art. The fortunate agent for most of those purchases was an enterprising Italian count, Alessandro Contini-Bonacossi. Contini-Bonacossi shrewdly sank the handsome profits of his transactions with the Kresses into Florence real estate and into creating his collection.

Whereas the vast Kress holdings were destined to become a munificent gift to the nation, the Contini-Bonacossi estate remained mired in family disputes and tax issues long after the count's death in 1955. When a handful of Contini-Bonacossi paintings were finally granted export permission ten years later, Thaw contrived to secure, as an agent for its sale, the most sought-after of the lot: the utterly magical and unique *Still Life with Lemons, Oranges, and a Rose* (1633) by Francisco de Zurbarán. Not only did Thaw arrange to put this masterpiece on his easel, he also knew exactly who should be given a privileged first crack at it: the rough-edged California industrialist and financier Norton Simon. At that time, Simon was beginning to flex his muscles as the world's most aggressively acquisitive collector not only of European art but of Hindu sculpture as well.

By the early 1970s, Simon was well on his way, in both fields, gathering the superb body of works that, at first, had no permanent home. Many were parceled out on loan to a variety of museums while others languished in storage. For

years there was much speculation about the eventual dispo-
sition of the Simon holdings. Finally, the long wait paid off
for the collector: true to form, Simon saw an opportunity
and seized it. He was able to "buy" (at a huge discount, of
course) an entire museum for himself. As it happened, the
worthies of Pasadena responsible for their small local
museum had, over the years, recklessly saddled the institu-
tion with debt by commissioning a new building. Simon
smartly stepped in, cleared up the red ink, and cleared out
the worthies. He now had a container – albeit not particu-
larly handsome or practical – to house his collection; the
makings of a museum where he would be in total control
and that would bear his name. After Simon had successfully
completed this unprecedented undertaking, his compulsion
to collect progressively waned and finally ceased. He would
turn up at "his" museum unannounced for a wheelchair
tour of the galleries, also invariably checking at the book
shop for the statistics on postcard sales. This was, for him, a
sure sign of what the star attractions were. The Zurbarán
Still Life, Simon's favorite painting, was, reassuringly, always
number one.

In the process of collection- and museum-building,
Simon hardly made life easy for the art world professionals
who were his principal correspondents and collaborators.
His was decidedly not the suave, slightly detached, and
graceful style of collecting in the European tradition of the
past. It was obvious that he did not consider art to be merely
a life-enhancing ornament. Simon was, first and foremost,
a consummate businessman and used all the tricks of the
marketplace to drive home his best deals. These were not
only purchases but included sales, exchanges, half-share
partnerships, and any manner of clever arrangement that
would assure him the upper hand. He was an incredibly quick
study and a voracious gatherer of information, seeking

advice from every quarter. Thaw was very much part of Simon's "advisory universe" and was continually consulted. The only problem was that Simon would invariably compare, correlate, and combine the information he most recently received with the vast store of data already squirreled away in his computer-like memory. Typically, advice was forever sought but was rarely followed. Not surprisingly, Thaw was deeply offended and irritated that his suggestions should be questioned and – worse – compared to those which Simon continually solicited from virtually every other operator in the field. Thaw saw this as a lack of trust. Even more upsetting was Simon's willingness to sell items, some even obtained from Thaw, simply to "confirm" the value of his other, similar holdings – a tactic suited more to a shopkeeper than a great collector. Indeed, it can fairly be said that, of the two, Thaw the dealer was the idealistic "romantic," and Simon the collector the cynical "realist." Despite the fact that the two played relentlessly competitive games on opposite sides of the net, and never became friends, Thaw and Simon had unbounded respect for each other and remained in cordial contact even long after their business dealings had ceased.

Thaw would certainly have described himself as a "private dealer" despite the wide recognition his name enjoyed. In pursuing this business model, he was, in a sense, adapting to a radical transformation of the post-war art market that saw the progressive decline and eventual demise of celebrated and historic firms such as Agnews, Wildenstein, Knoedler, Colnaghi, and French & Co. It would no longer be possible for them to maintain their palatial premises or – more importantly – to renew their inventories with material of sufficient quality. Equally significant was the meteoric ascendancy of the London and New York auction rooms. Peter Wilson of Sotheby's understood, more clearly than

anyone, the huge potential of the public sale. By dint of bril-
liant marketing, lavish cataloguing, and continued diversifi-
cation, auctions ceased to be principally a wholesale source
for dealers but were progressively transformed, much more
profitably for the firms, into sophisticated retail operations.

A visit to Thaw's premises was a required ritual for any-
one seriously involved in the visual arts from the mid-1960s
onwards. During these decades he occupied several venues,
none of which could be described as a "gallery." The last two
were residential apartments on Park Avenue where the visi-
tor would be greeted in the conventionally – yet elegantly –
appointed living room or library. Only the object of the
client's interest would be displayed, enhancing the item's
singularity. This was consistent with Thaw's belief that
what he called the "gestalt first impression" was of capital
importance in how works of art are perceived and, ulti-
mately, judged. Thaw was masterful at describing whatever
he was showing, always enriching his presentations with
illuminating observations about an item's aesthetic appeal
yet never foregoing the carefully researched details of its
historical significance. These were, typically, intense one-on-
one sessions that unfolded in hushed privacy. Needless to
say, the recent proliferation of the art fair was an incompre-
hensible phenomenon to Thaw. Its evident success in selling
material even at the highest level of value and importance
appeared to negate many of the traditional conventions –
discretion, exclusivity, and prudence – that, seemingly for-
ever, had guided the way art was bought and sold.

Unfortunately, Thaw has left a very sparse written record
of the principles that guided his aesthetic as well as cultural
endeavors. What we know of these survive chiefly in the rec-
ollections of colleagues, collaborators, and friends, his
impressive catalogue raisonné of Jackson Pollock – and in
the pages of *The New Criterion*, where he published essays

on eight different occasions starting with the very first issue in September 1982. Rare additions are the twelve interviews Thaw gave in 2006–10 to the writer Steven M. L. Aronson, which were published in *Architectural Digest*, and to James McElhinney for the Archives of American Art Project. They provide a revealing personal perspective on the subject of connoisseurship at a time when this concept of intuitive critical perception is rapidly losing its credentials. Phrases such as "end of an era" or "last of the scholarly dealers" might, unfortunately, turn out to be all too true.

The disappearance of a revered voice such as Thaw's has left an inevitable sense of melancholy and regret, particularly against the backdrop of the *Salvator Mundi kermesse* and the mindless hyperbole it unleashed; or the grotesque spectacle of tens of thousands of visitors standing in line for a recent Modigliani exhibition in Genoa that turned out to be replete with blatant fakes, where, again, the attraction of the "name" proved irresistible and subverted any serious critical evaluation. It's a fair bet that none of those duds would have passed muster had they been submitted to the scrutiny of one Eugene Victor Thaw.

February 2018

After the Great Flood of Florence

On the wreckage & recovery of artworks in the flood of 1966.

WERE ITALIANS to identify one monument in their cultur-
ally and linguistically diverse nation as representing its
Valhalla – the locus of their fatherland's identity – it would
be the great conventual Basilica of Santa Croce in Florence.
Begun at the end of the thirteenth century during the mete-
oric rise of the Franciscan Order, the giant Gothic structure
is surrounded by equally imposing monastic outbuildings
and cloisters, as well as that jewel of Early Renaissance
architecture, Filippo Brunelleschi's Pazzi Chapel. The nave,
transept, and chapels of the basilica tell a capsule story of
Italian art – from Cimabue to Canova – while, lining those
same walls, rows of tombs and cenotaphs recall human
achievement in all its manifestations: from Dante to Alfieri,
from Michelangelo to Galileo, and from Leonardo Bruni to
Gioachino Rossini. Santa Croce is really more a pantheon of
greatness than a church. Its nineteenth-century façade, a
symbol of ecumenical inclusiveness, was financed in great
part by an English Protestant magnate, Sir Francis Joseph
Sloane, and prominently bears a Star of David in tribute to
its Jewish architect, Niccolò Matas.

Just as I and most of my fellow Florentines were only
dimly aware that Santa Croce's façade was a Victorian pas-
tiche, so too did we barely realize that the basilica was built
on land far below the high-water level of the nearby Arno
River. This fact, however, was startlingly revealed to us and
the rest of the world on the morning of November 4, 1966,

when that level was hugely surpassed as the Arno suddenly overflowed its banks and protective parapets, roaring into the city with an avalanche of mud, organic detritus, and heating oil – a churning emulsion of filth. Although at the time, my family's home was only a stone's throw across the river from Santa Croce, I was not in Florence to witness the unfolding disaster. I learned about it on the radio as I began my workday at the Villa Favorita in Lugano, Switzerland. For the previous two years, I had been serving there as visiting conservator for the great collection of Baron H. H. Thyssen-Bornemisza, dividing my time with a private conservation practice I continued in Florence. The enormity of the cataclysm was progressively revealed in newscasts as I struggled to reach the stricken city by car over the next twelve hours – normally, in those days, a five-hour drive. Though by the evening of the fourth the flood had mostly receded, the devastation it caused in Santa Croce and other low-lying areas of the city and countryside was catastrophic. The great Franciscan basilica, its cloisters, and surrounding neighborhoods had been submerged to an average depth of eighteen feet. Even in areas where the flood had failed to reach such dramatic levels, the raging torrent, with its sheer force and headlong speed, left in its wake a nightmare landscape of utter chaos and destruction. Thousands of gallons of heating oil had mixed with the churning waters, everywhere revealing horribly soiled surfaces as the flood subsided.

Not surprisingly, each anniversary of that fateful event is somberly remembered in Florence. With this recent fiftieth recurrence, however, it became more of a national and even international commemoration. Much reported here and abroad was the reinstallation, in the Refectory adjoining the basilica of Santa Croce, of a huge depiction of *The Last Supper* by Giorgio Vasari, the mid-sixteenth-century painter, architect, and author of the celebrated *Lives*. It was

an apt commemorative gesture since the Vasari was billed as the last remaining flood-ravaged work to be replaced on public view after restoration. *The Last Supper* panel (in fact, five separate sections of poplar measuring a total of over six by eighteen feet) was originally commissioned for a nearby Carmelite convent. With the suppression of many cloistered religious communities in the nineteenth century, the huge painting was put on deposit at Santa Croce. Here, in the late 1950s, a place was finally found for it in a cramped, rather dark space adjoining the Chiostro Grande as part of a projected museum complex. And it was here, a day after the flood, that I encountered *The Last Supper* still bolted to the wall in a room where the water had just recently reached to the ceiling.

Having apprenticed at the Uffizi "Gabinetto del Restauro" several years earlier, I was known well enough by my older colleagues there to be put in charge of a small group of volunteers. We and other "first aid" intervention squads were dispatched as the need arose – and Santa Croce was immediately identified as the highest of priorities. Of these, by far the most important, not only in Florence but also in the entire Arno basin, was the great painted *Crucifix* by Cimabue. Dating from the last quarter of the thirteenth century, the imposingly large and poignant devotional image has always been regarded as a milestone in the early development of Italian art. After the last war, it spent about a decade in the Uffizi before being returned in 1958 to Santa Croce, the church for which it was originally created. At that point, however, rather than being placed on the main altar, the great cross was hoisted high on a wall in the Refectory. Tragically, it proved to be not high enough: the waters of November 4 submerged the panel nearly to the top and, by the time the feverish work of detaching it from the wall and laying it down had been completed, large portions of the

painted image had forever disappeared. The Cimabue *Cruci-fix* became the symbol of the Great Flood. The most sea-soned and experienced conservators of the Gabinetto were deployed in an effort to save this touchstone of Italian art. At the same time, the Vasari, in its small nearby room, received its emergency ministrations from a young opera-tive just arrived from Switzerland and not even on the Gabi-netto staff. Not surprisingly, the formidable task of restoring the Crucifix was the first to be undertaken and the first to be completed. In 1982, the Cimabue, in its now fragmentary state, was shown abroad and even made a fleeting appear-ance at the Metropolitan. Meanwhile, Vasari's *Last Supper*, a victim of its immense size and perceived marginal artistic value, languished.

Like all the other affected panels – even the *Crucifix* – the Vasari was subjected to a first emergency intervention that consisted in "papering" the surface to protect the color layer. The practice is one of conservation's most well-established and widely employed techniques. It consists in carefully applying to the painted surface small squares of wet-strength mulberry paper with an adhesive. The "patch" or "patches," once dried, allow an operator to safely perform consolida-tion in areas where blistering, fragmentation, and other deformations have occurred without fear of further losses to the pictorial layers. The preferred adhesive for "papering" has traditionally been a light, water-soluble animal glue that penetrates adequately, dries rapidly, and is easily removed at the end of the procedure. In the wake of the flood disaster, Uffizi conservators were, however, instantly faced with a major and obvious problem: with the support and painted layers of the affected paintings still damp, the preferred adhesive used for "papering" could not possibly function. A new substance needed to be chosen that would dry in high-humidity conditions. Not only had this substance to

be suitable for the task, but it also had to be used in the vast "papering" undertaking – immediately. This urgency was obvious to the conservators because, if the painted panels were allowed to dry unprotected, the wood supports would shrink rapidly and dramatically, causing further havoc to the images.

The decisions, after consideration of these stark realities, were taken in a climate of near panic, though surely with the best available knowledge. The first and most significant of these decisions was the choice of adhesive for the "papering." Rome's Central Institute for Conservation had been testing for several years a synthetic resin developed by the Philadelphia firm Rohm & Haas, known by the trade name "Paraloid." It is a polymer plastic, soluble in toluene. Unlike natural resins such as dammar or mastic that have been used for centuries, this material – technically a methacrylate – is highly resistant to atmospheric and environmental deterioration. Such stability is much appreciated by conservators and, by the mid-1940s, the resin was quickly adopted in American studios, particularly as a varnish. In 1966, after receiving Rome's blessing, Paraloid was just becoming fashionable in Italy as the "last word" but decidedly not at the Uffizi Gabinetto del Restauro, still very much a bastion of traditional conservation methods and materials. Nonetheless, large quantities of the synthetic resin were commandeered elsewhere and rushed to the city. Amazingly, by the fifth of November, the appropriately prepared adhesive was already in the hands of volunteer teams such as mine. We were quickly at work, applying it to hundreds of square feet of antique painted surface, all over the city.

The Cimabue *Crucifix*, although the focus of the senior conservators' most urgent attentions, suffered infuriating delays in being lowered from the wall and placed in a horizontal position – on a series of creaky wooden chairs hastily

arranged to receive it. Fortunately, the loss of color on the gigantic *Last Supper*, due to its more robust support and the execution in oil medium, was not nearly as dramatic as with the Cimabue, done in egg tempera. No attempt was made to detach the panel from the wall. The "papering," therefore, had to proceed in a vertical position, resulting in a very uneven distribution of adhesive over the surface; after all, this was a little-known Vasari and could be left as it was for the time being, with a relatively inexperienced practitioner in charge.

As papering of the seemingly endless number of panel surfaces continued *in situ*, the second important decision taken after the flood was beginning to be implemented: transfer of the works to places where slow and controlled dehumidification of the panels could take place. "Slow" and "controlled" were the watchwords here. The carefully planned strategy was to proceed gradually in consolidating the surfaces with conventional glue adhesives as the wood supports were slowly drying, thus regaining their original configuration and size. The process also called for the simultaneous removal of the papers and the methacrylate resin with which they were applied. In order to do this successfully, the panels had to remain in a horizontal position. While this, at first, posed significant logistical hurdles in terms of space, adequate locations were soon found in the various greenhouses of the Boboli Gardens as well as those of other Granducal villas. Within a few months of the massive relocation effort, the Uffizi personnel began to suspect that the strategy they had intended to follow might not be going as planned. Maintaining and controlling humidity levels in these new environments proved to be a far more daunting task than imagined. Serious problems began to appear in the most vulnerable of the panel paintings' components: their gesso (gypsum) ground or priming. Such pre-

192

parative layers are common to all Italian panel paintings whether executed in tempera or oil. They are generally quite thin, bound with animal glue, and are therefore hygroscopic (water-sensitive). Exposed to prolonged humidity, glue progressively loses its binding properties but, more seriously, is prone to mycological (fungal) decomposition. Such deterioration could be fatal to the continued structural integrity of a majority of the affected paintings.

A further complication also became evident. The molecular structure of Paraloid is more complex and "heavier" than that of the natural resins traditionally used by painters and conservators. This is, in fact, what accounts for the synthetic resin's much-praised stability, light-fastness, and permanence. But it also requires more efficient, or "stronger," solvents (such as toluene) to be diluted for normal use. Since, with time, all resins, both natural and synthetic, have a tendency to become progressively less sensitive to solvent action, the Uffizi conservators were now confronted with the excruciating prospect of trying to remove a hardened layer of paper and resin from paintings whose structures were deformed and severely weakened. Clearly, the sooner this could be accomplished, the better; an ominously impelling issue of time was again at hand.

The only reasonable course of action left for the harried Gabinetto staff was to determine for each painting a "rating" according to historical significance, state of conservation, age, and size. In effect, it became a kind of artistic triage whereby certain works, such as the Cimabue, went to the head of the line while many others languished in the dangerous limbo of the Boboli greenhouses. These were finally emptied when it became obvious that the numerous remaining panels would be at risk of ever greater deterioration if humidification continued. *The Last Supper* was put aside, semi-forgotten, and at the very end of the line. It was not

retrieved from storage until eleven years ago when a full evaluation of its state was at last performed. By then, most of the pictorial layers were adhering to the facing papers rather than to the panel; much of the color had detached from both and was irretrievably lost. The wisdom of those early decisions, so hastily taken, was seriously open to question.

On a positive note, however, the Great Flood had caused much to change in Florence in the intervening decades, none more than in the field of fine arts conservation. The cramped quarters of the old Gabinetto del Restauro behind the Loggia dei Lanzi at the Uffizi was closed, and so were various associated studios in other locations. All painting conservation activities were unified under the aegis of the still-surviving Medici gemstone workshops, the "Opificio delle Pietre Dure" (OPD). This new entity bearing an ancient name was now assigned much expanded and refurbished premises in the "Fortezza da Basso," the sixteenth-century military bastion designed by Michelangelo. The reborn Opificio was endowed with every imaginable contemporary diagnostic and technical tool as well as a steady flow of funding, some from corporate and foundation sources. Shortly after the "Fortezza" workshops opened, Baron Thyssen-Bornemisza, the collector for whom I worked for many years, generously underwrote the costs of a new, state-of-the-art woodworking shop. The tradition-bound artisan-restorer's atelier of the Gabinetto was rapidly transformed into an up-to-the-minute conservation facility.

It was in 2006, at the Opificio, where the task of piecing back together Vasari's *Last Supper* began. The timing was right because, by then, new materials and techniques that had not been available forty years earlier could be tested and applied. It was, nonetheless, Florence's unmatched and age-old tradition of sophisticated carpentry that was fortunately still alive and, in this instance, proved crucial. The

various sections of the huge panel were found to be hideously warped, shrunk, and split. What was left of the painted layers was mostly attached to the resin-hardened papers rather than to the wood support. Nothing could be done until this support regained a degree of planar coherence and stability. This was accomplished by a small team of superlative craftsmen who "opened" the panels by painstakingly inserting myriad thin strips of poplar into channels chiseled into the body of the original wood. Once the panel support had been restored to a semblance of its original self, a new ground layer was applied and made ready to receive the gigantic jigsaw puzzle that the color layers had become. Considerable wizardry in organic chemistry was needed to resolve the problem of softening the aged layer of methacrylate resin so that the color layers could be separated from the papers. The principal tool for this procedure was endless patience – more than five years of it! – plus a generous helping hand from the "Panel Painting Initiative" of the Getty Foundation.

The completion of the *Last Supper* project marked the closing chapter of the Great Flood saga. With much fanfare, the painting was returned from the Opificio delle Pietre Dure to Santa Croce for dedication on November 4, the very day of the tragic event fifty years prior. There was no shortage of other commemorations in the city, but the Vasari was firmly at center stage, described as a "masterpiece" and its restoration as a "miracle." The President of the Republic, the Mayor, and Matteo Renzi, the former mayor and prime minister, were all present, surrounded by the usual gaggle of dignitaries, large and small-bore. The huge panel now hangs in the Refectory, precisely where the Cimabue Crucifix suffered its fatal encounter with the waters of the Arno half a century ago (what remains of it was long since "promoted" to the basilica's sacristy). If nothing else, the event

was emblematic of how art-historical favor has shifted Vasari's way these last decades: from a cramped, low-ceilinged space on the periphery of the courtyard, his huge panel has now migrated to the soaring grandeur of the Refectory – and from the hands of a novice conservator to the care of one of the world's foremost museum labs.

All this would be abundant reason to rejoice, as did the press and dignitaries in perfect unison, were it not for the fact that the restored *Last Supper* is further proof that, in the field of conservation, "miracles" are, at best, elusive. Vasari's "masterpiece" is, and is destined to remain, a sorry, fragmentary shadow of itself. It would have been simply impossible for the restoration, epic and heroic as it was, to retrieve the surface, texture, and quality of a work of art that is now but a patchwork of bits and pieces. And yet such analytical considerations were hardly foremost in my mind as I stood in the Refectory for the first time in so many years. Too much had changed: the concerns of art history had evolved, and so had – dramatically – the practice of conservation itself. That private collection, once secluded in a verdant corner of a Swiss lake, was now a public foundation teeming with visitors in the center of Madrid. Most poignantly, there were no Uffizi colleagues still living with whom I could share memories of those terrible November days of 1966; they were the talented, supremely gifted craftsmen, who had devoted their lives to the care of paintings when they were then suddenly faced with this unimaginable spectacle. I remember how some at first cried, others panicked, but, eventually, all managed to gather their strengths and skills, bravely continuing for years the daunting task of retrieving what was left of their – and our – artistic heritage.

January 2017